THE WORLD ON

MY DOORSTEP

1950 - 1976

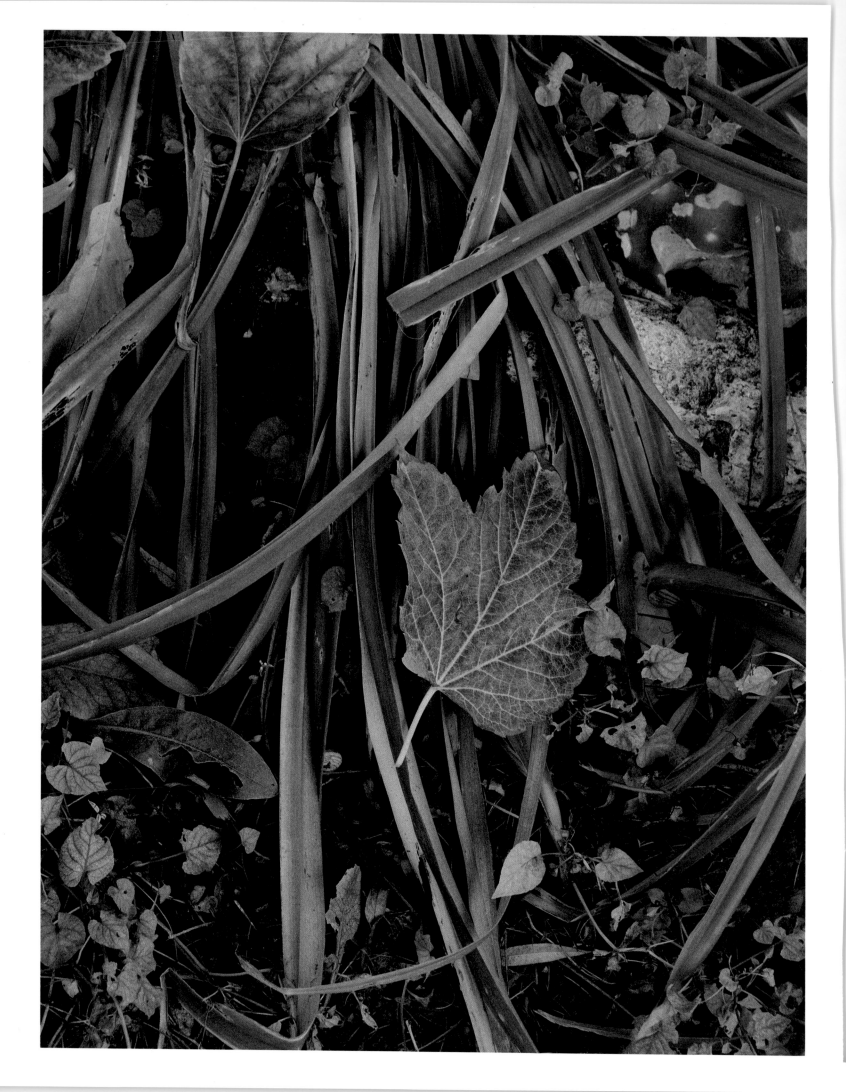

THE WORLD ON PAUL STRAND MY DOORSTEP

An Intimate Portrait
Catherine Duncan

Critical Essay
Ute Eskildsen

AN APERTURE BOOK

WHEREVER I happened to be, in the Southwest, in Mexico, in an Italian village, in Ghana or Egypt, in Morocco or on the islands of the Outer Hebrides, I sought the signs of a long partnership that give each place its special quality and create the profiles of its people....

So finally, it can be seen that what I have explored all my life is the world on my doorstep. And if the things that come close to me today are those literally only a few feet away in our garden at Orgeval, this too is another phase of the voyage.

When it is no longer possible to get about with the same energy and freedom, a man usually tries to find a way around the difficulty so that he can continue to do the things he wants to do. The question he asks is: What can the obstacle lead to that is new, positive and useful? In my case, the answer has been an intensified awareness of what has always been there to see in my immediate surroundings.

The material of the artist lies not within himself nor in the fabrications of his imagination, but in the world around him. The element which gives life to the great Picassos and Cézannes, to the paintings of van Gogh, is the relationship of the artist to content, to the truth of the real world. It is the way he sees this world and translates it into art that determines whether the work of art becomes a new and active force within reality, to widen and transform man's experience.

The artist's world is limitless. It can be found anywhere far from where he lives or a few feet away. It is always on his doorstep.

Paul Strand, from the Introduction
to the "On My Doorstep" portfolio,
Orgeval, December 1975.

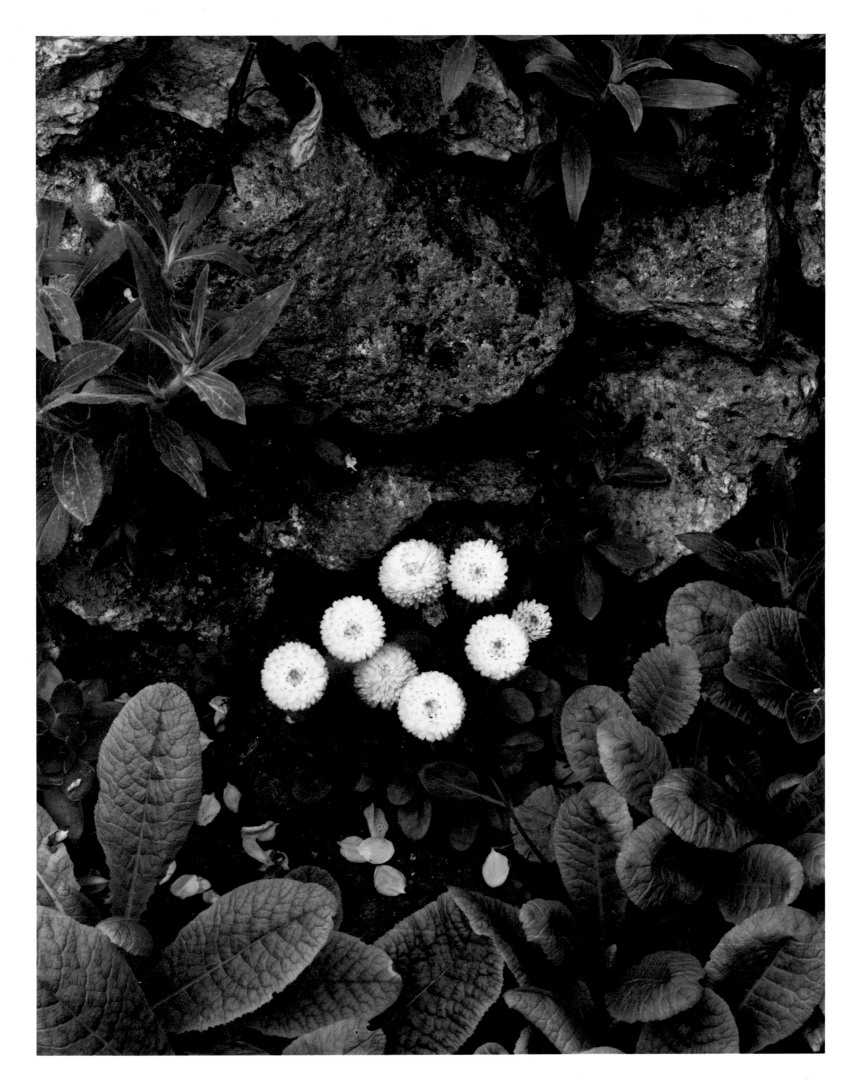

AN INTIMATE

PORTRAIT

Paul and Hazel Strand stood in the garden beside the old willow tree gazing back at the house, and as they looked it seemed to become transparent. The khaki-colored walls would have to be repainted white, the ugly fireplace rebuilt. Then the eye would travel comfortably from the front garden, through the big living room to include the weeping birch in the back courtyard. On the upper floor, the gallery could be filled in to make a studio for Paul, his darkroom behind it.... The main bedroom, like the living room, ran the width of the house with windows on both gardens, front and back, an inside/outside relationship Paul had often photographed in New England houses. But this was France, and the house stood in a village called Orgeval in the Yvelines, thirty-six kilometers from Paris.

What do you think, Hazie?

Having made over the house in imagination, Hazel turned her attention to the garden and its rows of espaliered pear trees, the drive up from the front gate straddling a bed of primroses. Old trees, simple flowers, a cloud of mauve wisteria clinging to the latticed walls of the house. And suddenly she had an urgent desire to get her hands into the earth and make it flourish. Instead of the earth she had known as a Red Cross photographer during the war, churned up by tanks and jeeps, bombed, toxic, a place for the

dead, she would have a garden. The garden she had never owned, where she could grow corn and Mother Hubbard squash, cucumbers for dill pickles, and the pears for ginger-pear jam.

The little room upstairs would become *her* workroom, housing a loom on which to weave the traditional patterns of early America, with still enough space to assemble pieces for a patchwork quilt. Her hands, practical hands, could do all these things as once they had worked helping Louise Dahl-Wolf make fashion photographs for *Harper's Bazaar*. But that was before the war, in New York. This was France, and one photographer was quite enough in the family, particularly if he were Paul Strand, whose name already figured among the great pioneer photographers of America.

Remembering Paul's question, she said: *I think we could work here.*

Meanwhile, Paul's eye had been traveling beyond the garden to the old farm opposite on the other side of the road, then sloping down the hill, across the cultivated valley, moving left, climbing again, this time to the woods, and from there, returning full circle to the house.

It's not far from Paris, he thought aloud. *We could get in easily and friends could come out.* To which he added another thought: *And we could travel.*

To find that village you're always looking for? Hazel

teased him. *You'd have one right here on the spot with Orgeval.* But she knew it was useless suggesting what or where Paul should photograph.

"MONSIEUR ET MADAME STRAND," the new owners of the property in Orgeval, were newlyweds, married recently by the mayor of Orgeval, who was profoundly relieved when Hazel Kingsbury became Madame Strand, a name he could pronounce without stuttering. The gossips of the village confirmed that Madame Strand was his third wife and a good deal younger than her husband. At least she spoke a little French. All he seemed to manage was *bonjour* and *au revoir. Americans,* stated the oldest inhabitant. *They won't last long. The house will be up for sale again in no time.*

En France, Hélène Letutour remarked crisply, *ce n'est que le temporaire que dure.* An old saying used ironically when referring to the longevity of the temporary.

Nobody in the village was better informed about the new owners than Hélène and her husband, Raymond Letutour, who had been engaged as housekeeper and gardener by the Strands. The gossips would have liked to ask on what grounds Hélène based her remark suggesting that the Strands had come to stay, but Hélène and Raymond were notoriously tight-lipped about their employers.

Perhaps, in those early days, Hélène herself would have found it difficult to explain why she felt the coming of the Strands was more than temporary. Even Paul and Hazel were unaware, the day they decided to buy the house in Orgeval, that they were laying the ground plan of their life together for the next twenty years.

MORE THAN A DECADE LATER, Susan Barron, a young American photographer, came to France repeating *Orgeval, Orgeval* like a talisman. Driving to Normandy, the name jumped out of the road map she was following. Taking an impulsive turn left, Susan began asking where Paul Strand lived.

I had to go where the pictures were taken, though the only pictures I knew then were in the book La France de Profil. *Finally, a cyclist pointed to the gate and something compelled me to go in. The garden was like fairyland. Walking up the drive with forget-me-nots and tiny pansies, the first thing you noticed were steps up to the lawn, rock gardens, and a willow to make you weep. It was early spring, you saw your breath and the buds just starting to come out. The house seemed very open. I peered in. You could see right through to the little backyard, holding the sun like a cloister. I knocked on the door and heard a noise upstairs as if I was being watched.*

What do you want? The voice was forbidding, a woman's voice.

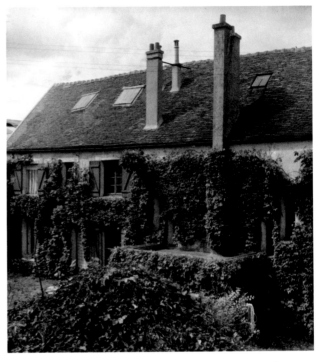

The House at Orgeval.
Photograph by Hazel Strand

Is this where Paul Strand lives?

Yes. Who sent you?

Nobody sent me.

What do you want?

I'm not sure. I just saw some photographs Mr. Strand made.

There was a pause. The wall between Paul and the public seemed to be deciding whether or not it would let her through. Finally the voice said: *If you wait a little he'll see you.*

So Susan sat in the garden waiting, while the birds fossicked between freshly weeded vegetables and the strawberry patch, or landed on the sanded *boules* court under the plum tree. After fifteen minutes of what Hazel called the editing process, the voice called out: *You'd better come in. It's chilly out there.*

The room was cold but thoughtful, Susan remembers. Craft materials, a flagged floor, and on the wall, original prints. Not even the wonderful reproductions of the book could do them justice. Then Paul came into the room. Backlit, he was much bigger than I expected. His center of gravity seemed higher. He had on a tweedy sport coat and sweater. Gray hair. Eyes light blue, with a strange look I discovered afterwards was cataract. Not athletic, but handsome, very welcoming and sweet. "You waited quite a long time, didn't you?" I was looking at a picture, and Hazel got out a box of prints. He wanted me to sit in the light and tell him what I was looking at. Hazel was in and out, scraggly, with a wonderful smile. She seemed pleased to see we were talking and that I was interested in him instead of coming with my own work to have the master's blessing. I didn't even ask to see his darkroom. I think that pleased him. "Why don't you

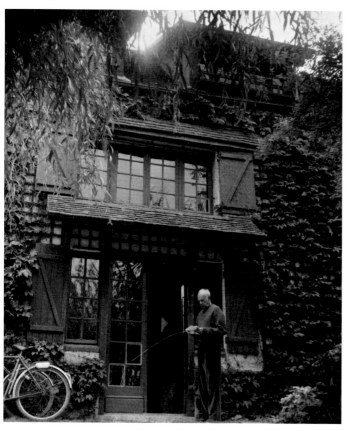

Paul Strand at Orgeval.
Photograph by Hazel Strand

stay for lunch?" So Paul and I went into the village to buy things and Hazel made a simple, lovely lunch. I told them about my trip to Normandy, and Paul got out maps to show me where to go.

About three o'clock, just before I was leaving, he asked if I had any pictures. I showed him the few I had with me, and he said one of them was a good picture but it wasn't printed well. "What do you think, Hazie?" He always deferred to her, and now that he couldn't see well because of the cataract she served as his eyes in the darkroom. She knew all about the mastery of Paul's prints.

From that first meeting, the house at Orgeval adopted Susan. For Hazel, she was like a daughter. *I'm not so sure about Paul,* Susan says. *The prints were his children. Real children were attracted to him. They clung round his trouser legs. But he was clumsy with them, and his portraits of children are sentimental. Of course, there was Viviane, Hélène's daughter. Paul helped with her education. She was still little when they came to Orgeval, and had to be coaxed out of her shyness with bonbons. Hazel and Hélène made a quilt for her wedding. Later on her boys came—they weren't shy about the bonbons.*

THE LIGHT-YEARS OF MEMORY can be condensed into a few sentences. In reality, those years for the Strands were filled with constant work. I met them first in Paris before they moved to Orgeval, when they had an apartment in the rue Auguste-Blanqui. Marion Michelle introduced me. She had worked with Paul as a still photographer on his film *Native Land* and knew most of the friends who gathered at the Strands' on Sunday. Almost everyone was an exile from different brands of Cold War McCarthyism.

When exiles leave home, they usually take with them books, objects, or projects essential to their identity. Many of these are jettisoned or replaced on arrival. Others need to be integrated into the new context before the exile can feel at home. Paul had brought with him an old dream of making the portrait of a village, where the inhabitants recount their individual histories, a dream caressed since the publication in 1915 of Edgar Lee Master's epic poem on a village, *Spoon River Anthology*. Paul saw the realization of this project as the bridge between his work in America and the work he would do in exile. As soon as Hazel joined him in Paris, they set out together, weaving their way over the roads of France, from Finisterre to the Upper Rhine, from the Vosges to the Pyrenees, through Charente and the Dordogne, always in search of Paul's village.

It was our fault if we didn't find the village in France, Hazel recalled. *We could have chosen any one of the fifteen places friends recommended if we'd known better. The village we finally picked in Italy wasn't any more attractive than those in France, but once you sit down in a village and go round the back streets and the back gardens, there's always stuff to photograph.*

Presumably, they also went round the back streets in France, because eventually, Hazel says, Paul began seeing things to photograph *that were very much France—things I'd never seen anywhere else. So although we didn't find the village, I ended up doing a lot of work.*

Indeed, he looked almost aghast at the mounting pile of prints. How could they ever make a book from such heteroclite material?

Claude Roy has a good visual eye, Hazel suggested. *If you asked him to write the text he might have an idea.*

Claude Roy not only had one idea, he had so many he took the prints away with him to see how they could fit together. Set side by side, relationships began to form, images calling up old sayings, peasant proverbs about weather and the seasons, inscriptions on sundials and tombstones. There were children's songs and sailors' shanties, as if the photographs released a cascade of voices from the echo chamber of the centuries. Juxtaposing this material with the photographs and his own poems and text, Claude Roy created a visual collage.

La France de Profil was published in 1952 by La Guilde du Livre in Lausanne, at a time when books of photographs were still rare. In spite of Daguerre and Nadar, in France no law existed before 1957 protecting *photographic works of an artistic and documentary nature.* Photography remained the poor relation of the arts. Signed by Claude Roy and Paul Strand, *La France de Profil* is the only book where Paul's photographs are listed as *illustrations.*

In his opening text, Claude Roy introduces Paul seen through the eyes of a Frenchman: *A bit like Picasso (minus his passion) with a peasant's walk and a gentleness that sometimes seems sleepy and is only meditative, a slow doggedness which when we were working together often gave us the impression of being at loggerheads with each other, whereas we shared the realities of a complicity that opposed and made us complementary, irritated and enriched us.*

THESE DIFFERENCES OF TEMPO and temperament are evident in the book. The text has a Gaelic verve that leaves the photographs oddly silent. Writer and photographer might be addressing different hemispheres of the brain, so that reading the text we do not see the photographs, and looking at the photographs we exclude the text. There is no *disagreement* between text and photograph for those who have an intimate knowledge of French, but in Paul's case, a text with so many levels of cultural reference and so subtle a play of language was almost impossible to translate, or for him to understand. Before leaving America, he had been among the most fervent of a group of artists, poets, and philosophers in search of a new language to express a potential world of creation and invention. His own play of language, consisting of puns so barbarous even his friends groaned, was perhaps a way of inventing *words which could express something which is our own, as nothing which has grown in Europe can be our own.*

Now, here he was living in Europe, and *La France de Profil* posed in dramatic terms the relationship between text and image.

So far as photography was concerned, Paul found no difficulty in adapting to the new context. Even before leaving America he had been a nomad, traveling to areas with widely different climates and ways of life. Exile in this sense simply extended Paul's way of working. The fact that he would be debarred from language as a means of direct communication meant the photograph would have to bear the full weight of what he had to say, obliging his camera to probe dimensions of the image beyond the reach of language.

Already, in *La France de Profil*, the titles he gave his photographs are no more than laconic statements of fact: *Harness, Countryside, Old Peasant*; or they situate the photograph as *Near Livarot (Calvados)*. Whatever else there is to say is left to the writer. The famous portrait of the angry young man is related in Claude Roy's text to the time of the Revolution and the anger of France against injustice, a specific interpretation dependent on the presence of both photograph and text. But when we encounter the same portrait on the cover of the monograph covering sixty years of Paul's work, the photograph stands alone with no text to tell us anything about it, and we are seized by deeper meaning.

In the fifties, when Paul made this portrait, rural France was still suspicious of being photographed. *Being taken like that I give myself to the camera.* Black magic at work, according to the peasant. Urban sophisticates judged such beliefs to be *a hangover from the prelogic mentality of primitive times, when the image was regarded as a physical emanation of the personality.* It is not sure, however, if the young man glaring into the camera was not right to be wary of the photographer, Paul Strand, who took from him more than a physical representation. *Jeune Gars (Gondeville, Charente)* is a portrait of rage itself, coiled in the archaic substance of our being.

A CHILD COMES INTO THE WORLD biologically programmed with fleeting images, patterns of light and shade, desirable shapes and finds outside himself their material counterparts. These are the strange attractors that beckon him to live, to catch, and to verify the sensual feel of things against the image of his own desire. The image shifts and changes as he grows, yet the primitive attraction for certain shapes continues to inform the way an artist works, and to distinguish what is characteristic in how he sees the world.

No artist has ever adhered more serenely to certain themes than Paul Strand. *I photograph the things that make a place what it is; which means not exactly like any other place, yet related to other places.*

The *things* by which Paul measures such differences and relationships are not chosen haphazardly. In 1932, on his first visit to Mexico, he reports that he no longer needs to know a region before beginning to photograph, as if *things* had been decided in advance, the themes set, and all he had to do was photograph the same *things* wherever he went for them to reveal automatically their particularities by comparison with those elsewhere.

One of the most enduring of these themes, which he would continue to explore and develop until the last photograph he ever took, was stated when Paul made the photograph of Wall Street: *I became aware of those big dark windows of the Morgan Building on Wall Street, huge, rectangular, rather sinister windows—blind shapes actually, because it was hard to see in.*

From then on windows marked a point of contact between the inside and the outside, a transparency welcoming the eye to see *in*, as with his own house at Orgeval, or a blind shape only to be *looked at* from the outside. Windows became a symbol of his relationship with the countries he visited and the people he met. If they never found a village to photograph in France, it was because at 6:30 every evening all the windows were shuttered. *We had a feeling of being barred from close contact.*

Some of the friendliest windows Paul photographed are in his book *Tir a'Mhurain*, on the island of the Outer Hebrides, where the thatched roofs are weighted by stones against the wind, and windows are set deep into stone walls. In the first place it had been the songs of South Uist and Eriskay that called Paul and Hazel to the islands, eerie echoes of an ancient language and culture, which their friend the musicologist Alan Lomax had collected. But in 1954, when they spent three months on the islands,

they came to photograph the *things* that held these Gaelic people so tenaciously to the rocks and parsimonious soil of their homeland. Here, the lacy curtains and pots of flowers in the windows invited Paul to enter, to take his time, quietly interrogating objects on the dresser, pots on the stove, books beside a china dog. The merit of these objects lay not in their beauty, but in the homeliness of their report on what was particular to this place, on how people lived, and what were their chances of survival in the modern world.

For Basil Davidson, who wrote the text of *Tir a'Mhurain*, it appeared paradoxical that a photographer should choose this outpost of an ancient culture and then insist it was a *romantic and unreal view of historical development to say the people can only survive through its continued development*. But Paul had no nostalgia for vestiges of ancient culture as such. He knew technology would change the very structures on which that culture rested. What he sought were the potentials of a *modern* relationship between the place and the people, the old world and the new.

We can trace Paul's mediation as he moves about the islands. Poring over a tangle of knotted roots. Observing cut peat stacked half as high as a house. Ropes lashed shipshape. Or, he remembers, making the photograph of a drowned boot washed up by the tide, its similarity to one made in New England of a woman's slipper stranded among seaweed. He would watch clouds blustering up and photograph the bull against them, steadfast as granite, eloquent of the stand made by the Gaelic people to keep their culture and their way of life.

The iris is another emblem we find on the islands, and again and again in his work. But instead of the New England iris in voluptuous acquiescence to the wind, on *Tir a'Mhurain* the wild iris resists, lacing its fronds in a buttress against the elements.

To appreciate how Paul worked and the scope of his vision, it would be necessary to set side by side the emblems he photographed wherever he went, comparing them for their likeness and for that nuance of difference conferred by the particularities of a region. The windows in *Tir a'Mhurain* tell us a great deal about a climate and way of living. The same is true of the window with the child's doll, the floor cloth, and scrub brush in the Italian village of Luzzara. There, camera and photographer no longer huddle in the lee of the wind, they share a luminous transparency traversed by the image. Certain shop windows and café windows could be found nowhere else except in France. In Egypt windows are shuttered against the heat with palm baskets leaning against the wall; in Italy shutters are framed by vines or wisteria. The black and white window in Ghana, with its closed shutters, withholds the mystery of a mask, no longer a sign of exclusion for the photographer but an engagement of regards between his own and the hidden force inside, looking out. Sometimes I think Paul didn't photograph an external image at all. He simply appropriated fragments of reality that coincided with a yet unrealized image within himself, an image never fixed, forever in flux, but guiding his choice of what to photograph by an imperative desire.

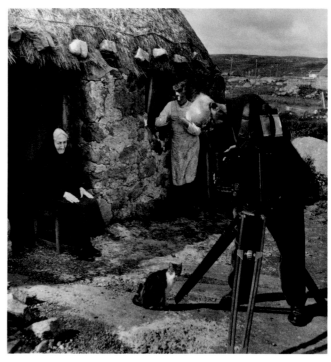

Paul Strand at work in the Hebrides, 1954. Photograph by Hazel Strand

ONE OF PAUL'S OLDEST FRIENDS, the photographer Walter Rosenblum, and his wife, Naomi Rosenblum, author of the invaluable *World History of Photography*, stayed on several occasions with the Strands in Orgeval, where Naomi worked on Paul's

letters and papers. She and Walter weren't always in agreement about Paul.

An extremely difficult character to grasp, Naomi felt.

A very special person, countered Walter. *The greatest photographer I ever met.*

They both described him as serious, retiring into himself if the conversation turned to tittle-tattle. Walter added that when Paul wrote in his beautiful round hand, it was always *as if history were looking over his shoulder.*

Talking to him however, Naomi detected a twinkle in the seriousness. *You were never bored or felt you wanted to strangle him as you do with some heavies.*

WEEKDAYS IN ORGEVAL followed the same pattern, with work in the mornings for Paul and his forays down to the village or to St. Germain-en-Laye in the afternoons. Paul did all the shopping, as Hazel

Hazel Kingsbury at Sag Harbor, New York, 1949. Photograph by Paul Strand

had never learned to drive. *He tried to teach her,* Naomi recounted, *but I have a feeling he was a terrible teacher.*

On this point, Walter leapt to Paul's defense. *Whenever he was around you learned something. After the war I had a little money saved and wanted to buy one of his prints. He chose a couple, and I wondered why those two pictures when there were so many others I would have liked better. He was teaching me, because at the time I didn't understand what he was doing in those pictures. I never learned so much as from looking at those two photographs.*

Paul always treated young photographers with respect, setting their prints up in a good light to be studied, as he did his own. He never criticized unless he could be helpful. *The fence doesn't work here,*

he told Walter the first time they met. *The shape doesn't go with the other shapes.* Walter stared at his print. He had never noticed before that there *was* a fence.

Marion Michelle also remembers showing him a photograph of children in Mexico. *It's out of focus but full of life.* Marion photographed Paul and Hazel's wedding, and he liked showing her his prints because she had a professional eye. Most of their regular visitors were writers, filmmakers, musicians, doctors, architects, or artists. Marion's husband, the French painter Jean Guyard, described Paul as his idea of an American sheriff, a man to be respected, even if he didn't understand Jean's painting! Paul's interest in modern painting had been sparked off by the Armory Show in New York and artists exhibited in the Stieglitz Gallery. His two-room apartment in New York had been full of paintings by O'Keeffe and Marin, but I don't remember any painting on the walls in Orgeval. Or perhaps they were overshadowed by his photographs and I didn't notice them. Once I suggested his overall flower photographs were doing what Jackson Pollock did in his paintings. Paul denied flatly any resemblance between himself and "Jack the Dripper."

His recognition of Piero della Francesca's kindred world had been immediate. The same emblems. The same portraits turned inward on an intense and subjective vision. And in Piero's landscapes stretching to infinity, Paul focused on that point where, in parallel, their worlds met.

Less predictable, perhaps, was Paul's admiration for Picasso. Claude Roy had described Paul as looking like Picasso, which, in Paul's case, might not have facilitated their meeting. Nor the portrait he had come to make of Picasso for an album on French celebrities—another idea suggested by Claude Roy— a series begun and then abandoned, not only, I suspect, because the editor wanted to impose his choice. Paul had no real interest in photographing celebrities,

and in several portraits of distinguished writers his Medusa glare tended to unhinge the public mask. Picasso met Paul's challenge with an equal gaze. Each time I see this portrait of Picasso I imagine Paul, the two in one and face to face.

THERE IS MUCH UNSEEN MUSIC in Paul's photography. When he gave me Vivaldi's *Four Seasons,* I heard the leitmotif of *The Garden Book.* The old, frail voices of my Gaelic ancestors are like the sound of the sea on the lonely coastline of *Tir a'Mhurain.* There are the drums in *Ghana,* reedy flutes in the desert, hurdy-gurdy tunes of an Italian fête. Paul took me to *Boris Goudonov* at the Opera to hear Boris Christoph. This, too, belonged to Paul's music, a dark and tragic violence still smoldering under other ashes.

But even in music, Paul had his lighter moments, surprising me one Sunday with a record by Elvis Presley! Sunday, of course, was his day off.

On Sundays, the papers, books, and correspondence encumbering the long country table in the living room gave place to Hazel's traditional American lunch. Roasts, vegetables from the garden, and, of course, an American pie! Hazel was a stressed cook, and Marion one of the few people allowed in the kitchen while she was getting lunch. Their New England and Chicago accents could be heard swapping recipes or talking gardens. Outside the kitchen door Marion broke off flowering thyme, sweet basil, and tarragon from the herb garden to take home. Hazel usually added a pot of jam or dill pickles at the last moment. *With Hazel,* Marion said, *everything was real and homespun. Her way of showing affection was to make food or useful objects for others.*

In summer, Ruth Lazarus from UNESCO arrived early so she and Paul could go swimming in the pool at Pontoise. Paul had been a Polar Bear in his youth, and he still loved to swim. Afterwards they sat in the sun and talked politics. *He was very concerned about pol-*itics, Walter confirmed. According to Naomi, *absorbed by politics* would be a more precise description.

But whatever he was, or whatever he did, Paul liked to be the center of attention. If anyone monopolized the conversation or beat him at *boules,* he had a way of disappearing. Hazel would find him sulking in the bedroom, waiting for her to plump up his rumpled ego.

Rather childish, like his jokes, Naomi considered.

He was a great man, Walter objected. *He deserved to be the center of attention!*

And so he was on Sundays, presiding at the head of the table, sure of getting a second helping of Hazel's pumpkin pie without her watchful eye on his girth. The French, who eat their pumpkin as *soupe au potiron,* preferred the season of her aerial strawberry shortcake puffed with cream.

When there wasn't a strawberry left and we'd drunk two cups of coffee, we all crowded into the little sitting room seldom used except to show the prints. This gave it a rather formal atmosphere, with upright chairs and black boxes to store the finished prints. Hazel took them out of their tissue-paper wrappings, one at a time, and Paul presented them without hurry, letting us study each print. He rarely talked about his work because *talking about it shattered the illusion.*

I often pondered over this word *illusion.* It seemed strangely paradoxical for the realism of photography. Yet the power of the image is ancient and mysterious, a rite of passage between two worlds, performed since the beginning of time in caves and grottos, in temples and churches, and here, once again, in the little sitting room at Orgeval.

IN 1949 PAUL MET THE FILMMAKER Cesare Zavattini at the Congress of filmmakers in Perugia. The two men liked each other and found they shared the same approach to film and photography. Once again, Paul spoke of his elusive village—could it be

found in Italy? If so, and they made a book, would Zavattini write the text?

Zavattini thought of all the suitable villages he knew, and the Strands set out on another journey of prospection. But although life continued long after sunset in Italian villages, Paul still hesitated. Finally, Zavattini proposed that no village had the same music on his tongue as Luzzara, the village on the Po where he was born. *All right,* Paul said, *we'll go and see.*

Cesare Zavattini, October 6, 1952

When they came back with the photographs, Zavattini refused to be parted from them. He had a dozen stories to tell of his childhood, his grandfather going off with the dog to hunt for truffles, a professor who read him one of Petrarch's letters describing a visit to Luzzara, and the town's rich spirituality. Zavattini remembered the noise of the festival, running like a horse through the narrow streets, and returning home late with his friends by the light of their bicycles.

In his text, Zavattini lets the people Paul photographed tell their own stories, lives and memories strung along fourteen kilometers of the river Po, always the same river, never the same water flowing under the two bridges.

Paul's emblems are all in place. Windows open, windows shuttered, windows barred. Ropes of ancient, interlocking vines. Even more explicit than the people, objects report on how life is lived in the village. Hats come from the hat factory, milk from the Latteria Cristo. Umbrellas because it rains. A fertile soil with oxen plowing, scythes for mowing, forks for haying. Boats on the Po, where German soldiers drowned in borrowed clothes, trying to escape after the Occupation.

In *Un Paese*, Paul's photographs are not even titled, so we vision them with the unimpeded flow of a film, to the rhythm of a film text. We know life in Luzzara has already changed. Yet for us, the old lady who served the great during forty years is still there long after her death to tell her story: On the whole she had been well treated by her patrons, and felt more at home with them than with her own kind.

Was it the village Paul dreamed of making? Perhaps. Or perhaps he discovered in Luzzara that his village could be contained in a single photograph. With the consummate economy of a Samuel Beckett, he made a set piece, grouping a woman and her five sons in the doorway of their house. It is one of his great emblematic photographs.

THE CONCEPT OF *LIVING EGYPT* arose from a visit to Orgeval by the writer James Aldridge and his Egyptian wife, just returned from a year in Egypt. Their enthusiasm for changes taking place since the 1952 revolution was so communicative that Paul and Hazel were soon studying maps and reading books, sure signs of a forthcoming journey.

Egypt? queried Hélène. *Will you photograph the pyramids?*

Hazel laughed. *I doubt it. We'll leave them to the tourists. Where Paul likes to go there aren't many tourists.*

On their journeys together, Paul and Hazel had their separate roles. Hazel did the background research. A fast reader, she could sift and communicate information most likely to interest Paul. He studied the maps, planning the itineraries they would follow. In practice, these were flexible. After a couple of hours on a highway, Hazel would propose turning off. *Let's see what's over there. It looks interesting.* The only problem was that others also found it interesting. As soon as Paul set up the camera people materialized out of an apparently empty landscape, demanding to be photographed. When the curious pressed too close to the camera, Hazel enticed them away with her own little camera, taking hundreds and hundreds of photographs, with the names and ad-

dresses of where to send them, as send them she always did after her return to Orgeval.

Meanwhile, Paul made his portraits undisturbed. There are many portraits in *Living Egypt*, people they met along the way as well as portraits painted on buildings and private houses. Ancient Egyptians invented the comic strip at about the same time they invented a written language, and today their descendants still decorate their walls with the pictured account of journeys to Mecca, marriage festivities, or family portraits. So Paul borrowed from the same tradition, setting his portraits against walls chalked by weathering and the hieroglyphics of time, the same people thousands of years later as pictured in popular frescoes. Only the chalk marks changed. Behind the portrait of Rushdie Abdul Salan in the Halen steel mills, the chalk drawings on the wall are plans of technique and construction.

Paul has sometimes been accused of presenting only the positive side of Egypt, where so many people are victims of disease and impoverishment. For him, the victims bore witness to the power of negative forces hidden behind black windows. The tension existing between the actual state of things and Paul's belief that human beings had the potential to change them is the motive behind all his work. *I like to photograph people with strength and dignity in their faces. Whatever life has done to them, it has never destroyed them.*

DRIVING ALONG THE ROAD, Hazel sometimes pointed out things of interest. Usually Paul grunted and drove on. Where the car skidded to a stop in some arid landscape and Paul piled out, setting up his camera with feverish proficiency, always surprised her. What had he seen that had to be photographed with such urgency?

To capture reality, a distance had first to be established between himself and the object by structuring the image with the lens. Paul, even as he worked, an-

ticipated every fluctuation of light that might fill the object with his ardor. He knew there was only one instant of isomorphic coupling between the real and the image, an instant so vertiginous that when the shutter clicked and light entered laying traces on film, he would be absent. His participation in the event could be restored only when the print emerged and the black vertigo of absence was transformed into light. For this moment he would have to wait until they returned to Orgeval and work began in the darkroom.

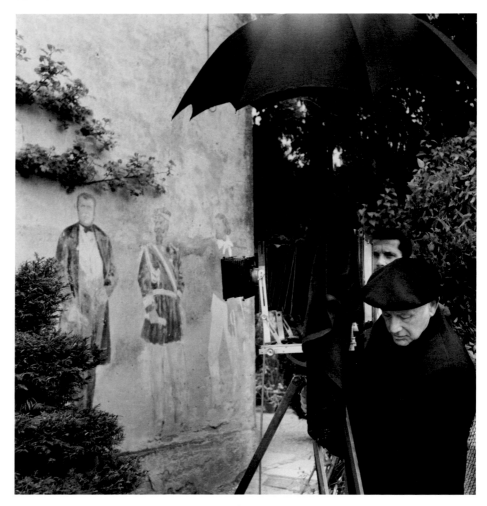

Paul carried the print, still damp, from the final wash.

What do you think, Hazie?

For the first time Hazel saw what he had been so impatient to photograph.

The ruins of a village, stained by black shadows of courtyards among the rocks.

Paul Strand at work in Italy, 1953. Photograph by Hazel Strand

What was the name of that place?

Hazel, who kept account of every photograph, checked her notes on the map.

El Shadida el Manaab. In Upper Egypt.

Paul touched the print to test the reality of El Shadida el Manaab now that time had stopped for all time in the village. Had the photograph captured that instant when the object became the image, the reality became the illusion? Had the print an integrity of being which restored the village to his touch? He let the mobility of his eye travel to include the imaginary world beyond the frame, making sure none of the essentials had been lost when he pressed the shutter. Then, with the gesture of recognition Hazel knew so well, he caressed the print, feeling under his fingers the dust of those disintegrating walls.

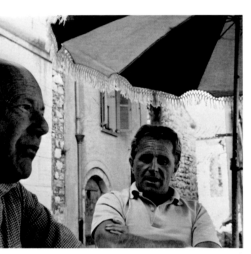

Paul Strand and James Aldridge, 1965

LIVING EGYPT IS DEDICATED to Hazel, and at times, Paul's sensual delight in tactile recovery could be almost indiscreet. His friends thought him to be something of a prude, and certainly reticent about his personal relationships. But he showed no reticence when handling a certain photograph of Hazel made at Sag Harbor on their first weekend away together. Hazel said it had been very hot and she'd got terribly sunburned lying on the beach. The photograph shows us only her smile and her youth, and each time Paul caressed the print, the grains of sand and the sunburned skin responded to his touch.

One morning I had gone out early to work on a text with Paul and found both Paul and Hazel sunning themselves over coffee in the living room. The atmosphere seemed unusually relaxed and communicative.

You're up early, Hazel.

We were making love, Paul said, *and I had a black-out.* It was so unexpected I could see they enjoyed my confusion.

What do you mean—you had a blackout?

For a moment I wasn't there.

I turned to Hazel for help. *Has this happened before?*

She gave her brief, gurgling laugh. *First, last, and always a photographer.*

The Hazel of Orgeval wasn't always so responsive as her beach photograph. She suffered from chronic insomnia and was often depressive and abrupt, going to earth in the garden, grubbing away on her knees behind the laurel, smoking savagely in secret. In such moods, Paul's plaintive call of *Hazie?* usually got a tart reply. Even when guests were there she could be embarrassingly sharp with Paul, irritated by his slowness or his obvious need of her. *What can I do?* he begged Hélène to tell him. *Let her alone,* Hélène said. *She'll get better.*

She was never like that with me, Hélène recounted. *We did everything together. She taught me how to weave and to make quilts. I learned how to retouch prints. I loved doing that, the photographs were so alive. Sometimes I'd arrive in the mornings to do the housework and she'd come downstairs and say, "Not today, let's work in the garden." And how we worked! It was crazy. We'd go to the woods and trundle home barrow-loads of humus and little plants to fill up the shady corners. Paul didn't like changes in the garden. We finally persuaded him to let us take out the pear trees, but he never allowed us to touch the willow. He said he'd come to France to discover the difference between an American and a French tree, and the willow could never be lopped however much Hazel insisted.*

DURING THE SIXTIES, those questioning years for the whole of Europe, Paul and Hazel were almost always traveling. In 1960 they went to Romania, where Paul had heard of a center reputed for its rejuvenating cures. He also planned a book, and returned

in 1967 to continue photographing. But the book was never completed. Nor was the book on Morocco, where Paul began to photograph in 1962. *How can I make a book when there are only kings, bitterness, and serfs?* For Paul also, it was a time of questioning, and only in the young republic of Ghana, to which he traveled at the invitation of President Nkrumah in 1963-64, did he find a positive answer. The book that resulted would not be published, however, until 1976.

There had been an exhibition of rotogravure prints taken from his books at the Kreis Museum in Germany. He received the Swedish Archives Award for his films, a recognition of past work rather than his place in the present.

On Paul's return from Sweden, Hélène noticed a change. She was always there to meet them when they came home, the house full of flowers, the garden impeccable, and the gate wide open. She knew the first thing Paul would do was make a tour of the garden. It had almost become a game between them, for her to preserve an equilibrium between the inevitable change and his desire to find the garden as he remembered it. Afterwards, she would make tea. They would all sit round the fireplace while they told her about the trip, and she told them what had been going on in Orgeval during their absence. This time it didn't happen that way.

I know it was summer because I was picking raspberries. Paul seemed so—bizarre. He didn't look at the garden, just went straight inside and up to his room. The house changed after that.

Friends also noticed the change. There were health problems, the cataracts that made him increasingly dependent on Hazel to assist him in the darkroom, and omens of bone cancer in his shoulder, which prevented him from traveling. Paul became withdrawn, his energy concentrated on the world on his doorstep, shrunk to the dimension of the garden.

From the time they came to live in Orgeval, Paul had photographed his emblems. A lupine here. There, a cascade of flowers falling over the rock garden. Or the magical path under Hazel's window leading to some imagined Cytherea. He began to talk to me about a garden book, using a selection of photographs made over the years and completing them with new work.

As summer passed and the leaves began to fall, he kept urgent watch from his upstairs studio. Nothing must be touched. The leaves must lie where they fell, the yellowing stalks allowed to rot in the ground. Hélène and Hazel could hardly venture into the vegetable patch without Paul arriving to see what they were doing.

For the first time since he made *The Garden of Dreams*, on his first visit to Versailles in 1911, he began giving titles to photographs, as if the simple naming of their reality ceased to be appropriate. For him, they had become *signs*.

Winter came. In the woods he photographed *Things Past on the Way to Oblivion*, searching in the disintegration of forms and devouring creepers some intuition of a new order. The threat he saw advancing through the undergrowth clutched at his heart with the tentacles of *The Great White Wood Spider*.

ESCAPING FROM THESE SATANIC twilights, he turned for reassurance to the emblems so often photographed and cherished, the willow and the iris. But the garden had lit its *Last Candles to a Dying Sun*.

How long did Paul doubt and question before the spent lilies offered him their *Revelations*? Before he learned to interpret *The Oracle* of the ivy? Not until, perhaps, the brittle stalks had dressed for him their *Arc de Triomphe*.

Paul had been working alone so long, Hazel said, *he'd been forgotten. Nobody knew what to make of him. Young people were either crazy about his work or found it too finicky and precious for words. Finding a publisher wasn't easy. "Is he still alive?"*

THE POLITICAL CLIMATE in America had changed after President Kennedy's election, and in 1966 Paul and Hazel returned to New York, Paul with a letter in his pocket from an unknown young man, Michael Hoffman, recommended by Nancy Newhall, who had worked with Paul on *Time in New England*. He wanted, this young man wrote, to relaunch the moribund photographic review, *Aperture*, and create a book-publishing program, which had never existed. Nancy had a genius for getting people together at the right moment, and she must have thought Michael and the "forgotten" photographer could be mutually helpful.

On Paul and Hazel's arrival in New York they went to lunch in Michael's Brooklyn apartment, where he lived with Misty Carter before their marriage. It could have been a difficult encounter without Misty's charm and intelligence to put everyone at ease. The Strands liked her at once, and some of Paul's reserve dissipated.

The apartment overlooked the ocean, and during lunch clouds rolled in, piling up as they once had done behind the bell towers of New England and the church of Taos. Paul felt his life had come full circle. There were the skies he loved, sharing that moment of supreme suspense before the storm broke and the clouds scattered into new formations.

They were discussing the possibility of reediting *The Mexican Portfolio*. Michael knew of a press where a man of eighty-four could make by hand the twenty thousand gravure prints required, a redoubtable task that of course Paul would supervise. Michael had also discovered another man who made lacquer for religious objects, and tests proved it to be the purest lacquer available. The hand-molded paper for the portfolio could be imported from France.

Paul liked the sound of the old printer and his way of working. But he was still wary. Only Hazel knew of the prints and negatives locked away in the vault in Versailles or hidden in a box under Paul's bed. A life's work waited to be discovered, and Paul was determined it should not become the feast of crows.

Over the next five years, beginning with the reedition of the *Mexican Portfolio*, Paul and Michael undertook several projects together, but the real turning point in their association came in 1971. During the intervening period Michael had helped to found and direct the Alfred Stieglitz Center at the Philadelphia Museum of Art, and he looked forward to reacquainting the American public with Paul's work within the same context. As one of the world's great museums, famous for the Annenberg collections and exhibitions presented under the inspired direction of Evan H. Turner, the Philadelphia Museum's recognition of Paul's place in American photography would establish his reputation at an international level. This prospect became reality when the Philadelphia Museum scheduled a major retrospective of Paul Strand's work for 1971.

Michael flew to Orgeval, where he and Paul could select prints from sixty years of photography for the exhibition. After two days of working on a single sequence, Paul taking his time as always, never allowing prints to be eliminated, Michael became frantic. The third morning, when Paul came downstairs, he found Michael, up since five, laying out prints on the floor with a reckless disregard for Paul's meditative eighth-of-an-inch moves to which these precious prints were accustomed. Michael looked at Paul, and Paul looked at the prints. Shorn of their tissue-paper wrappings and precipitated into new unexpected relationships, they revealed unsuspected dimensions. Paul realized that with other eyes, in other contexts, people would see his prints as he had never seen them. This way of working opened abruptly on such a vast perspective, he needed time to adjust his focus. Almost grudgingly, he said: *Go ahead. Keep on with what you're doing.*

GIVEN PAUL'S CARTE BLANCHE, Michael prepared the great retrospective exhibition that opened at the Philadelphia Museum in 1971, a major artistic event all over America, which later traveled to great museums in Europe. When the photographs were on the walls, Paul and Hazel traveled to be present at the opening.

Slowly they walked together through the gallery, where Brancusi sculptures and other works of art evoked the original exhibitions that they and Paul's prints had shared in the early Stieglitz "laboratory centers." Without speaking, Paul and Hazel looked at every detail, at every one of the four hundred and forty prints. At the end, Michael waited for the verdict.

Paul said, *There is only one picture that isn't properly hung. It's upside down.*

Issued as a catalog for the exhibition, the two-volume monograph on Paul Strand—then the most expensive publication ever devoted to a photographer—immediately attracted book collectors and sold out. Encouraged by the growing interest in Strand, Aperture listed a forthcoming edition of *Ghana: An African Portrait*, which, ten years before, Paul had laid out with a text by Basil Davidson. Michael insisted on reviewing the original version and making changes. Paul, having suffered what he described as the Dresden editor's *attempted violation of the unity and integrity of Tir a'Mhurain,* the first book made with Davidson, bluntly resisted editorial demands. Michael, equally intransigent, matched Paul's stubbornness in knowing how things should be done. Hazel remembered a former dispute in Orgeval when both men stormed up separate staircases, each followed by the other's wife to coax the unyielding partners down again. This time, an underlying issue had to be reconciled. Both Paul and Michael recognized the Ghana book as a test of their relationship.

Paul needed someone he could trust if he were to continue working, and perhaps he chose this occasion to be the proving ground for his decision. He capitulated, but with the worst possible grace. *All right, have it your own way. I want nothing more to do with the book.*

Another project met with unexpected opposition from Hazel. For a long time Michael had worked with a young American printer and photographer, Richard Benson. Knowing his outstanding qualities, Michael proposed the publication of two portfolios of Strand prints, in an edition of fifty. Hand-printing fifty faithful reproductions of each photograph was an unimaginable task for Paul, who had never printed a negative more than twice on the dwindling stock of sixteen-year-old Illustrated Special, the paper he loved best. Michael suggested that Richard Benson come to Orgeval and work in the darkroom under Paul's supervision. To this suggestion Hazel opposed an outraged veto: *Over my dead body.*

After further discussion Paul agreed, since he and Hazel were in New York, to meet Richard. He chose a negative for Richard to print, giving him his own print as guidance, but no instructions. When Richard returned he told Paul it had required every skill he had to make the print, but that he had been unable to tone it. Paul nodded, examining the results.

I never said I was a straight photographer, Paul remarked, examining the results. Then he added: *Once toned it wouldn't be a bad print. Do you think you could make fifty of the same quality under my direction?*

IN 1975, PAUL AND HAZEL returned from the United States to France and we began work on a

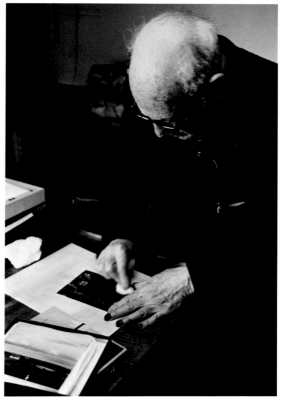

Paul Strand varnishing prints.
Photograph by Paolo Gasparini

book of photographs of the Strands' garden at Orgeval, to this day unpublished.

We set up the prints round his bed upstairs, replanting the garden in his bedroom. Columbine days and the sunshine of marigolds. Happy families of buttercups and bachelor's buttons, the garden as

Paul Strand inspecting prints from Portfolio One. Photograph by Richard Benson

he had photographed it when they first came to Orgeval. In retrospect, Paul preferred the later, more austere prints, when winter laid bare the structure of the willow and the dark whorls of its bole. For hours Hazel and I shifted prints as he tried out different relationships to reveal their attractions and antipathies. Not until they combined to make a third dimension did Paul give the imprimatur of his approval:

Very handsome.

There were other hours when he couldn't work and the pain came back. On one of his visits, Michael Hoffman saw that Hazel was exhausted and suggested sending someone over to help her.

THE HOUSE FILLED with young people. Downstairs, Susan Barron and Ann Kennedy sorted prints while Naomi Rosenblum worked on the papers and correspondence for the archives. Richard Benson arrived to work on the two portfolios, "On My Doorstep" and "The Garden." In this atmosphere of activity Paul's optimism revived. Like Methuselah he wanted to live nine hundred years, even if he set his claim on eternity more modestly at a hundred

and fifty. Each day he announced a still-to-be-accomplished project. He showed me magazine photographs magnifying monsters in a drop of water and spoke about the astronomic discoveries of galactic space. The house resounded with a recording of Beethoven's Ninth Symphony.

As boxes of negatives came out of storage and were excavated from under the bed, images of a lifetime confronted Paul. He astounded Michael by dismissing the *experimental period* of 10-by-13-inch platinum and palladium contact prints with its magnificent *Bowls* and *Porch Shadows* as "not worth keeping." Other negatives, stored since the twenties, he had never printed nor shown to anyone. They belonged to that tempestuous period with Stieglitz when the two men photographed their wives, Georgia O'Keeffe and Paul's first wife, Rebecca. To immobilize Rebecca while he photographed, Paul had used a steadying device known as the Iron Virgin, and now he suggested Richard should use an old Hollywood trick with cheesecloth to soften the print. Even then Rebecca's torso in its strange and shocking nudity gave us the ghostly shiver of voyeurs.

Although I was often in Orgeval during those last months, working with Paul on text for the portfolios and preparations for the presentation of his retrospective exhibition that Michael Hoffman had organized with the National Portrait Gallery in London, I was not there the day Michael arrived with *Ghana: An African Portrait* in its published form. Michael described what happened in a letter written to me after Paul's death.

I remember bringing the Ghana book to Paul from New York. After what seemed to me an interminable wait and his careful looking from image to image, checking and rechecking every nuance, I left the room not being able to bear the tension. As I returned and sat down, he took his hand and passed it over the front of the book and then through the pages. He said, "Very handsome." His eyes filled with tears and he said, "It couldn't be better." His

statement seemed an affirmation that his work could go on even without his direct involvement—an affirmation of the strength of his work, his nurturing of others, and that the work might take on new meaning without his physical presence.

During those poignant hours when Paul and I worked together, Paul dictating texts out of a fog of drugs and pain, word followed word with infinite slowness, but never losing the coherence of his thought. Waiting for the next word to come in this struggle for clarity and expression, I felt I had never been admitted more closely to knowing Paul Strand, for each word, when it came, seemed to rise from the darkness of our origins, on the long haul upwards toward a humanity Paul had always believed possible.

HAZEL TOLD ME that one night, alone in their bedroom, she and Paul drew up the balance of their life together. Neither of them looked back nostalgically on a grand passion. Right from the start, Hazel said, *we were too old to jump into things.* They weren't romantics. *Come over,* Paul proposed when he left for France, *and we'll see how it works.* They had made it work because they could work together.

Of Paul, she said: *He was a kind and thoughtful man.*

Of her own life: *Doing what you like to do is what matters. I can't understand just pleasuring yourself.*

Paul made his own summing up when we were trying out relationships between photographs for his garden book. Looking round for the photograph made at Sag Harbor, he said:

Give me Hazel. She goes with everything.

AS THE TWO PORTFOLIOS progressed toward completion, so Paul's strength diminished. At first he had been able to work with Richard in the darkroom, later Richard went backwards and forwards between the darkroom and Paul's bed, where he mas-

tered the prints. The friendship between the two men took its source both at a professional level and at a profound level of trust. At night they talked, sharing the sleepless hours when Richard washed and lifted Paul, changed his position to ease the pain. In so intimate a proximity, Paul felt that Richard touched the inner image of himself, that fluctuating image he had matched with fragments of reality from the outside world to become his photographs. The final print of Paul Strand he himself would never see, never be able to touch as he had touched the print of *El Shadida el Manaab,* feeling under his fingers the reality of his own creation. How could he verify what he had done? That must be left now for others to decide, for others to interpret. In those moments of doubt and discouragement, Paul's only consolation lay in Richard's touch. The same tact and tenderness conferred on his inner image Richard would bring to the understanding of his prints.

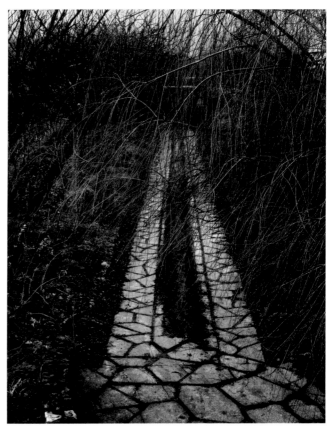

The driveway at Orgeval, 1973. Photograph by Paul Strand

Three nights before he died, Richard kept watch in the shadowy bedroom where Paul lay. Once the fourth portfolio had been approved, Paul refused to eat or drink. For over a week he had been in a semi-coma. The house slept and no sound came from the garden. Suddenly, Paul sat upright in bed, his eyes wide open, and cried out his final words: *All my books!*

Catherine Duncan
Paris, 7 July 1993

FRANCE

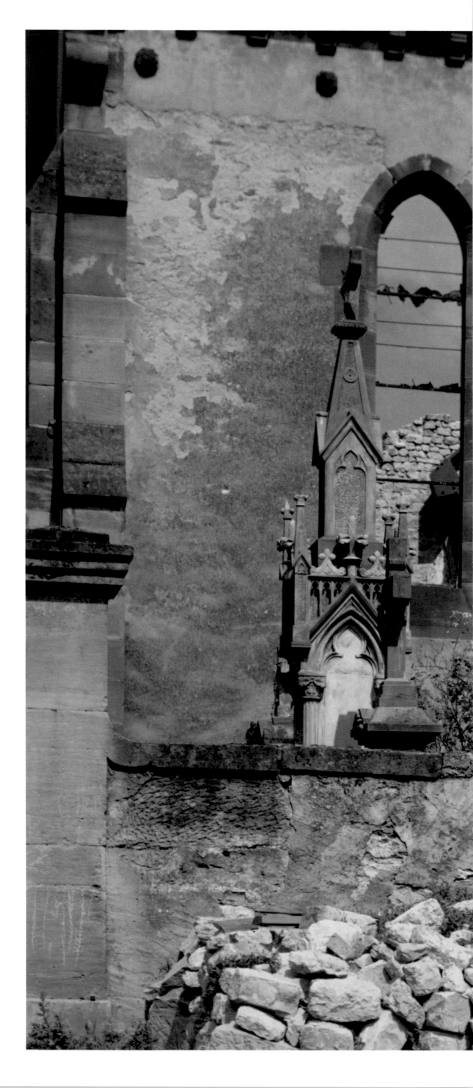

Strand went his way on a road full of musings, capriciousness, meditation and reveries, a road whose unharried curves and bends he enjoyed like a child playing hooky with no purpose other than that of observing and absorbing as much of humanity's simplest, most naked truth as possible. He avoided with royal nonchalance almost everything the "foreign" photographer feels obliged to investigate from top to bottom. Paul Strand never photographed Notre Dame or Mount St. Michel, Versailles or Chartres. Nor did he feel compelled to take a shot of the inevitable bottle of Pernod, the ladies in black coif, the men in mustache and beret nor anything in France that might appear singular or sublime to a person from the other side of the world. One of Strand's characteristics was that he never chose a subject at first sight, no matter where it was. He was a stranger who was drawn to that which might habitually appear "strange" to foreigners and Frenchmen alike.

If he had something to teach us about our country, its inhabitants, its way of life (which at times is slow-paced, parsimonious and dull as to be no way to live at all) it was not due to the innovative candor of his way of seeing it. The fact is that Paul Strand did not enter life in France like someone who came from the outside. The harvest reaped by this ambulant photographer is disconcerting only insofar as it takes us to the center of that which we no longer see and forces us to stop and take a look. Strand did not try to rediscover or renew France's image through the artful tricks and inventions of his craft. He simply tried to penetrate it by descending into the country's taciturn depths with the unhurried docility of a pebble making its inevitable way to the bottom of a well.

From "Paul Strand," by Claude Roy,
translated by Helen Gary Bishop.

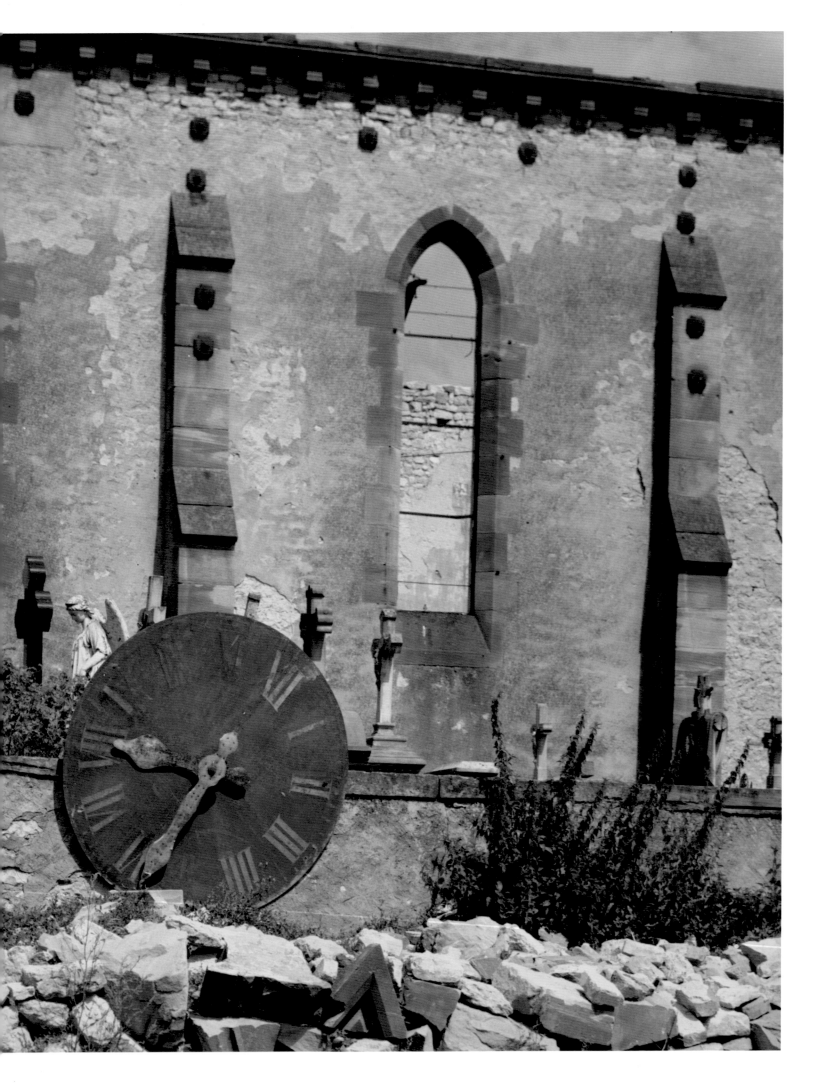

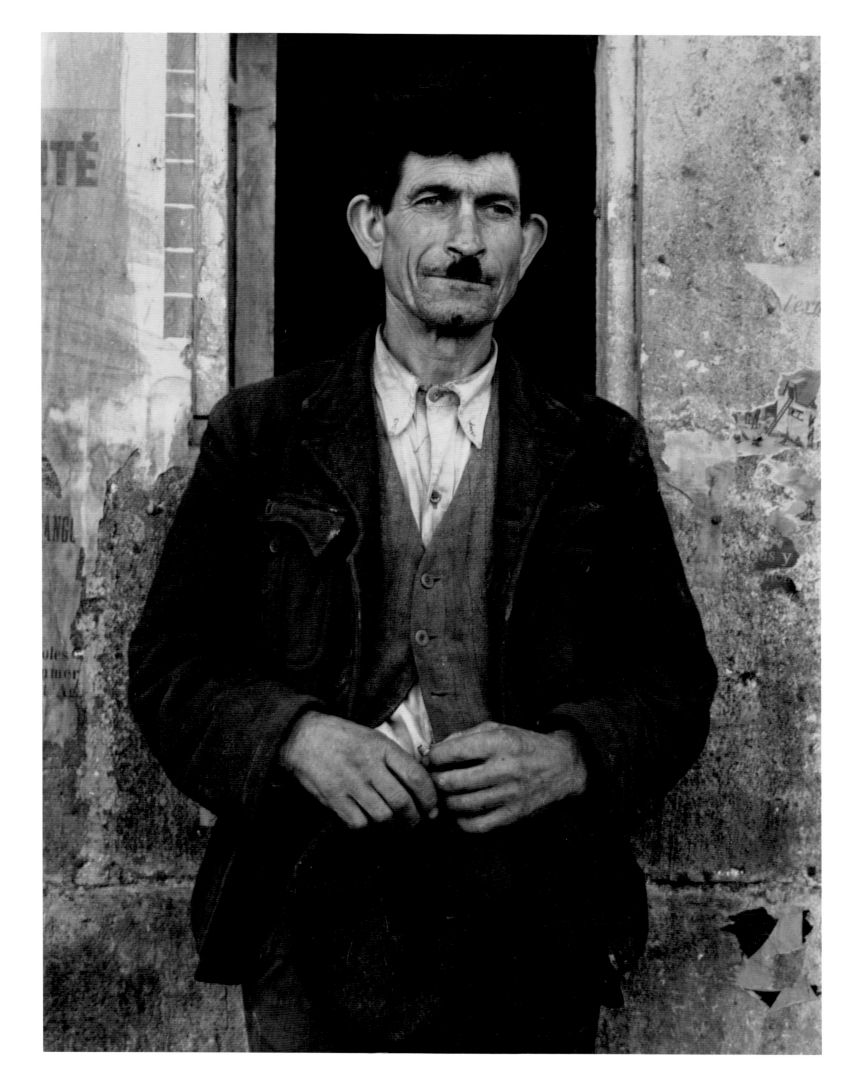

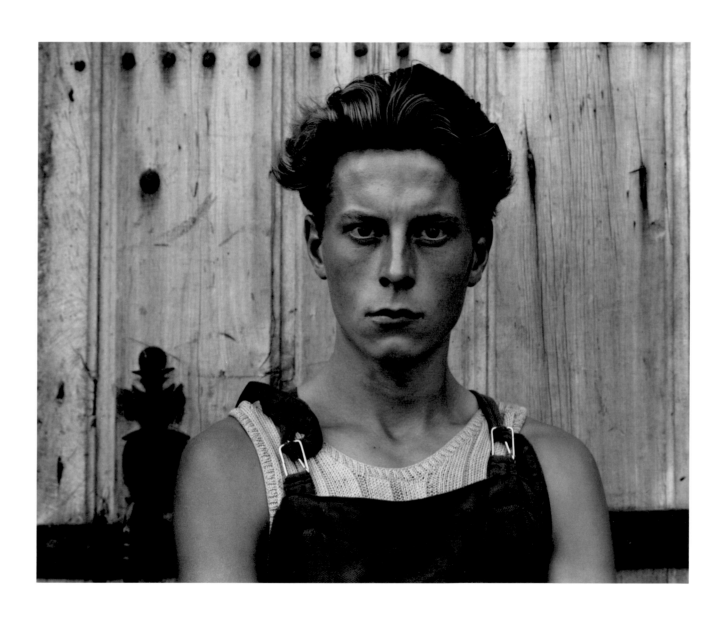

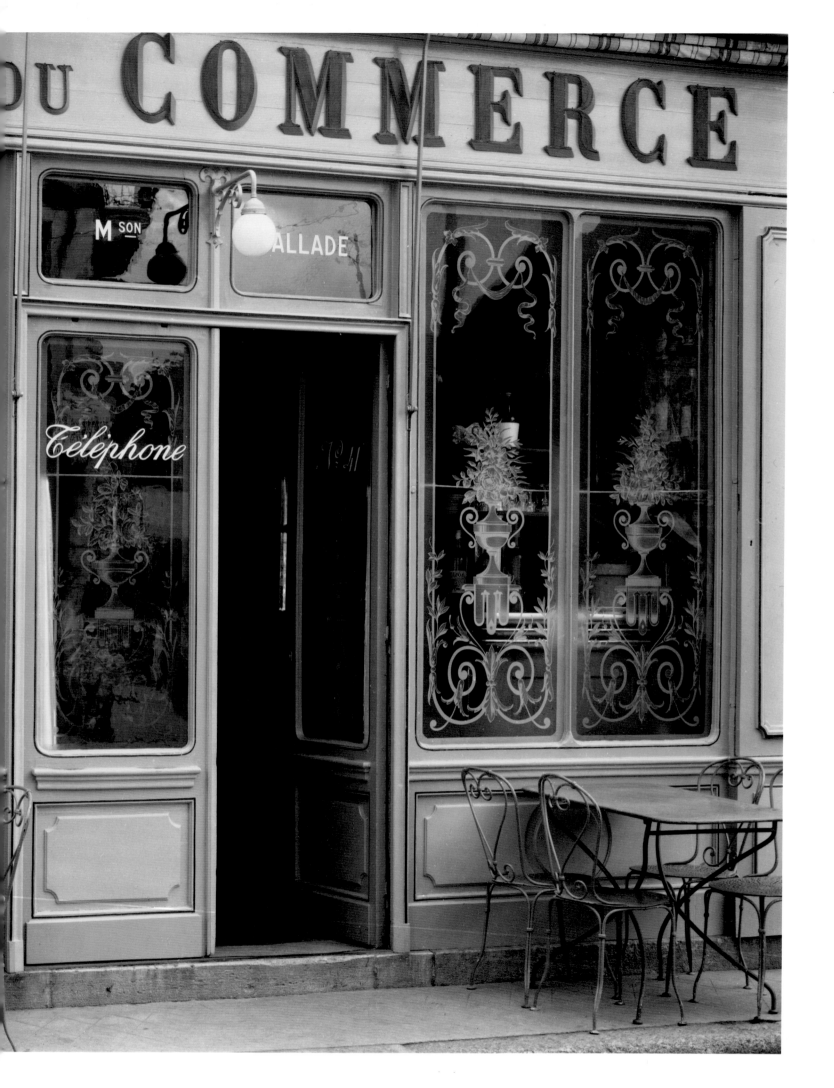

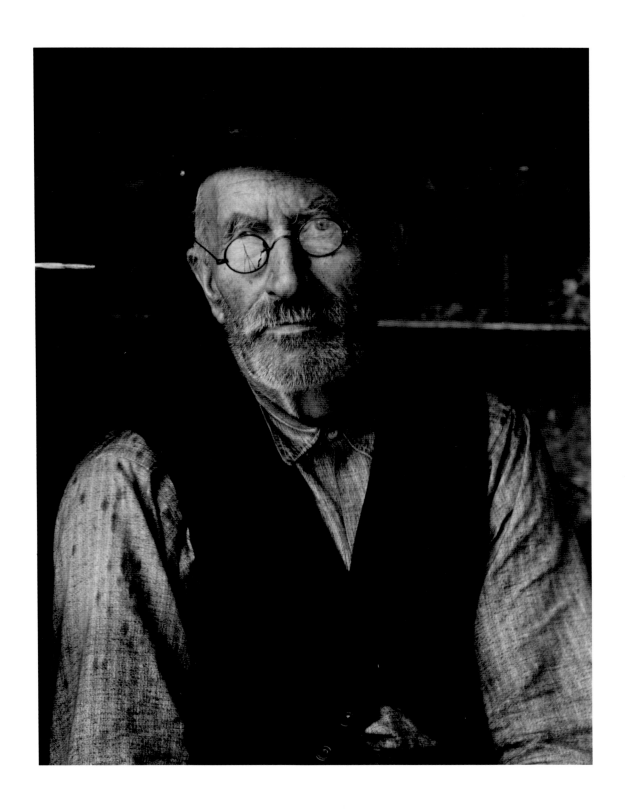

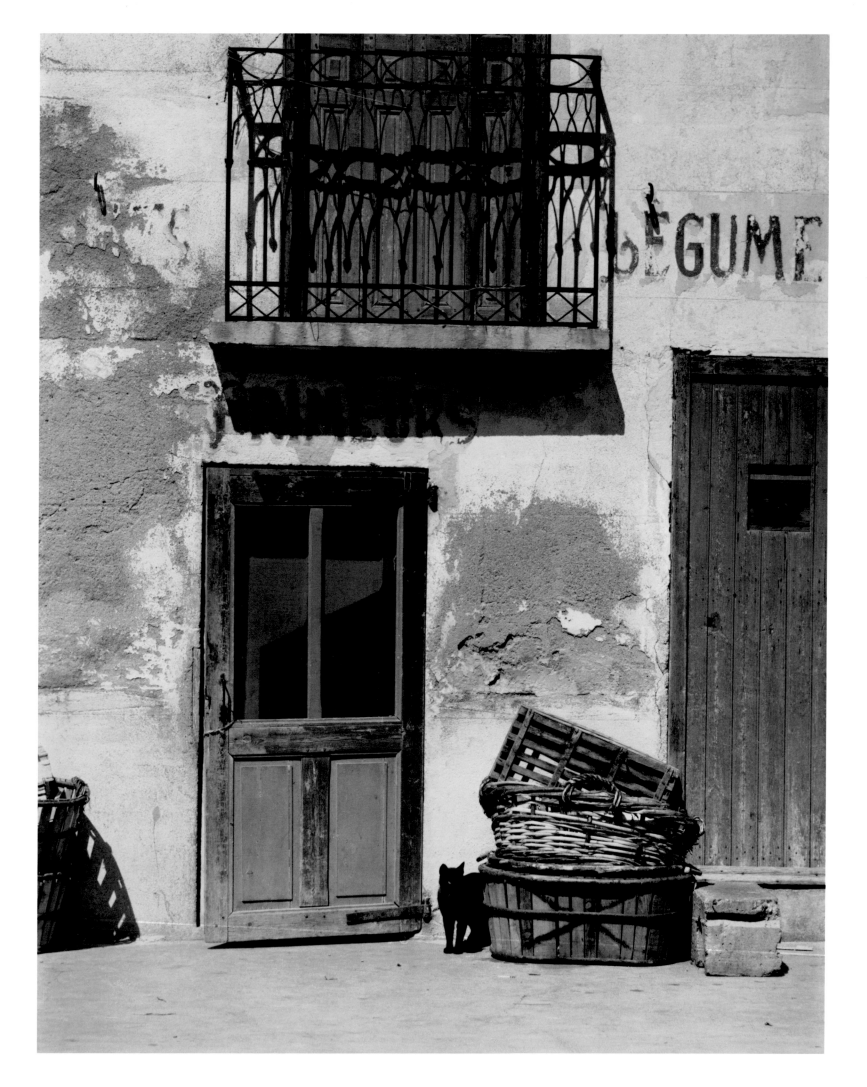

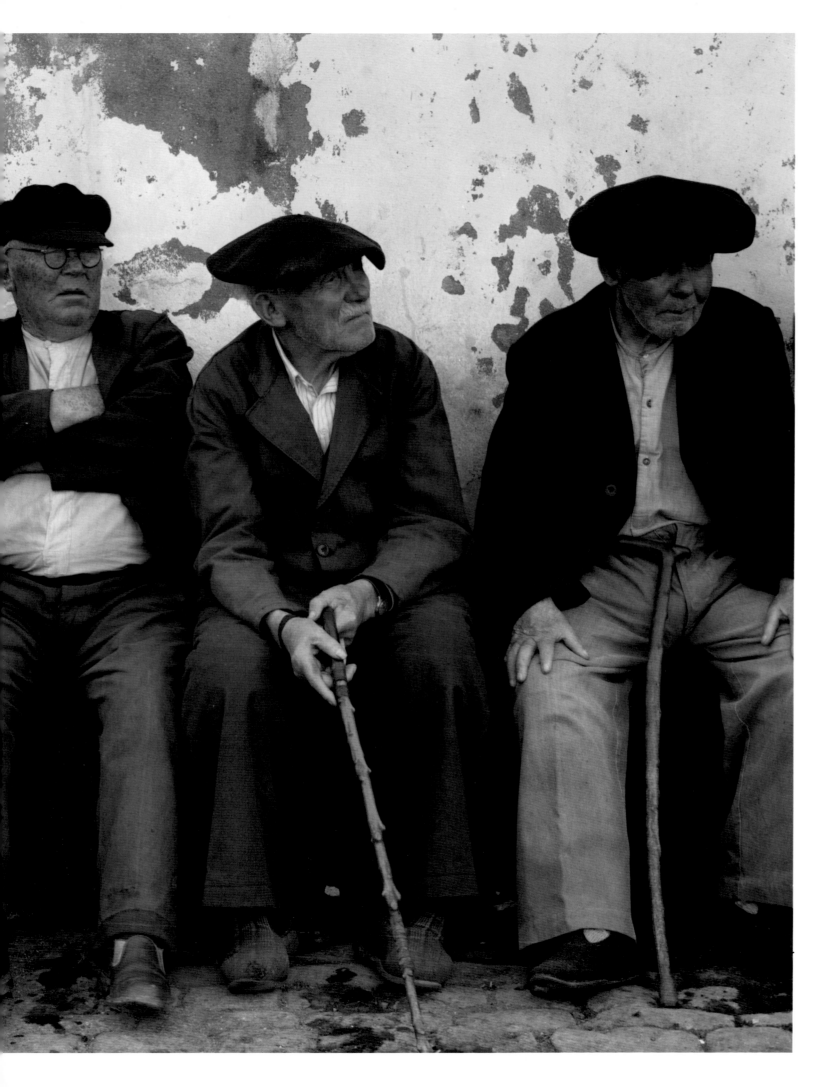

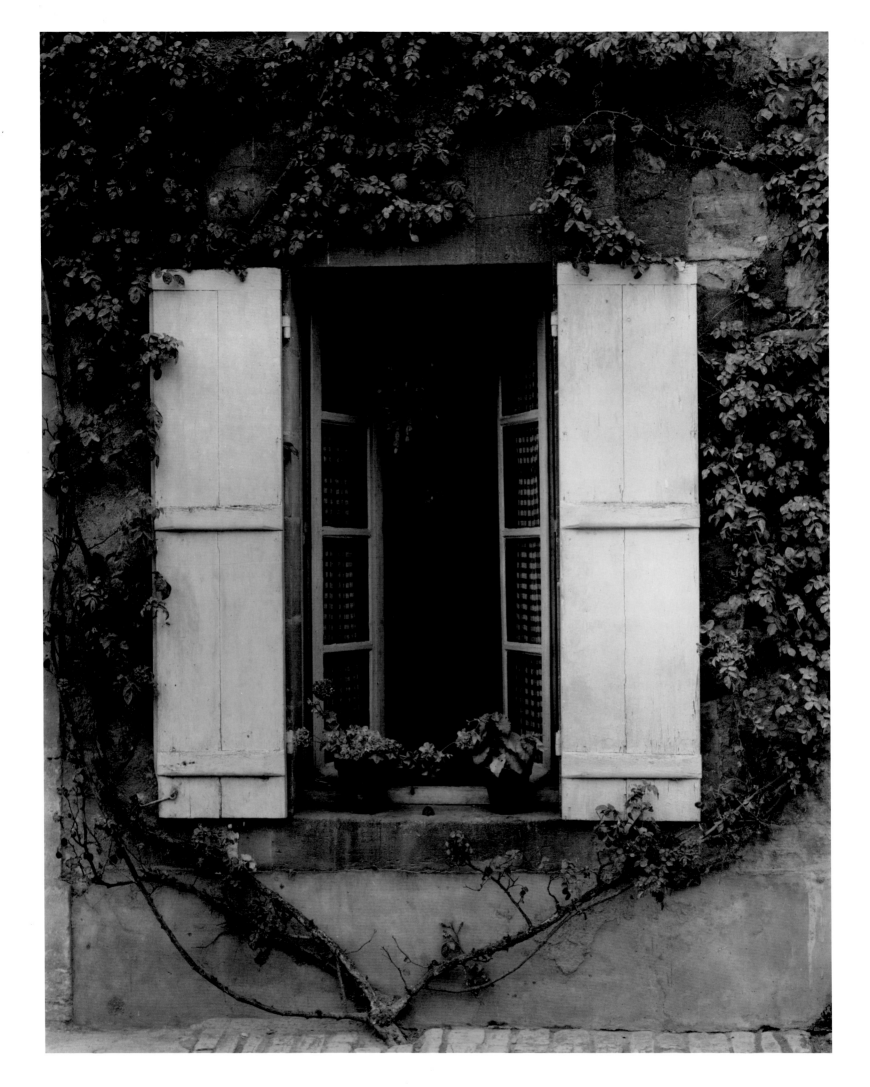

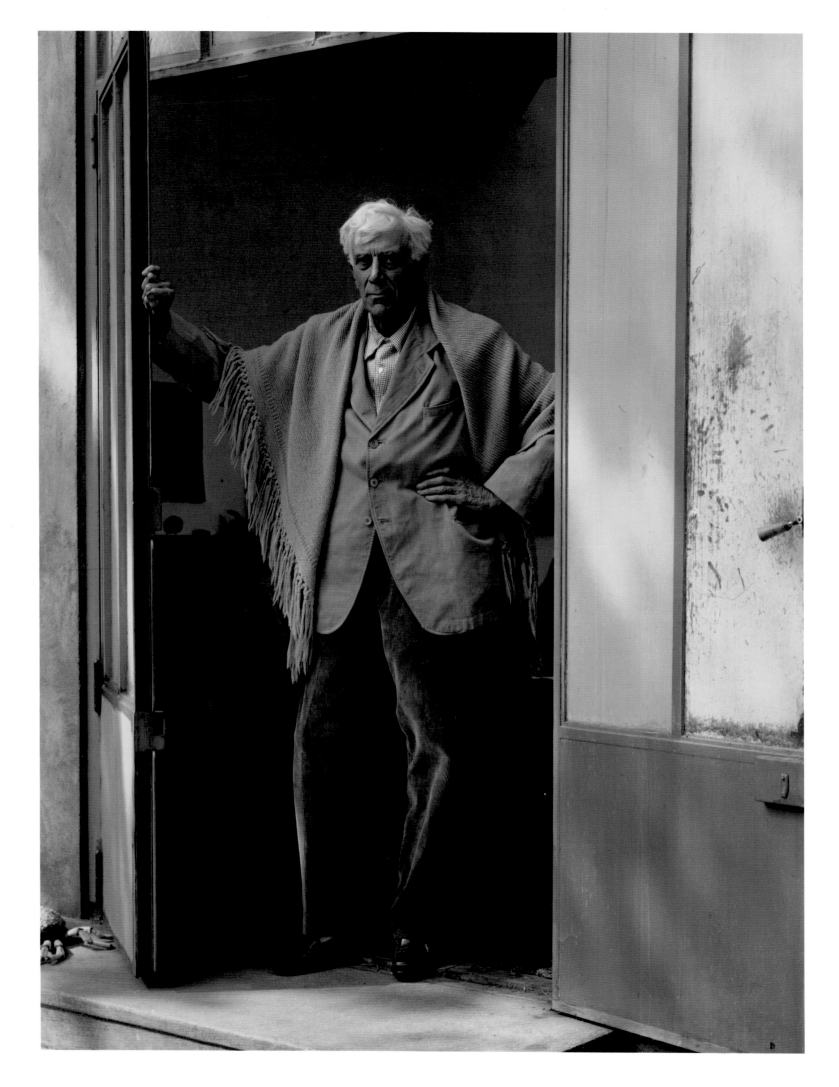

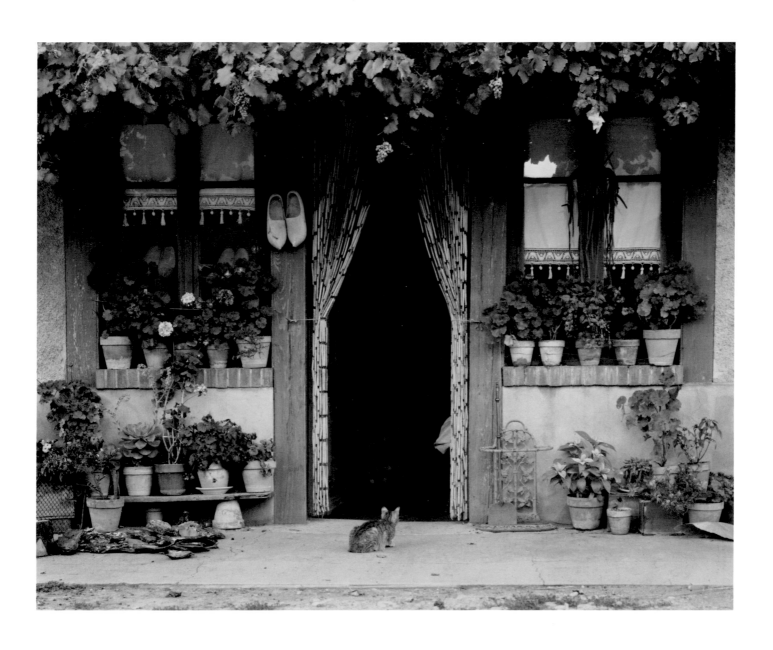

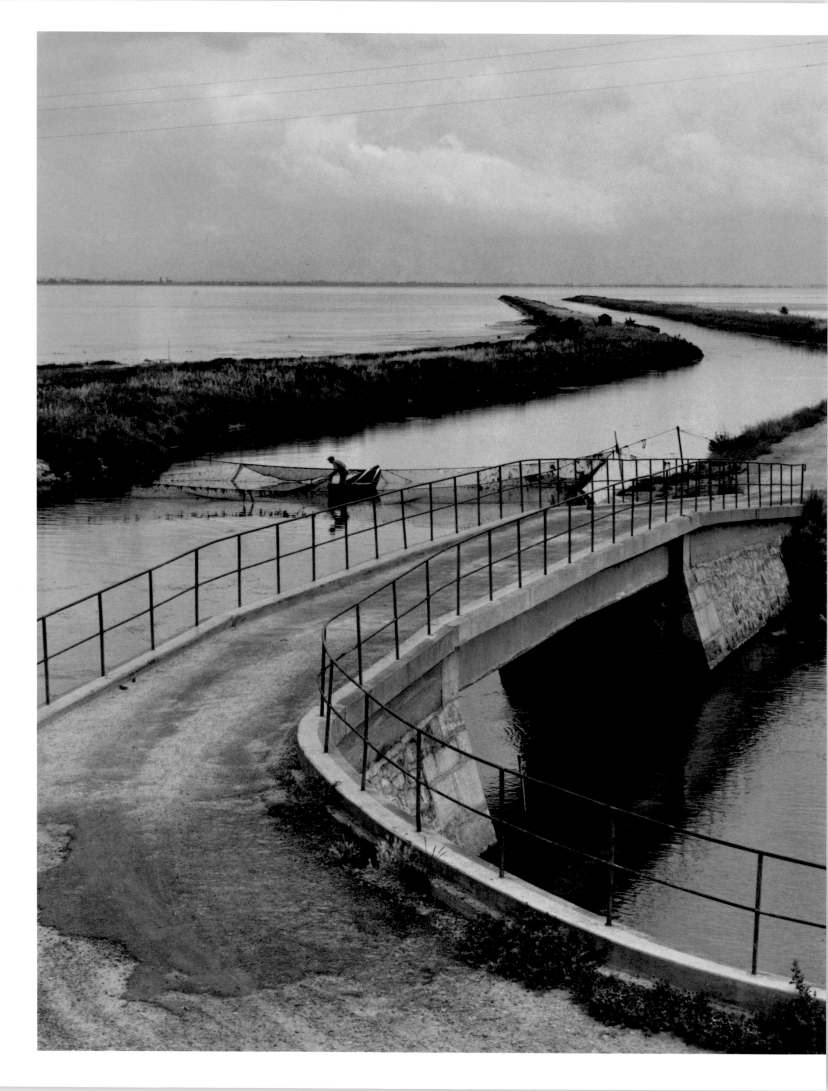

ITALY

I first shook hands with him in 1949, in the intense atmosphere of Perugia, where filmmakers like myself were trying to give neorealistic cinema a sociopolitical structure that would reach beyond Italy and combine with the most recent advances in motion-picture art. I never could have imagined then that this quiet, self-contained American would within a few years become one of the people I most loved and respected.

Our mutual friend Virgilio Tosi helped us get better acquainted, and I felt honored when Paul Strand later wrote to ask that we do a book together. The pictures and text, he said, would issue from the same impulse, the same need. So, after a few false starts, we settled on a project called *Un Paese (A Village)*, based on Luzzara, where I was born, which Strand immediately made *his*. (The book was published in 1955.) We made the decision to begin work together in a small Roman trattoria in Via degli Avignonesi, called, not coincidentally, Emilian Hills. I had been there before with other great men such as Jean Renoir and Roberto Rossellini.

Paul Strand has since become a legend to me (and to others, I am sure), with his silence, his integrity, his independence, and his extraordinary energy. I heard him raise his voice only once. He and his wife Hazel were boarding ship for Sardinia, when a sailor urged him forward saying, "Old folks first." Strand responded, practically shouting back, "Old? *Me?*" Then he repeated it, a little astonished, a little sad.

He was ageless really (the records say that he was sixty-five that year—1955). The eye never ages. Strand's certainly didn't; he always engaged the two dimensions of things: being and becoming, conversing intimately with time and space, even when he slept, so that his camera might capture sleep itself. Was there anything he did not claim and use?

His serenity was merely an appearance. He in fact quarreled intensely with those tricky movements of time and space that sometimes concealed his own primary reason for existing. His way of working was deliberately casual; he always acted "like a native," bound up with the very subject whose presence he wanted to capture and fix. People thought him careless, I suppose, or too trusting, when they saw him set up his camera only to walk away, leaving it on the street as if he were more concerned with the random and commonplace than with the exceptional. It was a calculated absence though, and upon returning he reaped the rewards. He knew what he would find: the bonding of a particular time with a particular space. Sometimes he dealt with simpler problems: a fraction more or less of exposure time. Secretly he swung back and forth between infinity and the ticking of his watch, which whispered the language of mortality....

I will always be grateful to Strand for what he made me see about my own townspeople. He could always capture that moment of light and line when things have absorbed our presence and our hard work....

Strand was reserved, but he was also human. In an almost biblical way, he always journeyed down from the heights into the valley, losing himself among configurations of dust and human shapes. If then he climbed back up to the summit, toward his own Sinai, this too was part of the mystery with which he struggled so powerfully for as long as possible so that he could communicate directly and immediately with his fellow man.

From the Introduction to Portfolio Four,
by Cesare Zavattini,
August 18, 1981,
translated by W. S. Dipiero

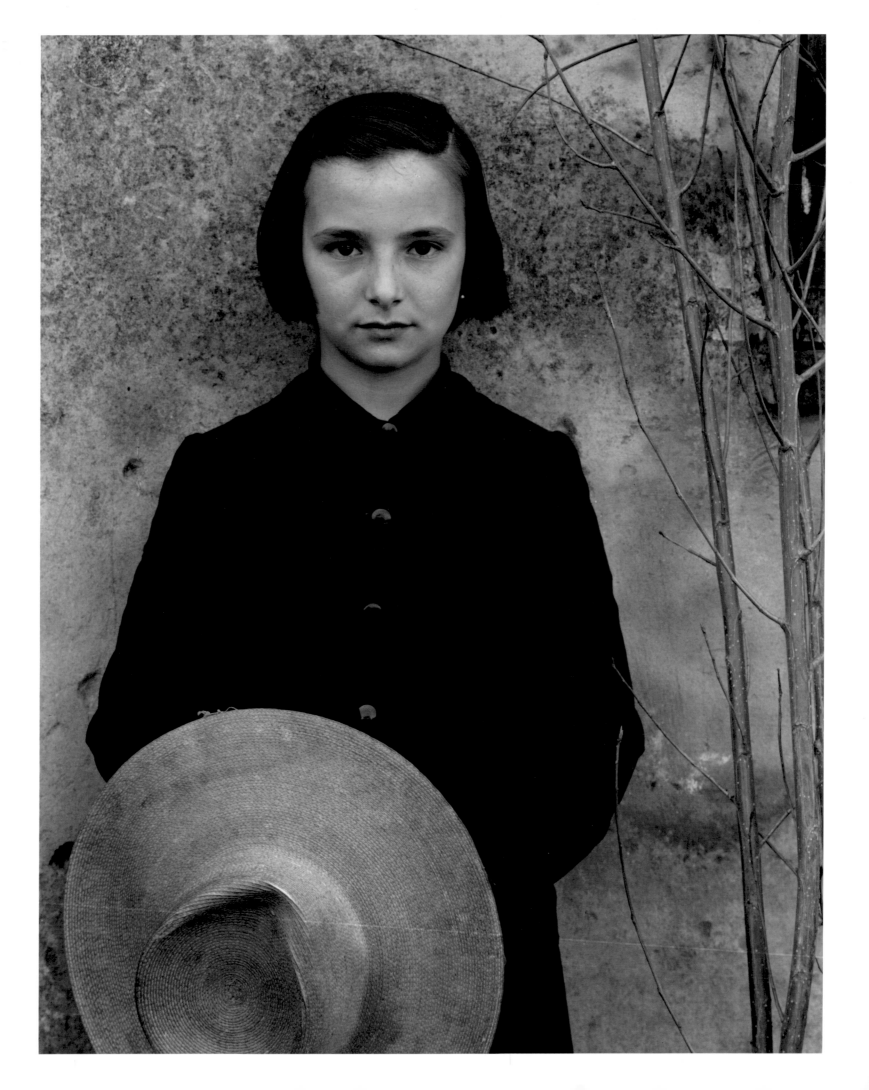

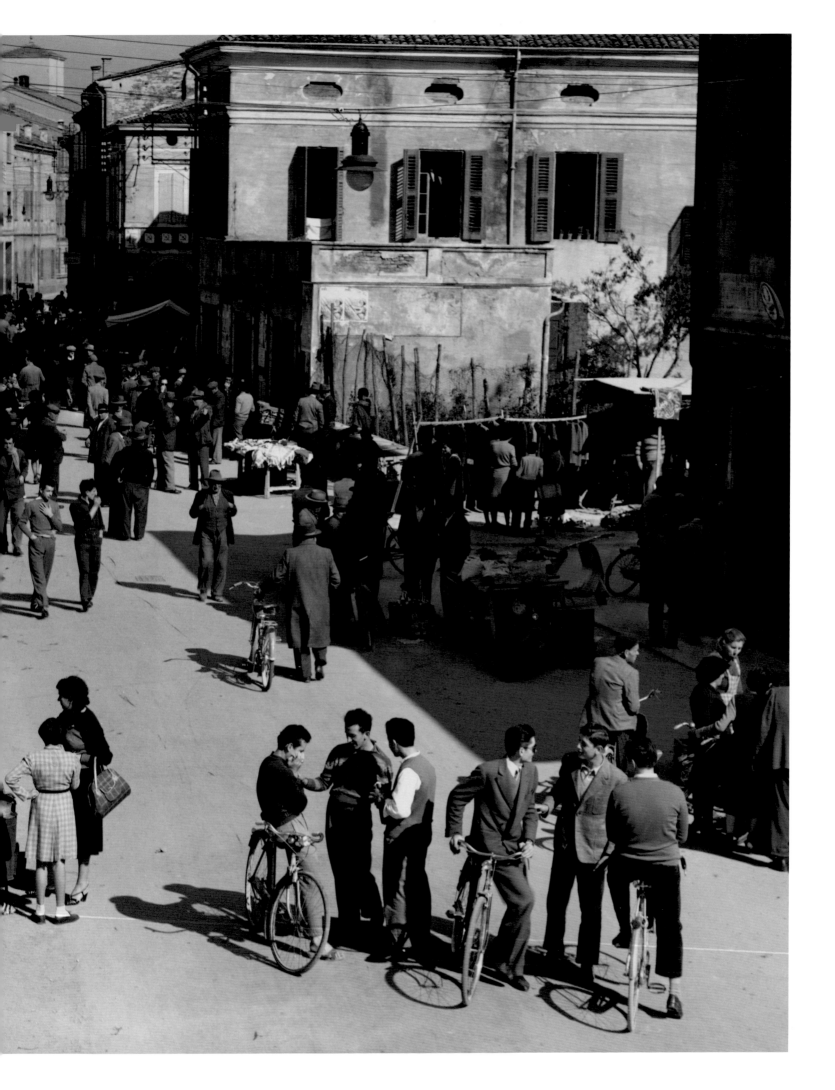

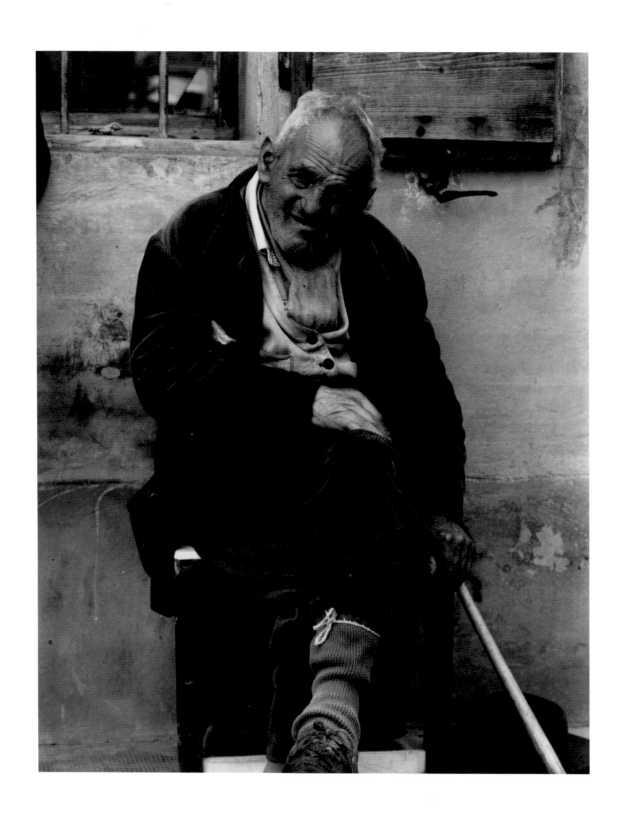

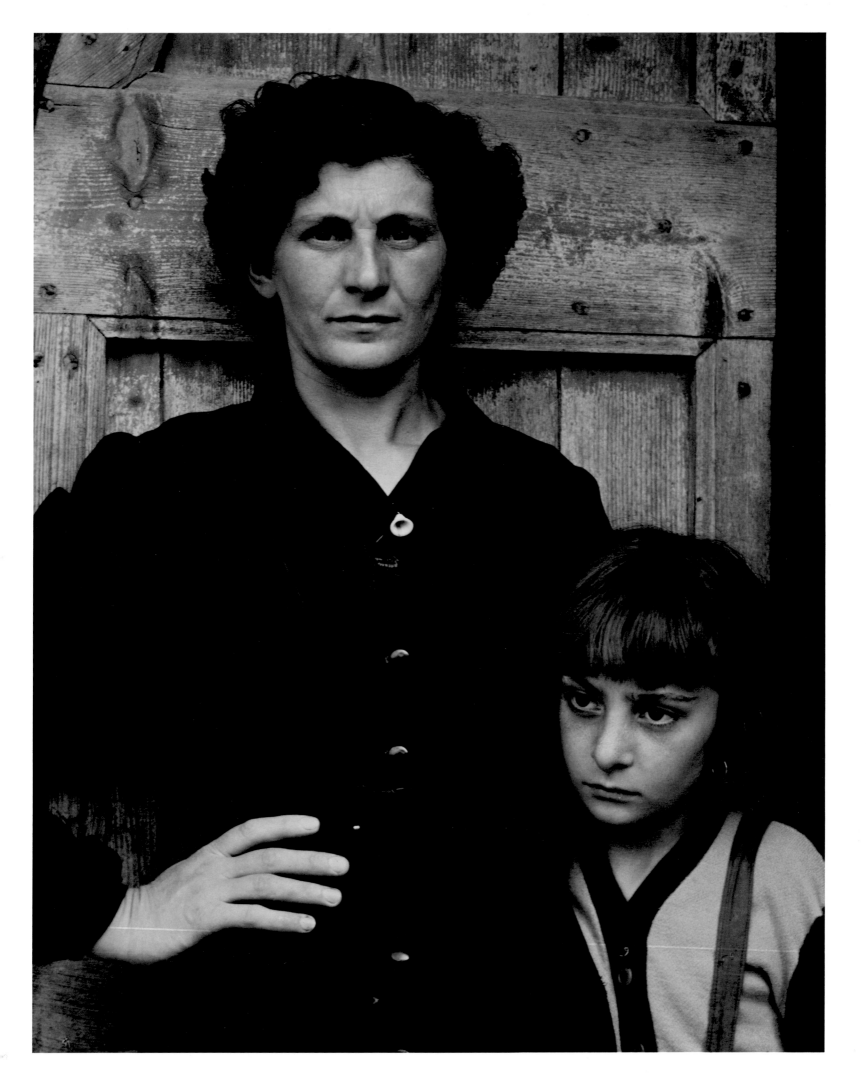

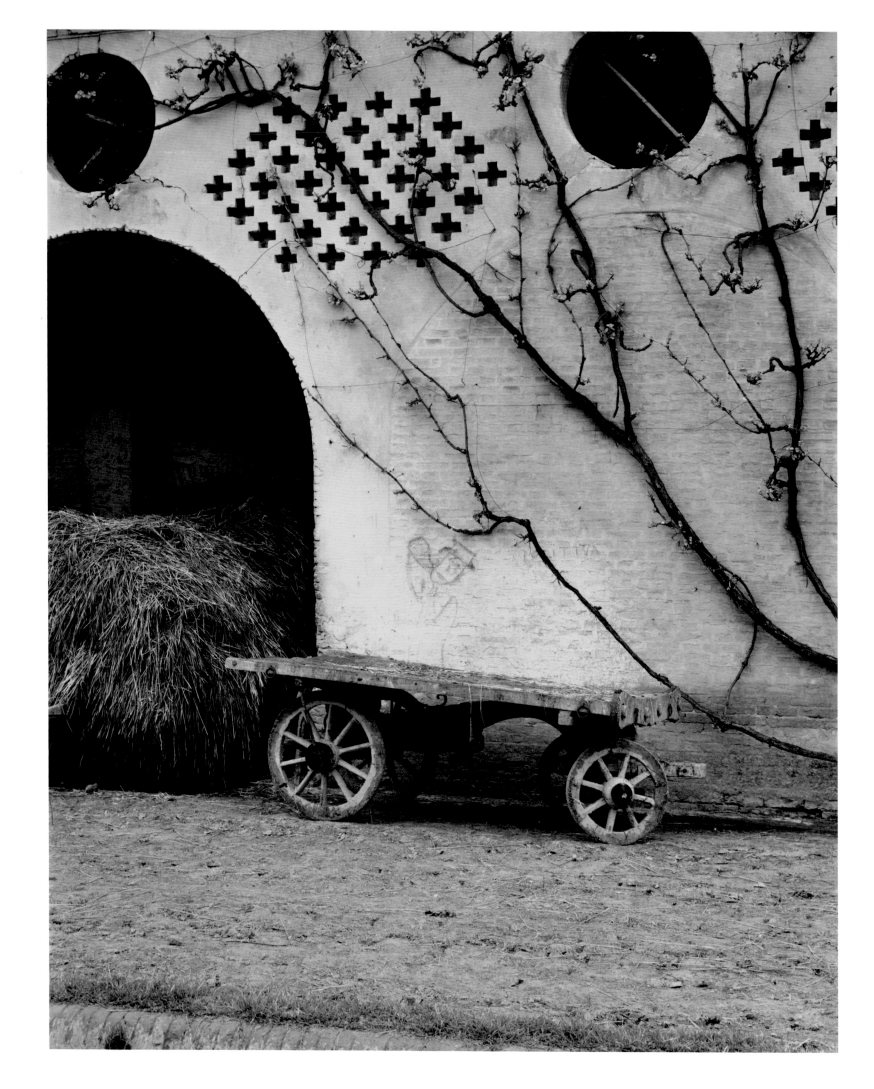

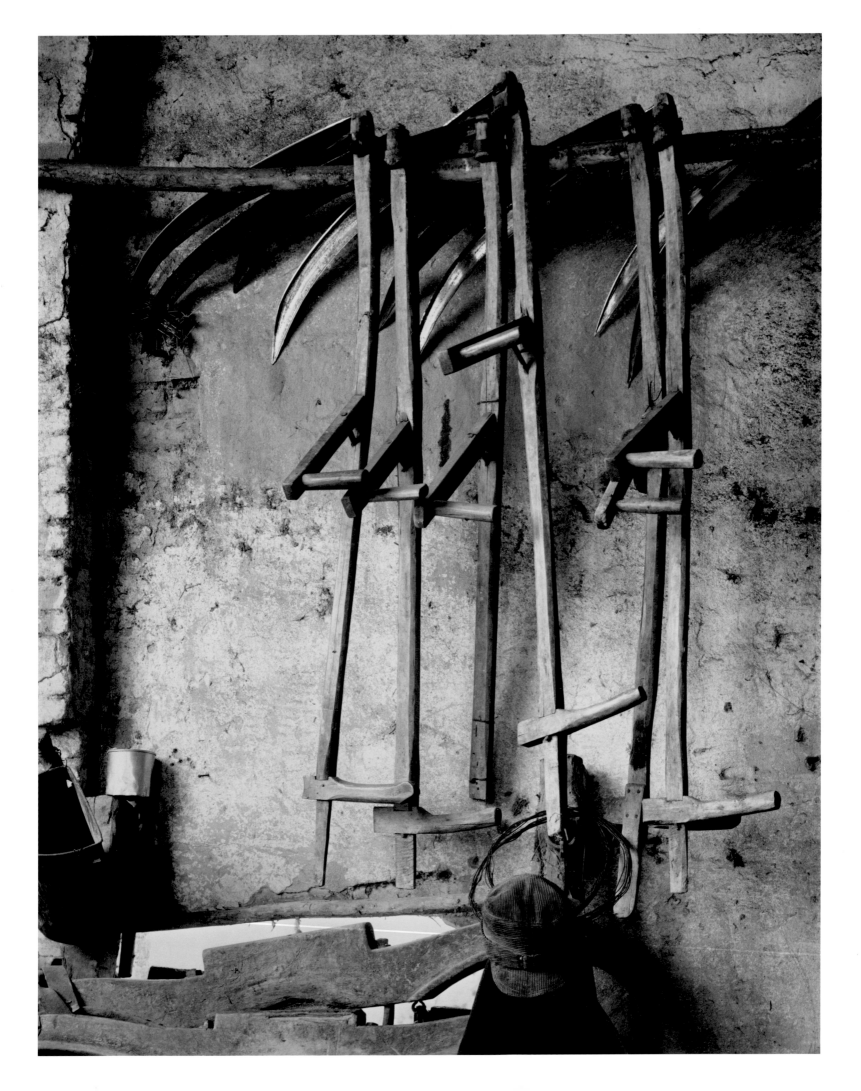

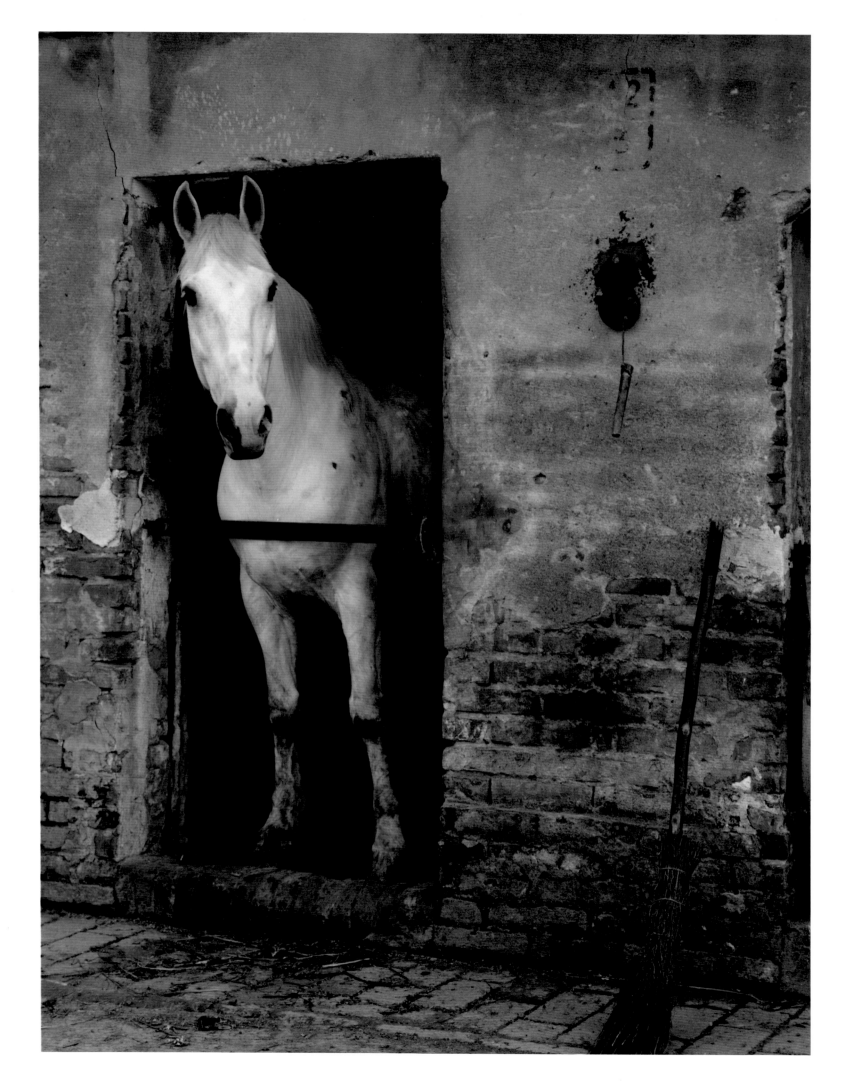

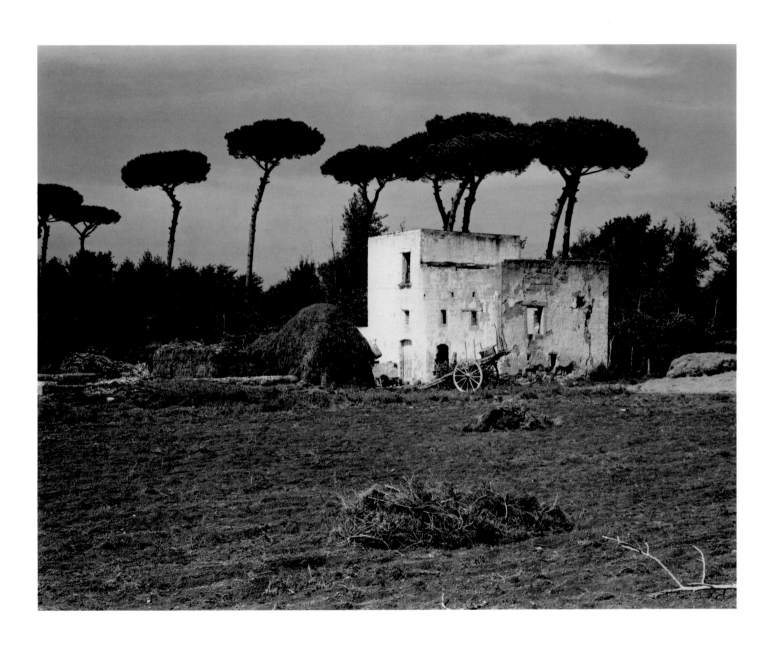

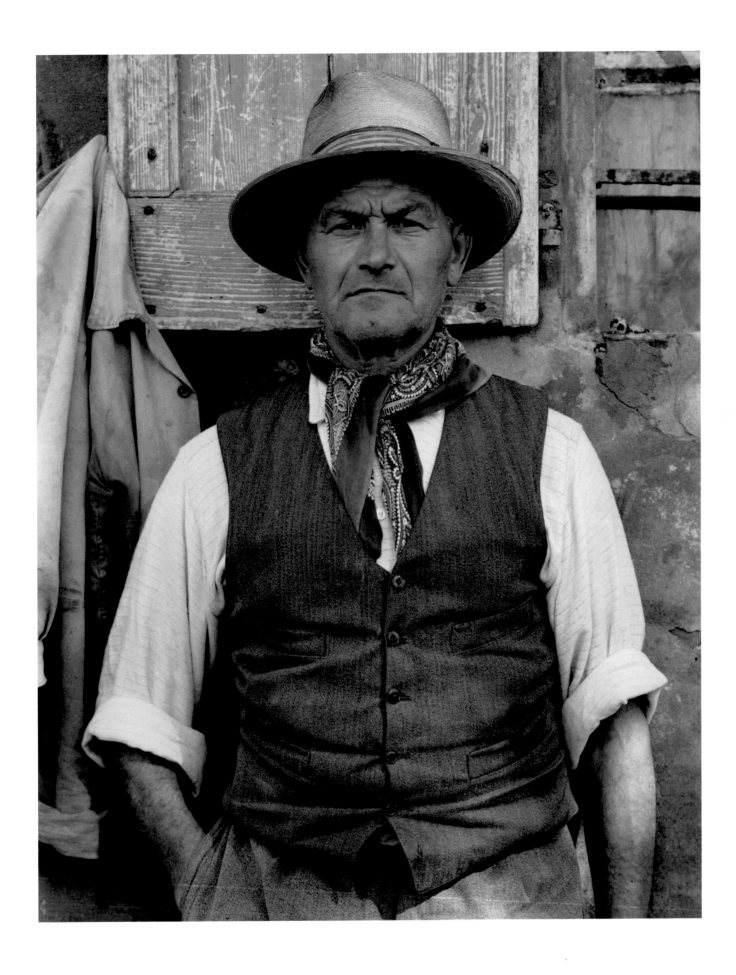

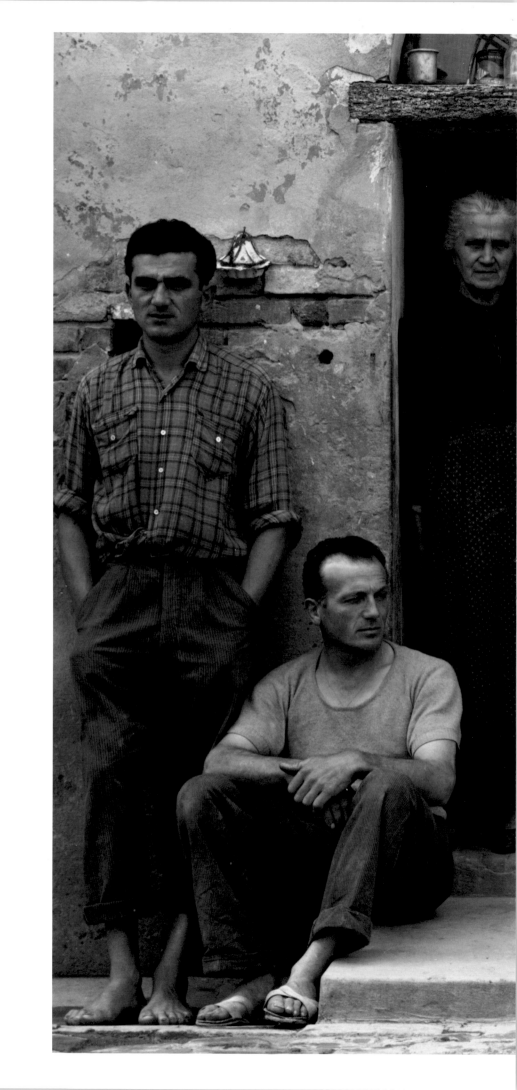

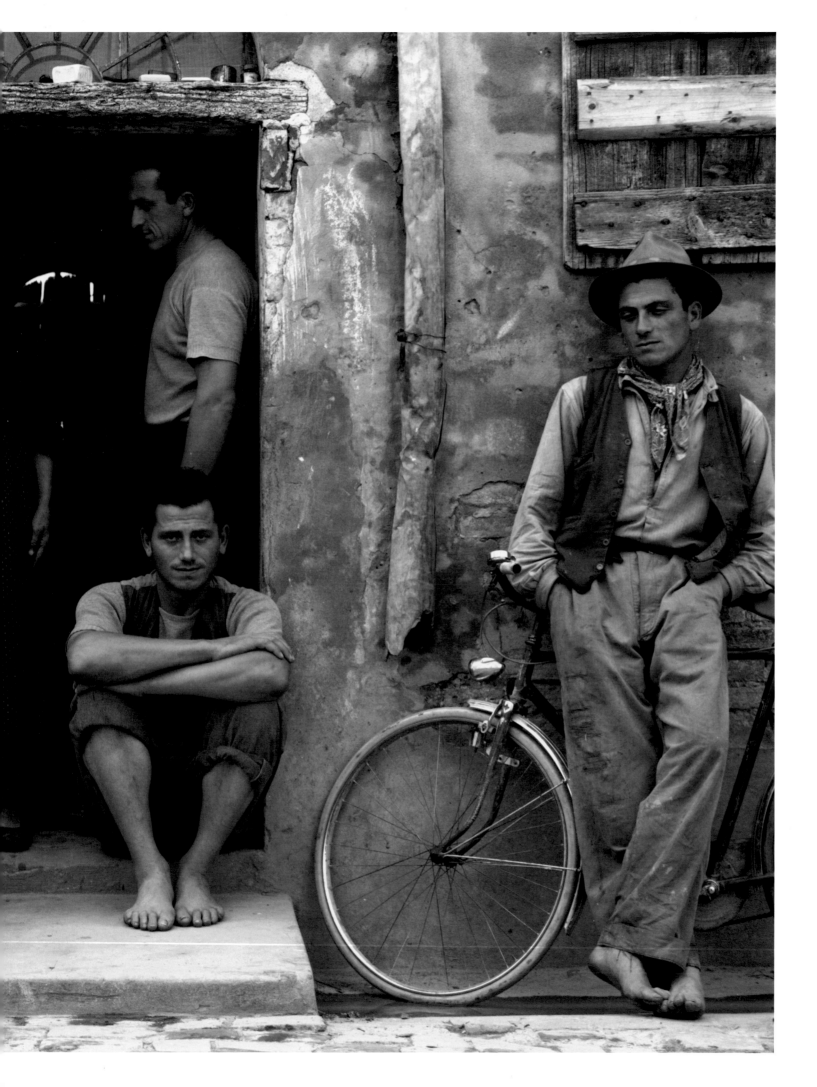

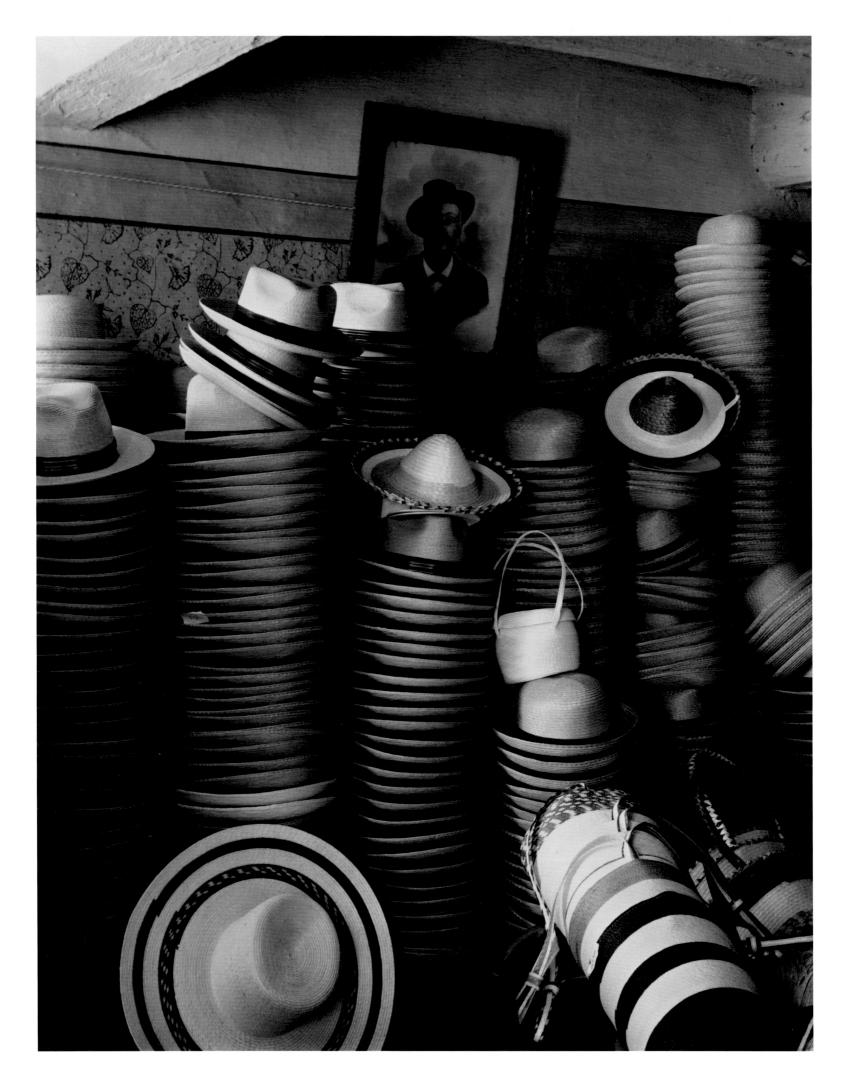

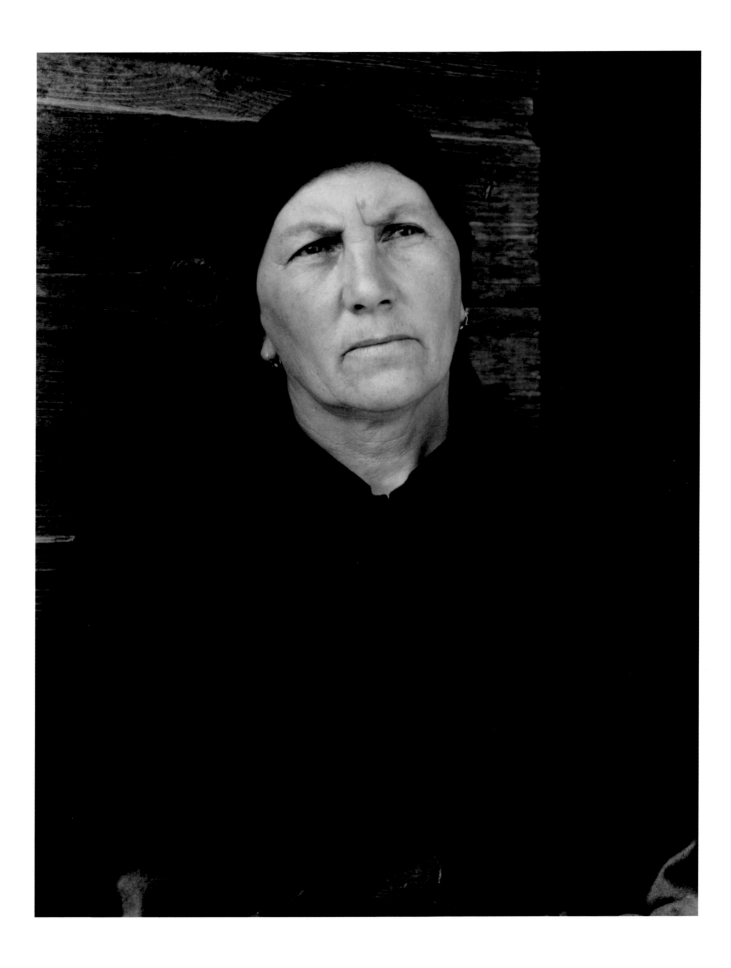

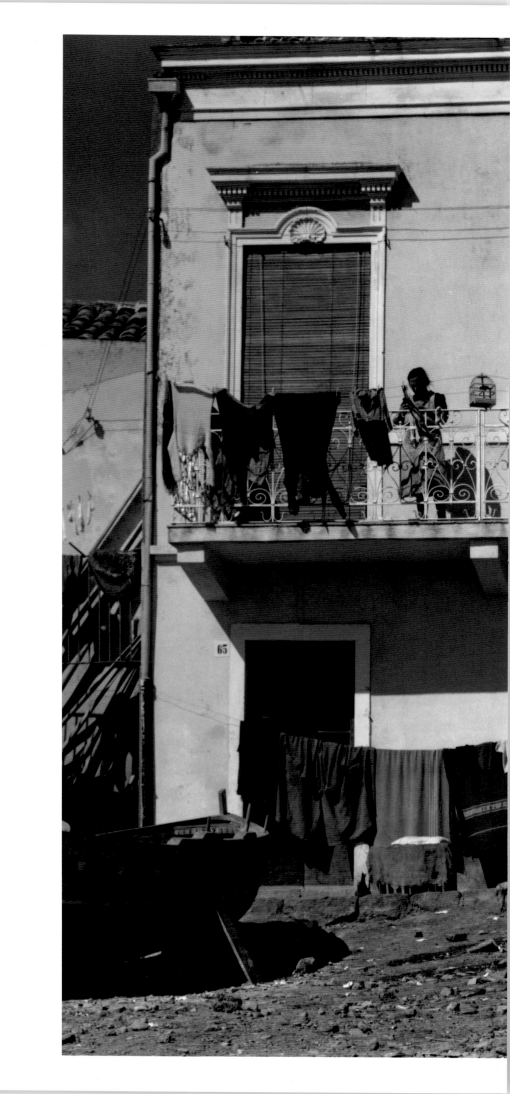

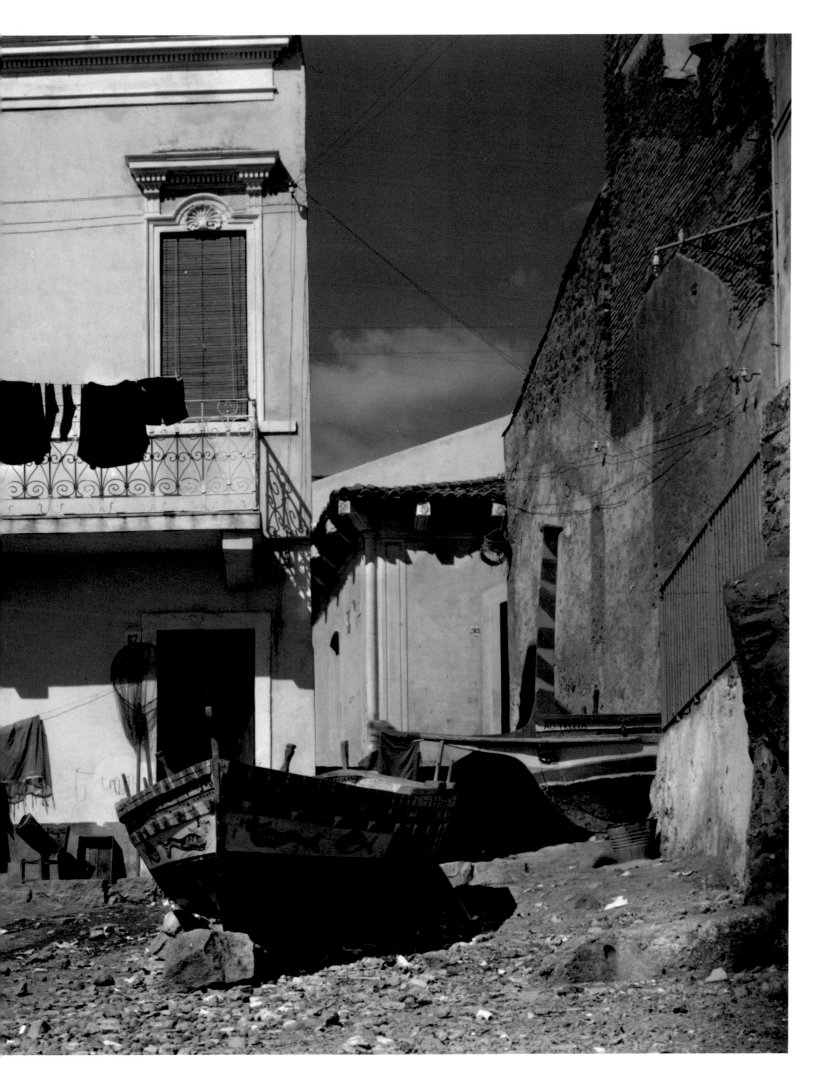

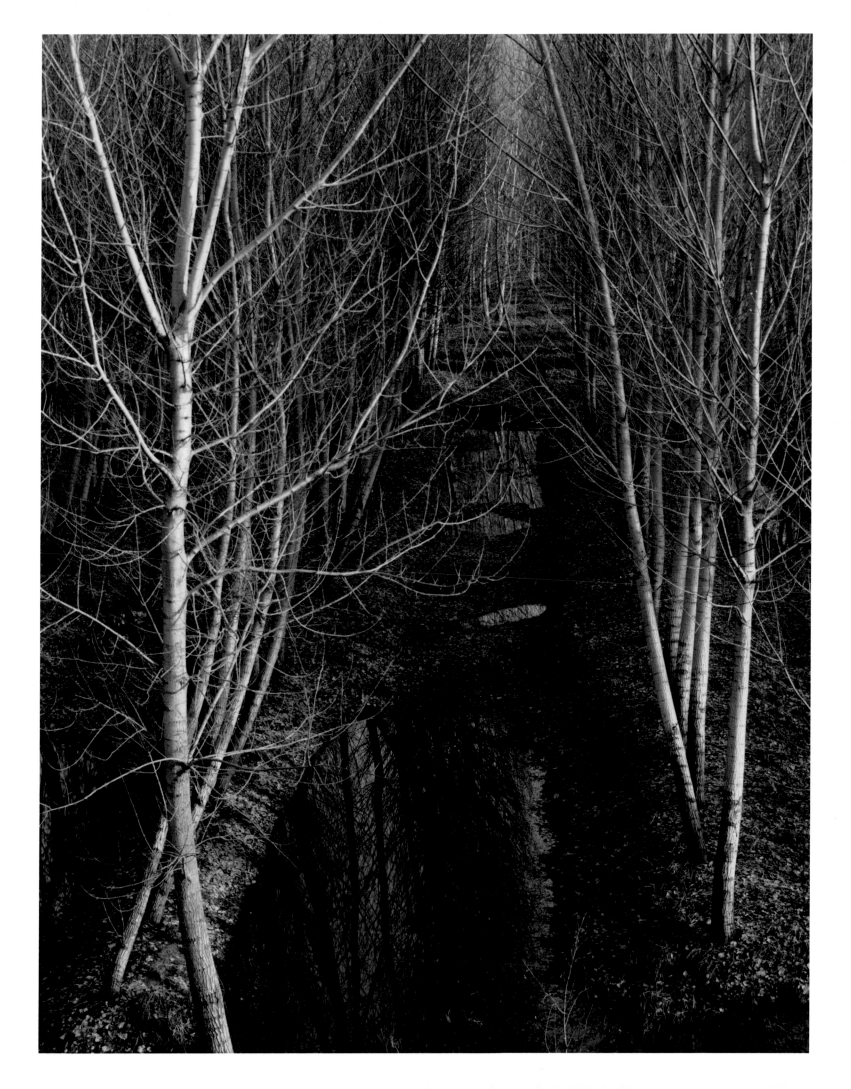

THE HEBRIDES

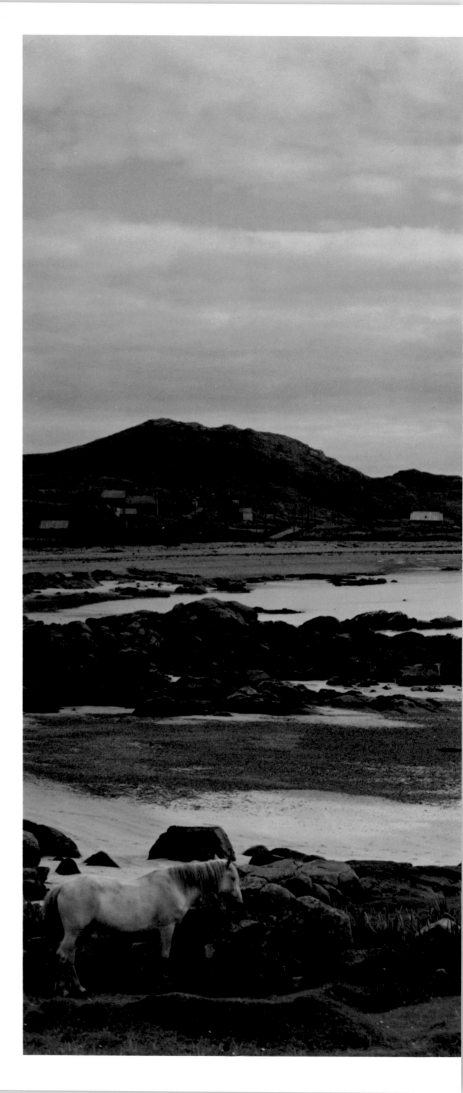

The name of Paul Strand is honored by everyone who believes that photography can be more than a superficial trick of light and chemistry and mirrors. Thirty and forty years ago his early work had the quality of pioneering vision into the art of photography; and throughout his life since then, passed mostly in the United States where he was born, Strand has worked exactingly at raising the standards of photographic art to higher levels....

Working at a slow pace, at his own exacting pace to his own exacting standard, Strand lived in South Uist for three months of 1954 so that he could take the photographs that he felt he wanted. He and Hazel Strand, who is also an experienced photographer, wandered for long weeks up and down the southern islands of the Outer Hebrides, waiting until they felt they understood the nature of the place, before he was ready to begin work.

But once hc was ready the photographs seem to have come into existence without the camera; for the great gift and genius of this artist, it will appear, is to be able to place reality before you without demanding that you "see" the cameraman as well. Perhaps that is why his photographs achieve an intimacy that is always without embarrassment, a depth of purpose that is never pretentious, a truth that is momentary but is also universal. These islands of the Outer Hebrides deserved a great photographer: it can be seen, in this volume, that at last they have got one.

From the Foreword to *Tir a'Mhurain*,
by Basil Davidson, 1962

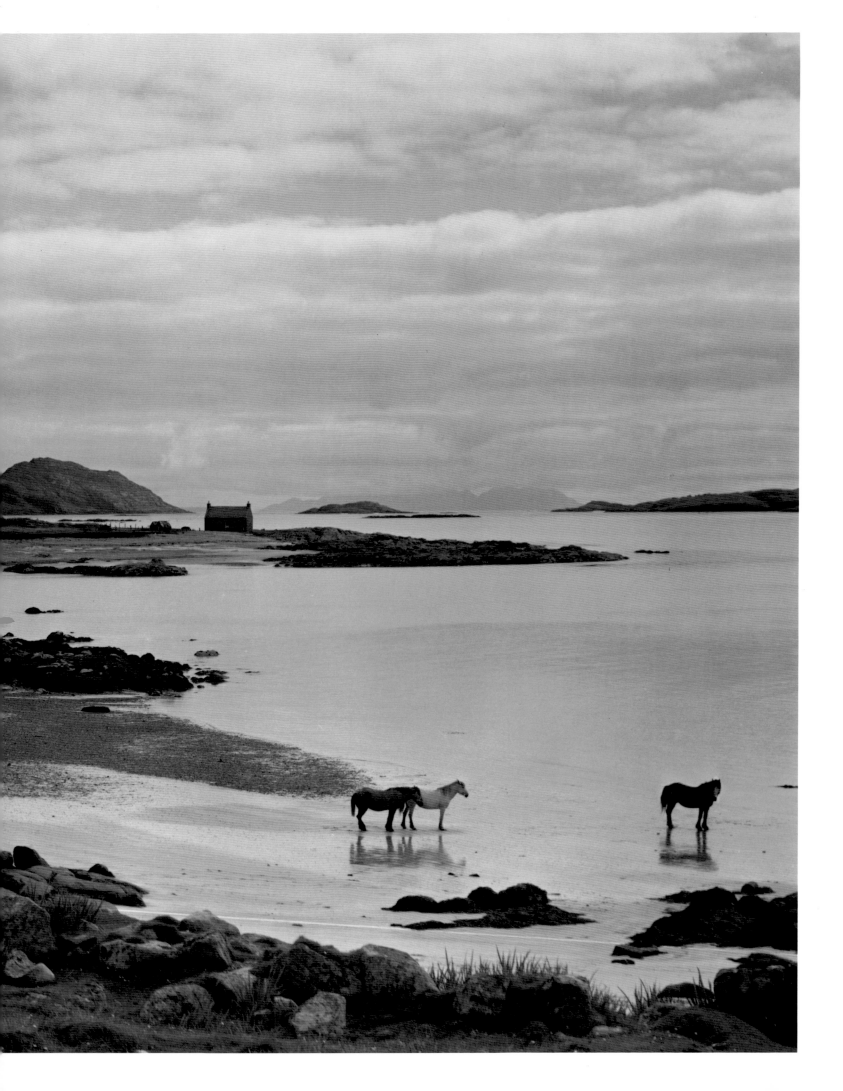

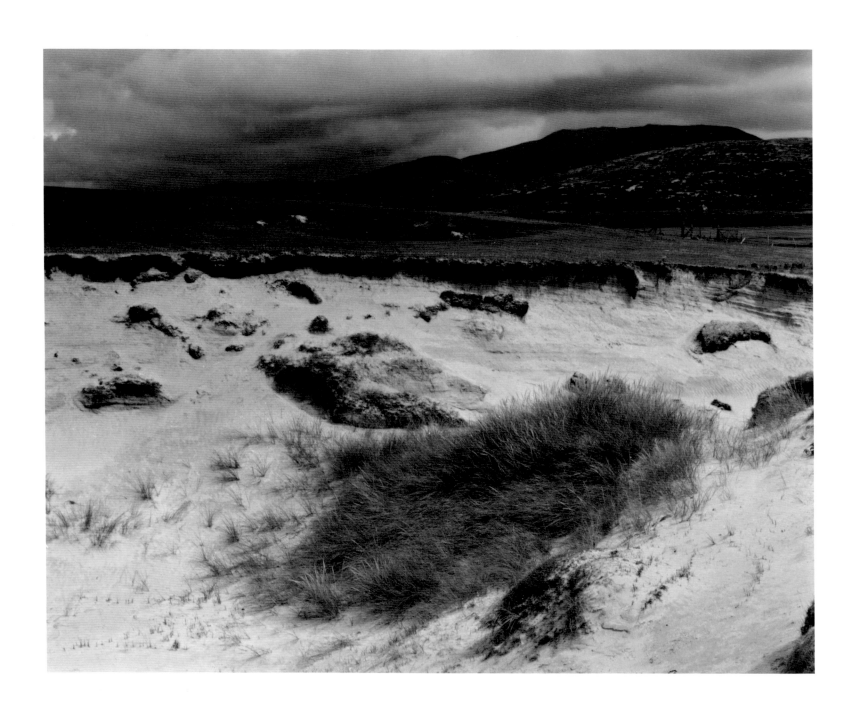

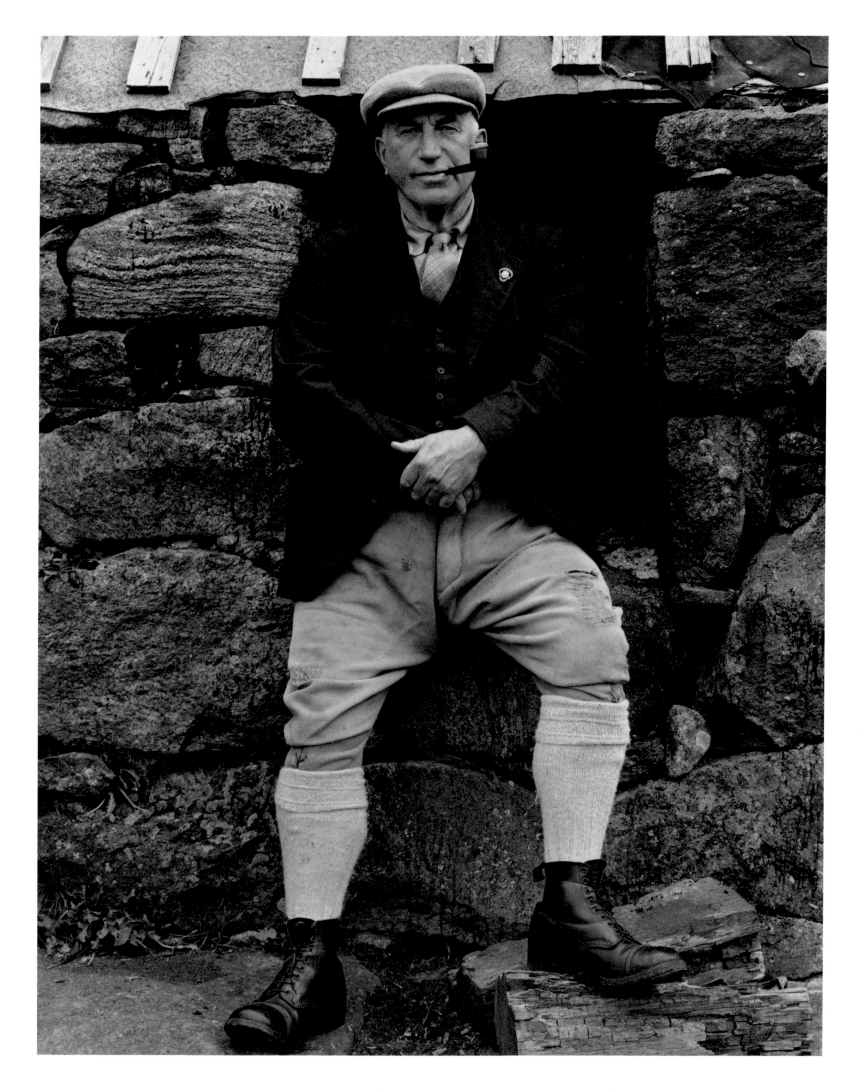

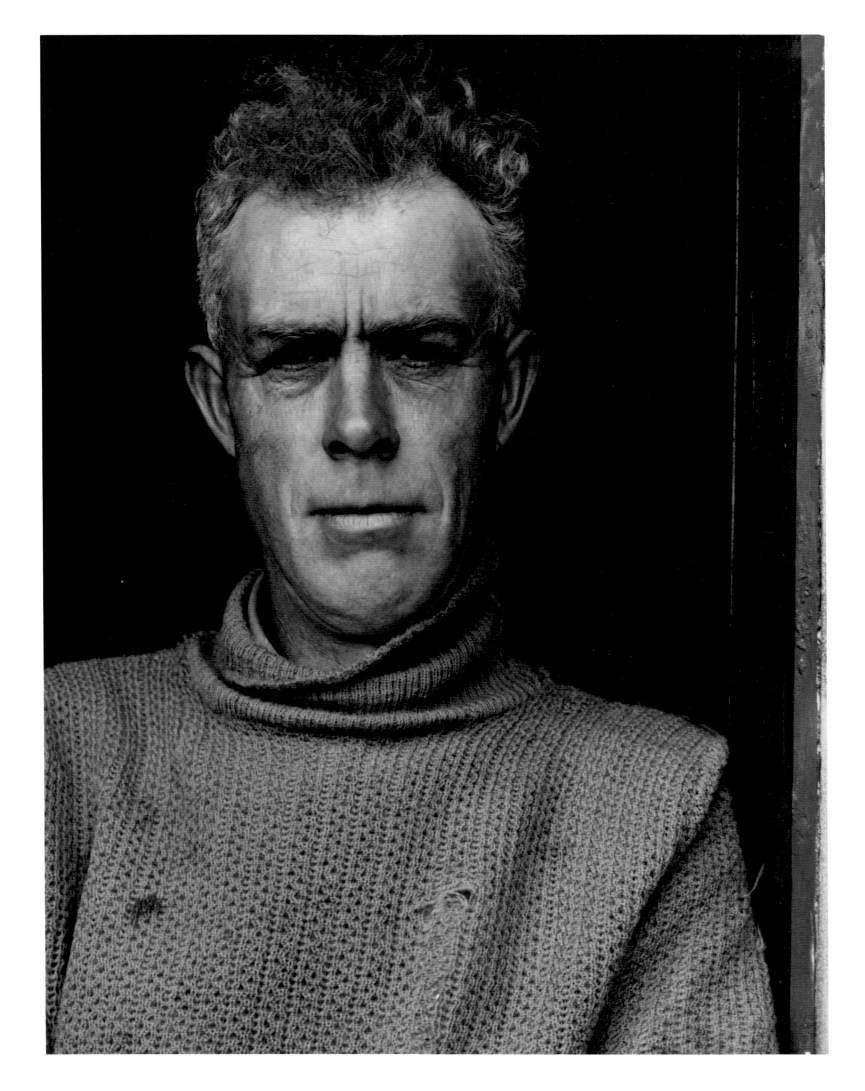

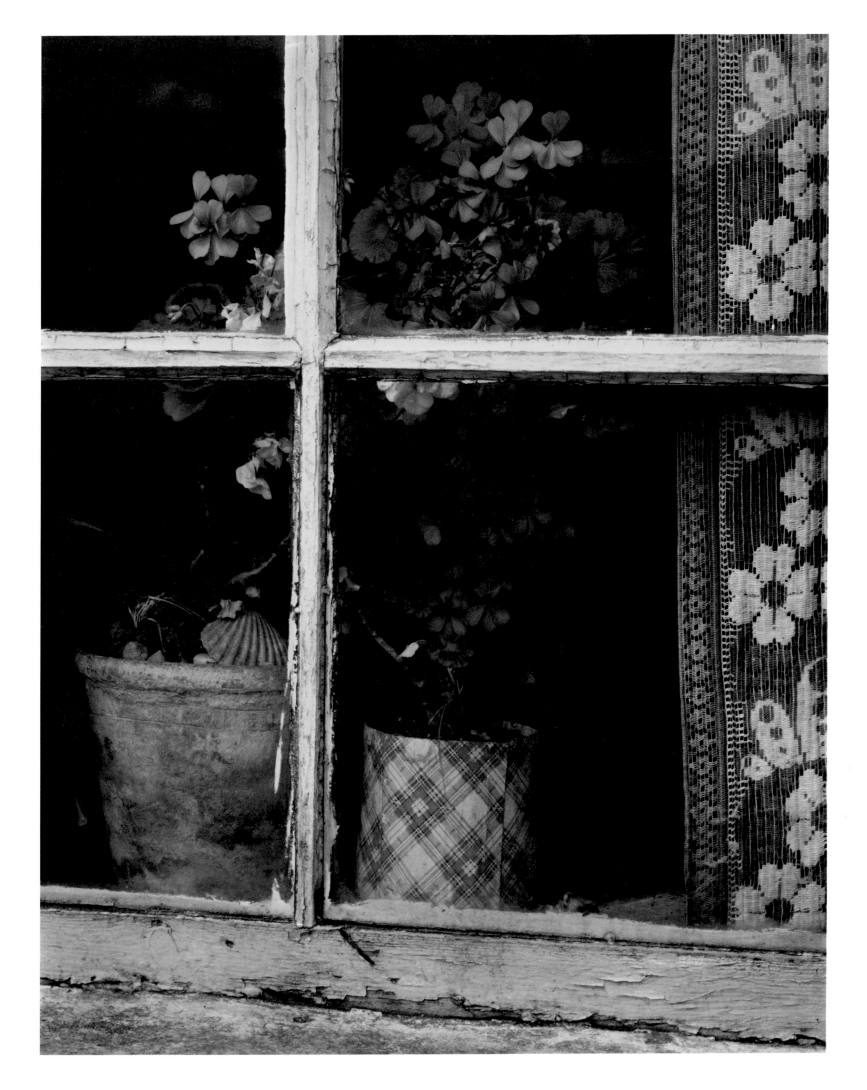

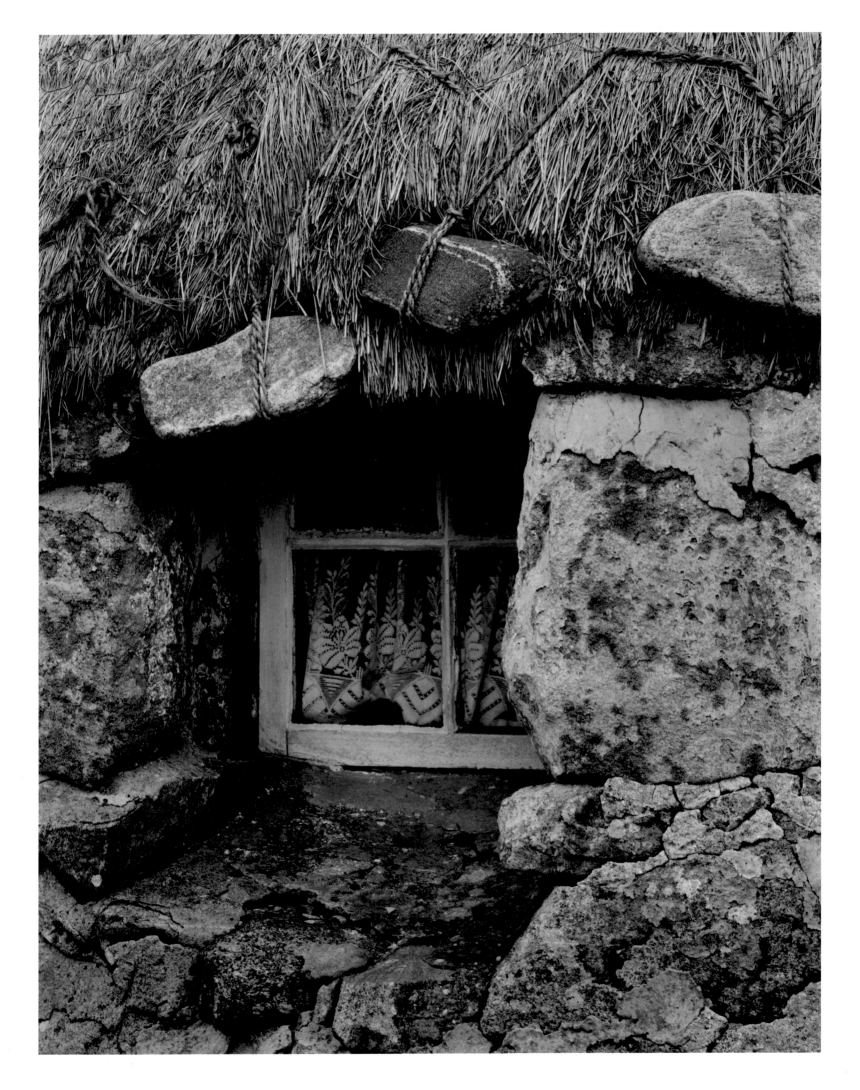

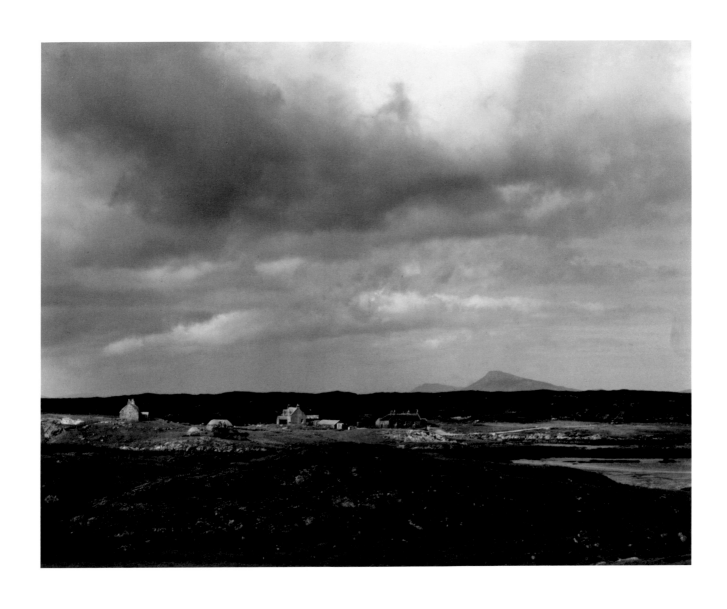

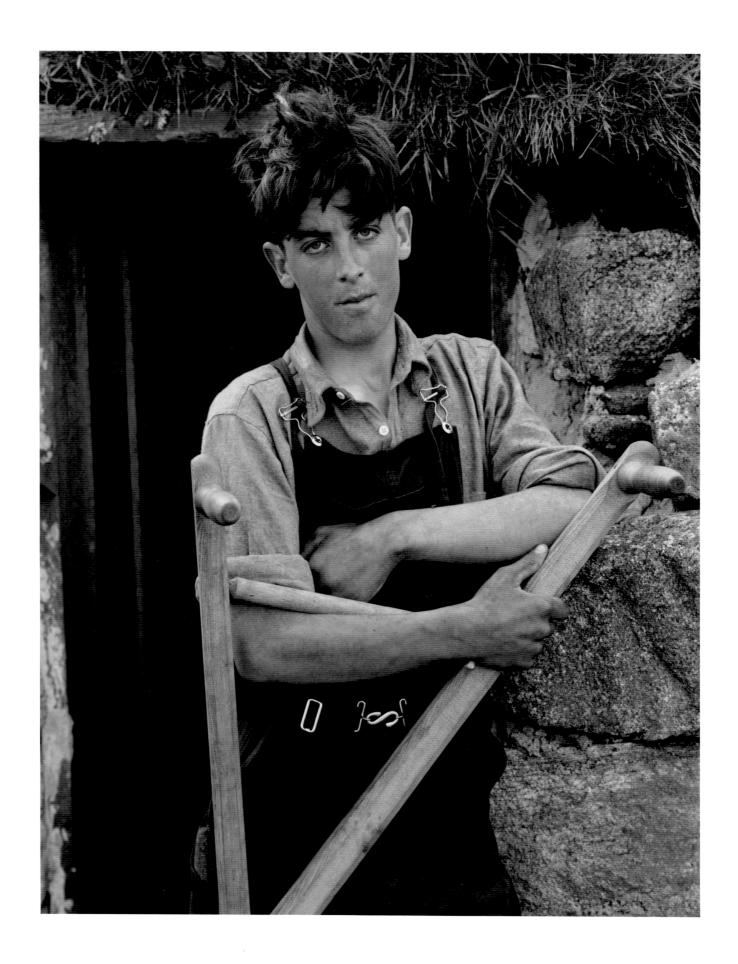

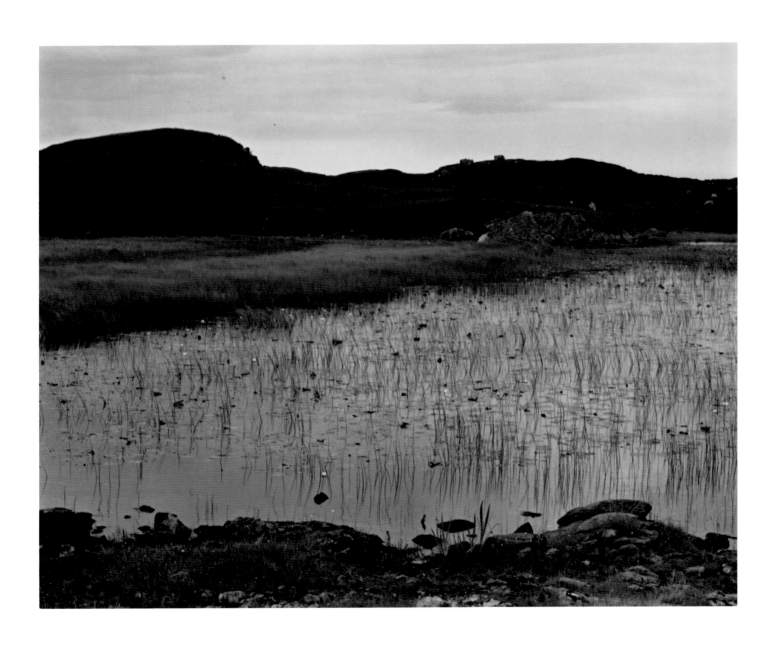

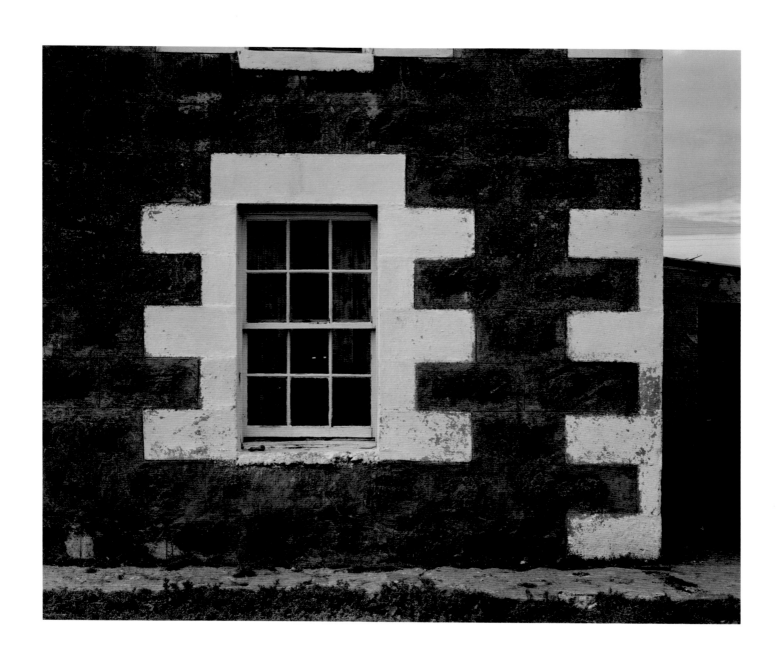

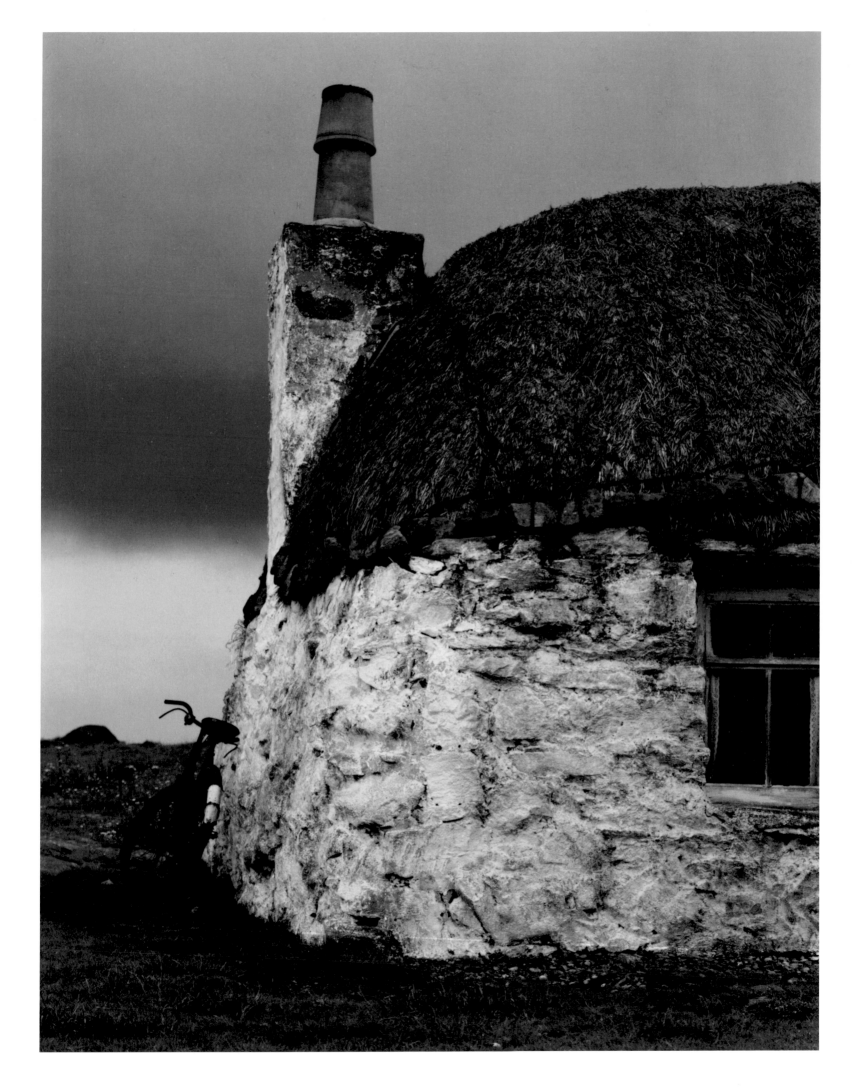

EGYPT

The task we set ourselves was to try to lay the foundations for understanding Egypt and its people. Egypt's history has always evolved out of its rich land and its poor people. The photographs and the text of "Living Egypt" begin there and develop, on this basis, the idea that modern Egypt is emerging from her past and her poverty, and is trying to overcome the heritage of more than two thousand years of continuous occupation. Egypt is quite incomprehensible without this approach.

What emerges at the end of it all is the revolutionary Egypt which was born in 1952. In print we have to stop the revolution at a given moment and say: "That is where it is now." But what the text and the photographs have tried to show is that the problem of Egypt is not simply the development of day to day events. For Egypt it is still a matter of transforming, painfully and with great difficulty, what is already there. We did not want this obscured. We have therefore concentrated on the human material the Egyptian revolution is working with, and we have set out to show that in fact Egypt is still incredibly old, even at the moment when it is exhilaratingly young.

From the Foreword to *Living Egypt*,
by Paul Strand and James Aldridge, 1969

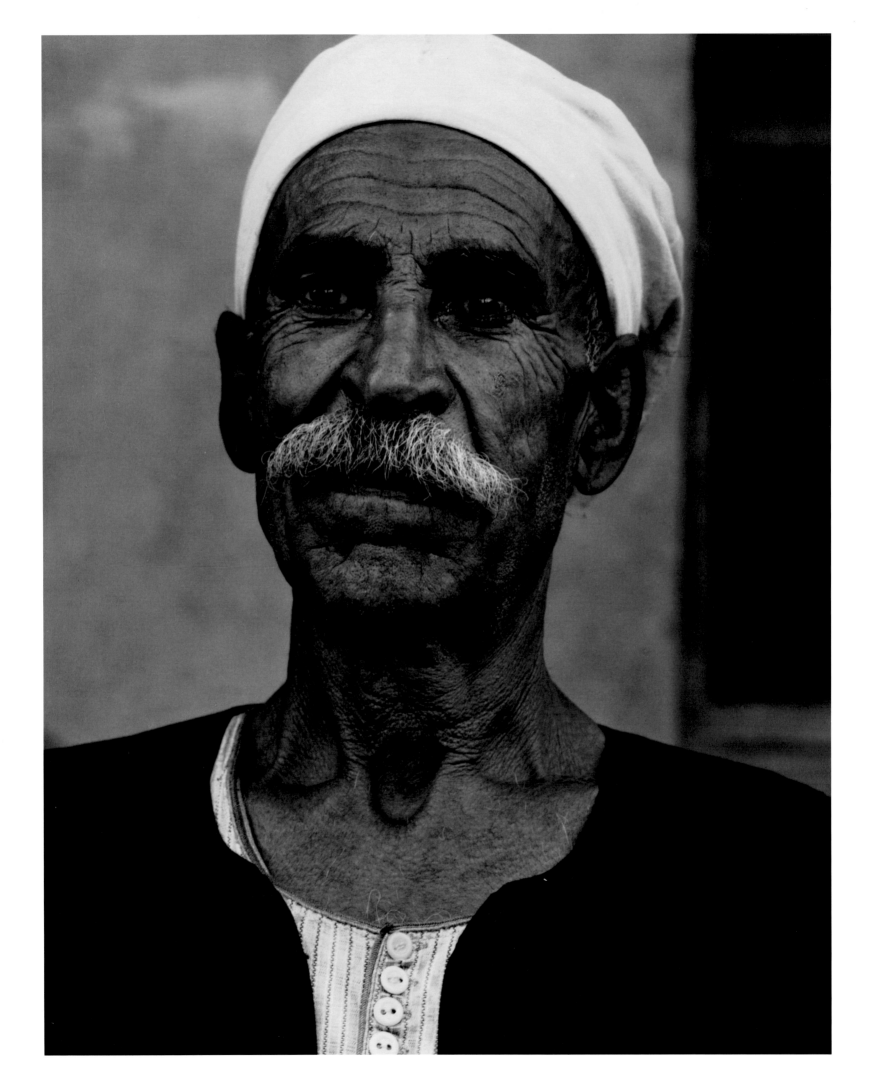

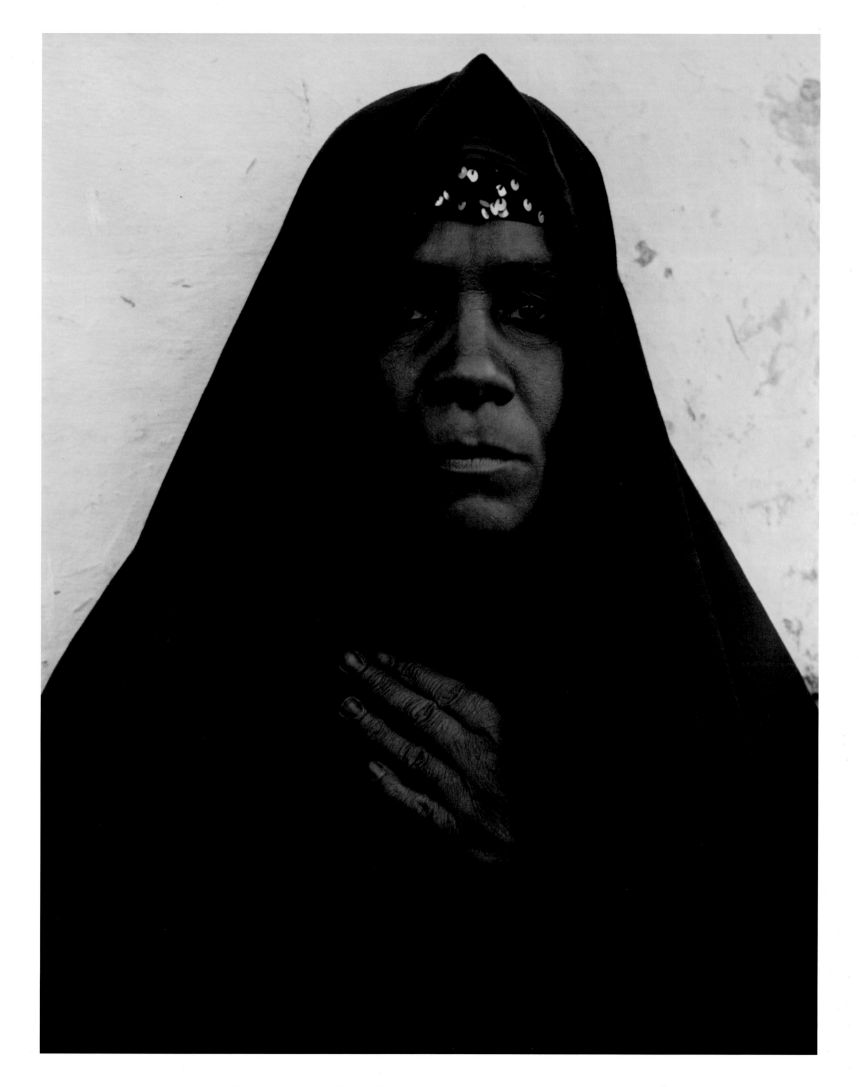

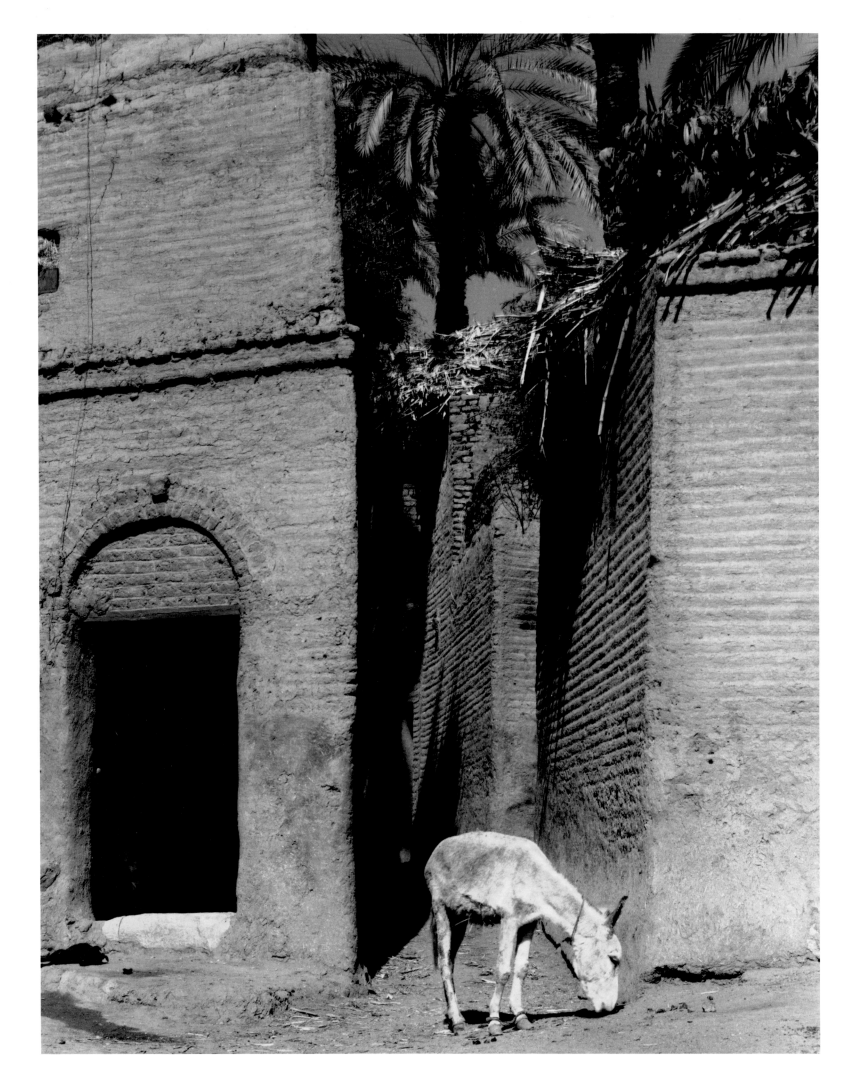

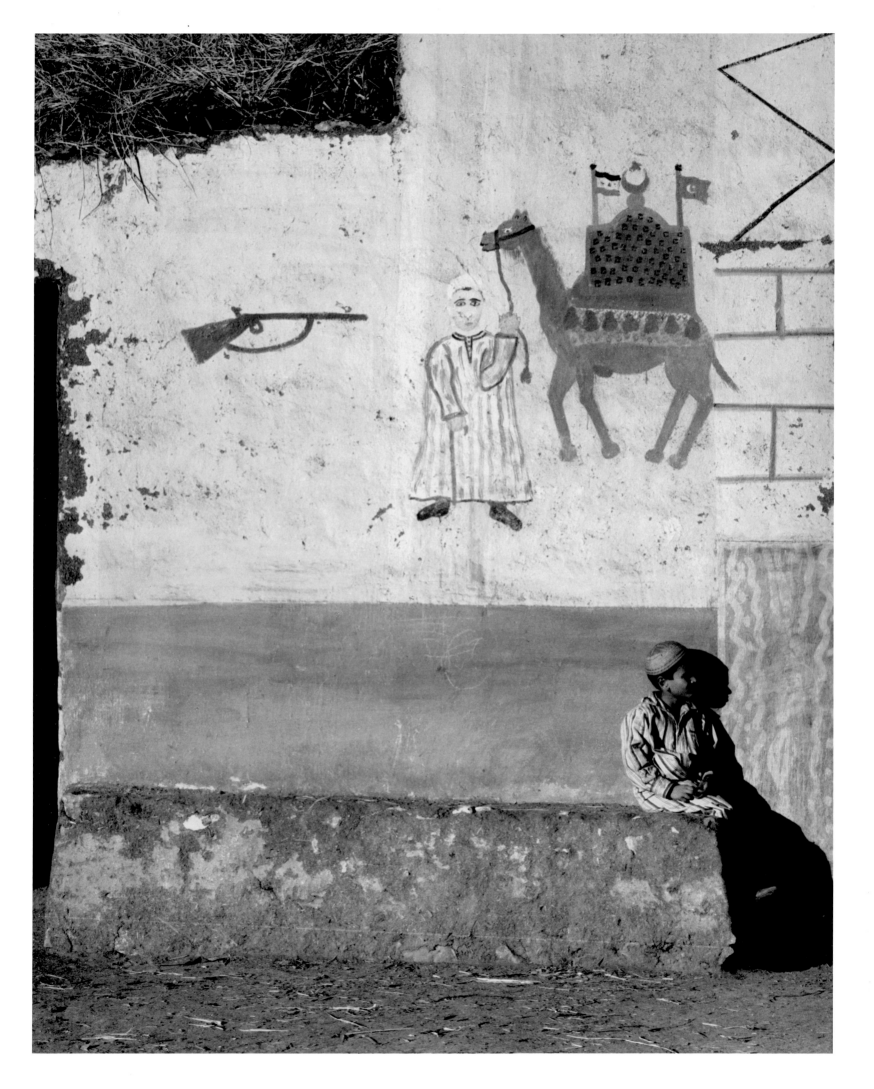

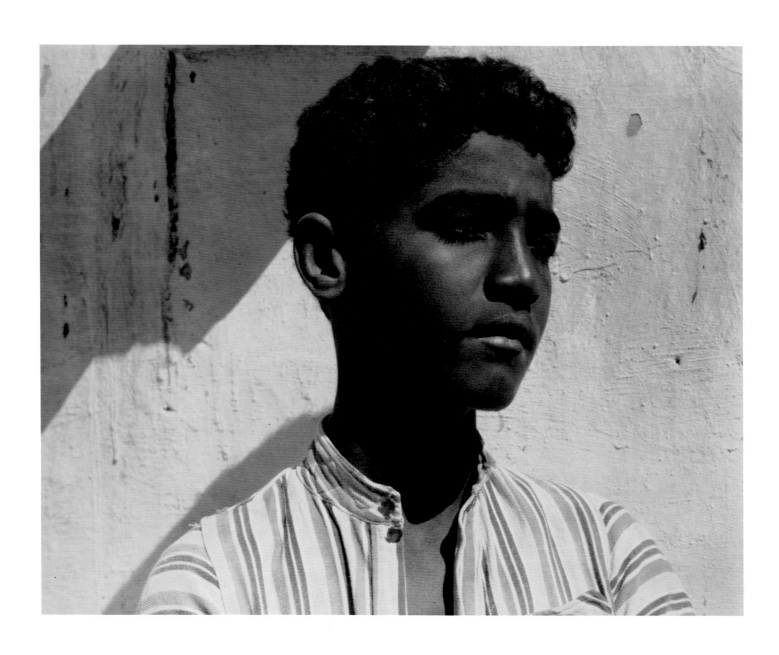

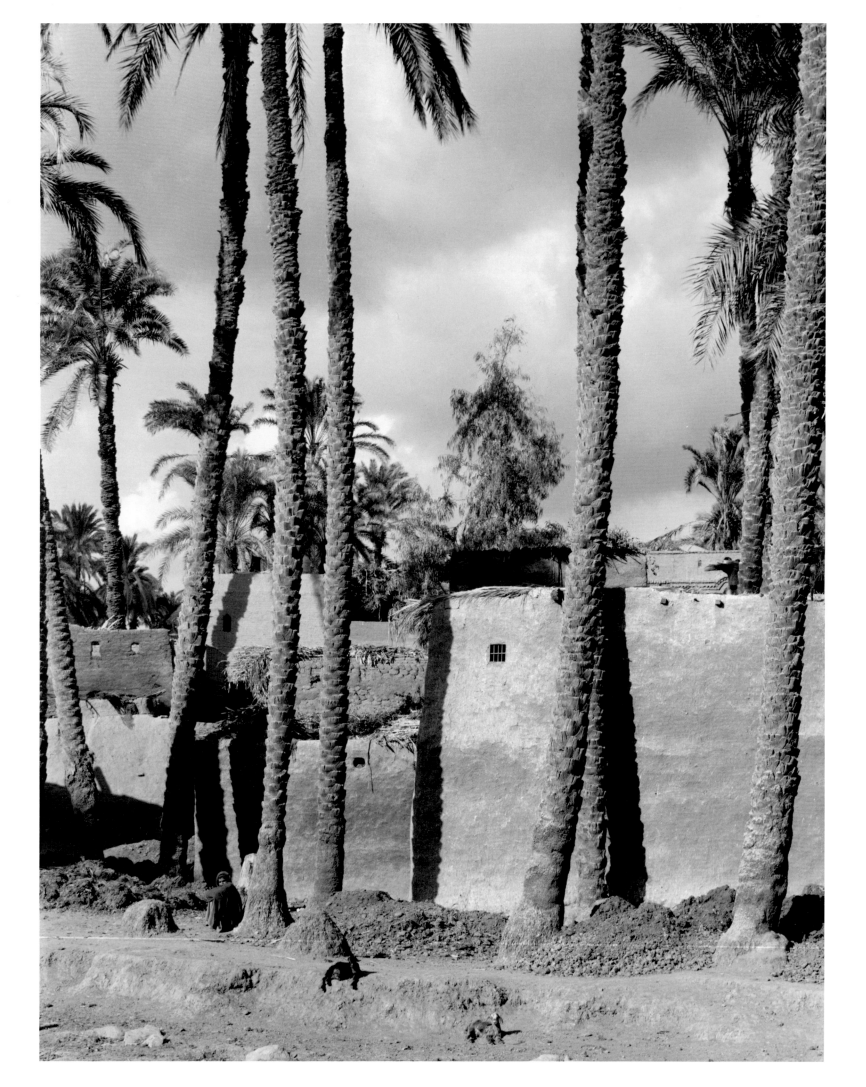

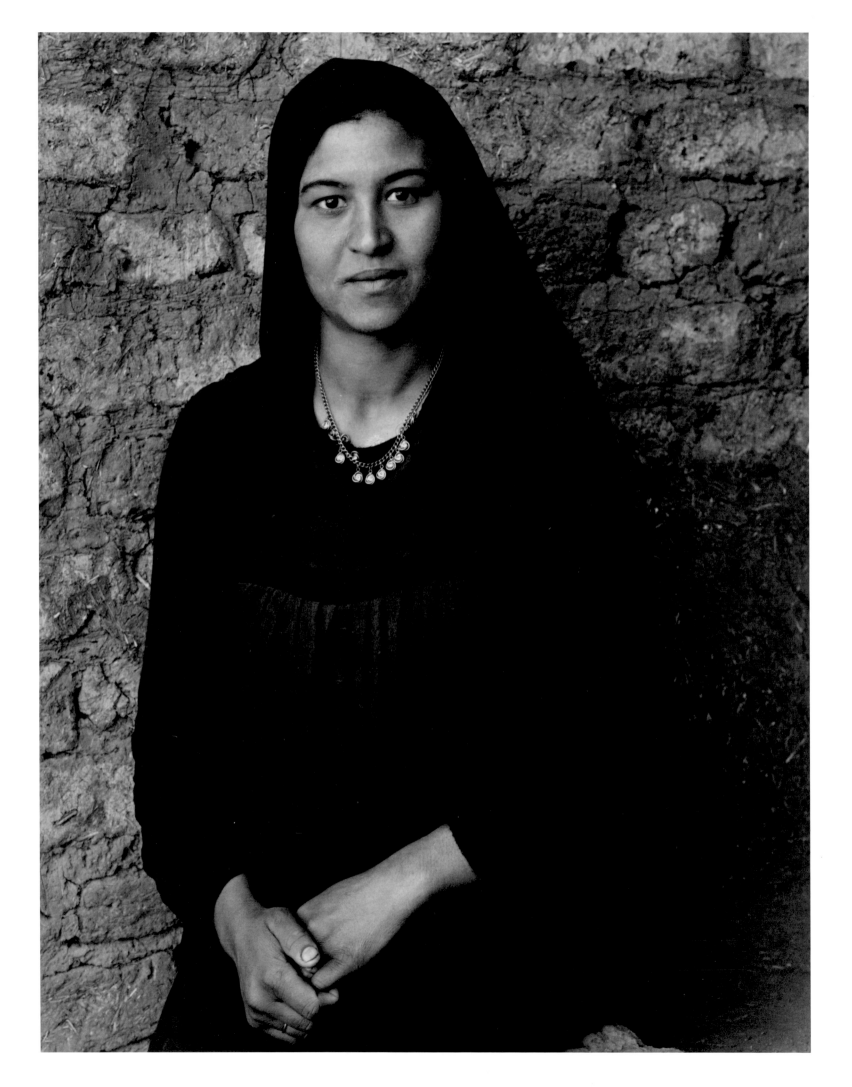

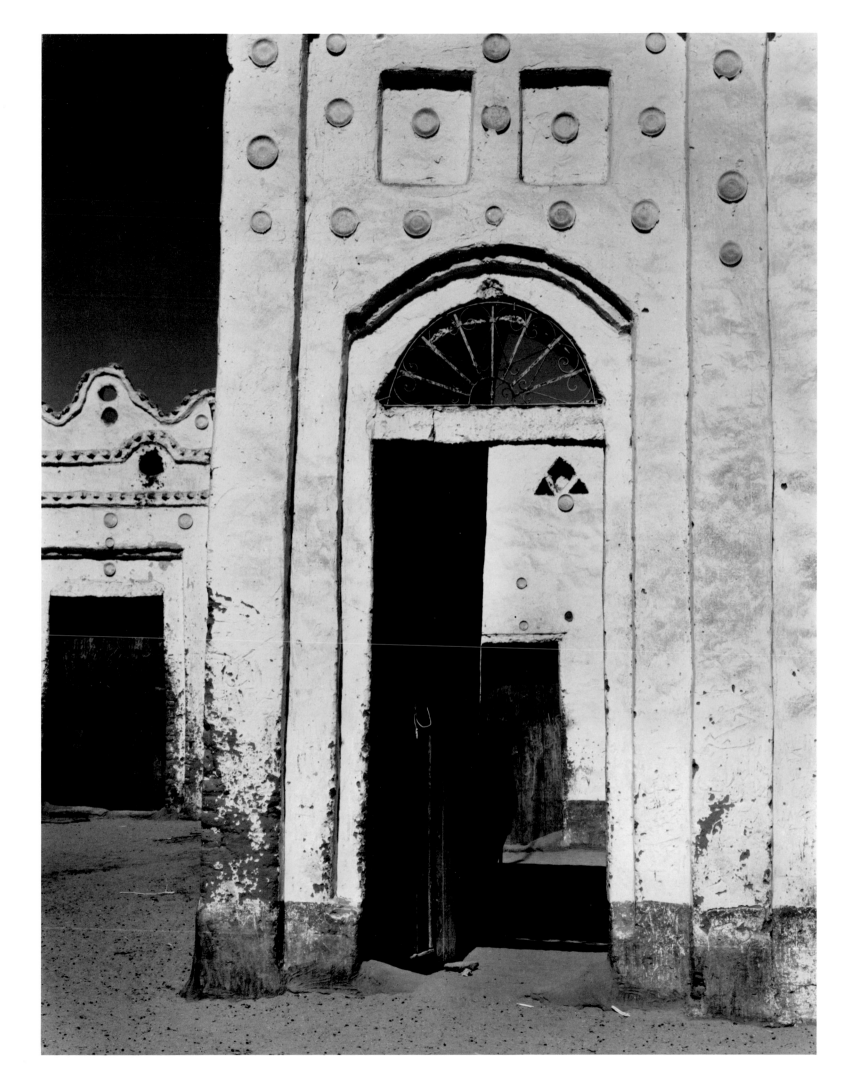

MOROCCO

Wherever the painter, writer, or photographer
may be working, he has, I think, a great responsibility
for truthfulness. But if the place and the material
chosen is a country which is not his own, that
responsibility is heavier. Here he is relatively a stranger.
He must come to know, to see, and to understand
what he sees with a great deal of humility and respect.
Otherwise what he does cannot be much more than
an impertinence. In the past, European artists have
come to America and tried to express the quality of
life there before they really knew what it was all
about. One may learn from such mistakes....

To know a land somewhat, its special character,
the qualities which make its individuality, the
temperament and life of its people is a process of
gradual absorption, of sympathetic perception....

What happens, I think, is that the cultural
treasures of the past lead one into the country itself,
to the country and people who at one time or
another produced them.... I arrive finally at the
smaller, the less known, but I think not less expressive,
aspects of life, in the landscape, the detail of a window,
above all in the people themselves. It is my hope to
find there what is explicit and implicit...that essential
character which is compounded of both past and
present. To find that, may be to arrive at the common
denominator which makes us all kin.

Paul Strand in *U.S. Camera*, 1955

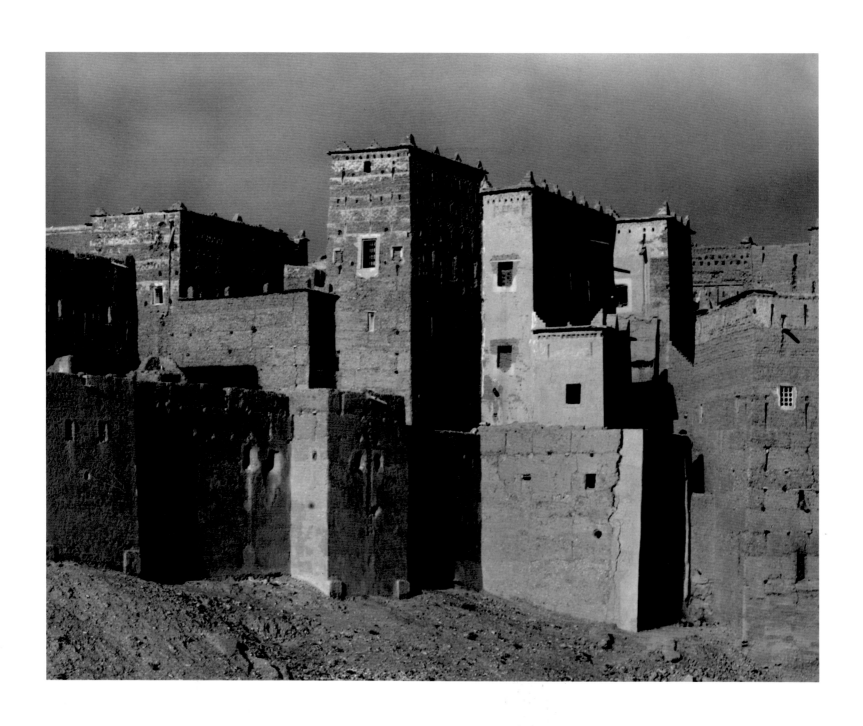

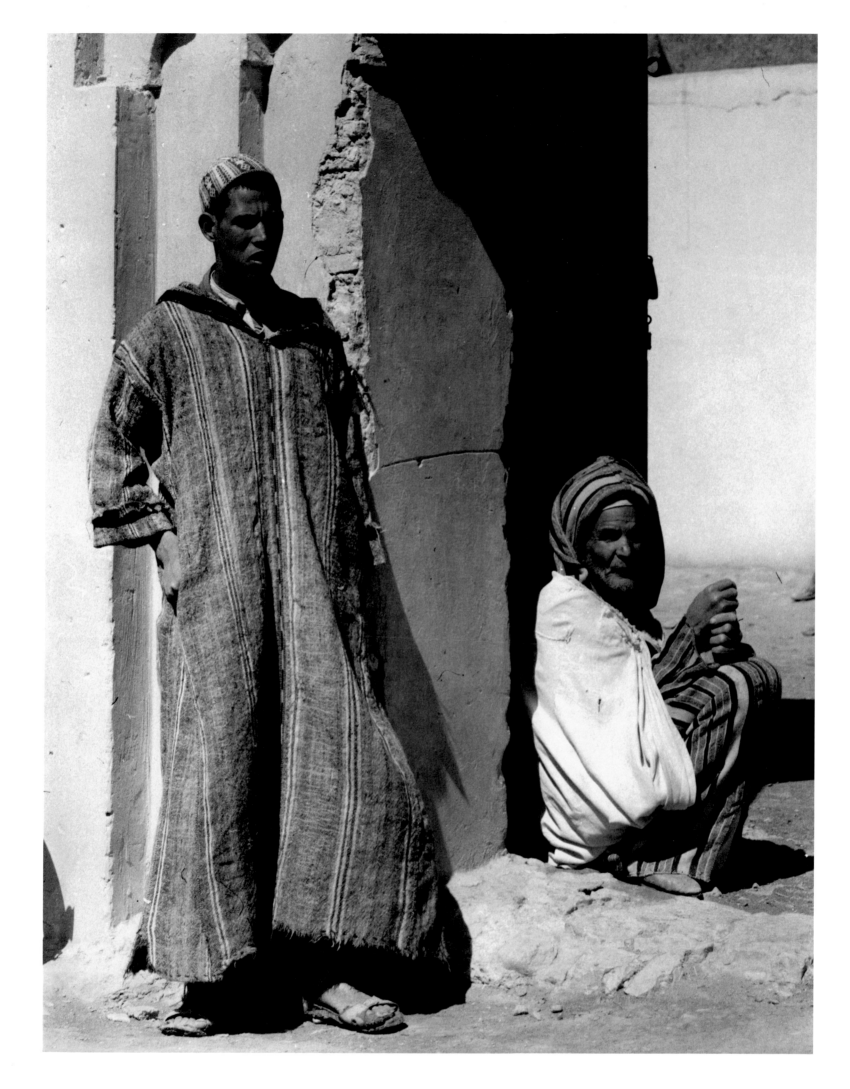

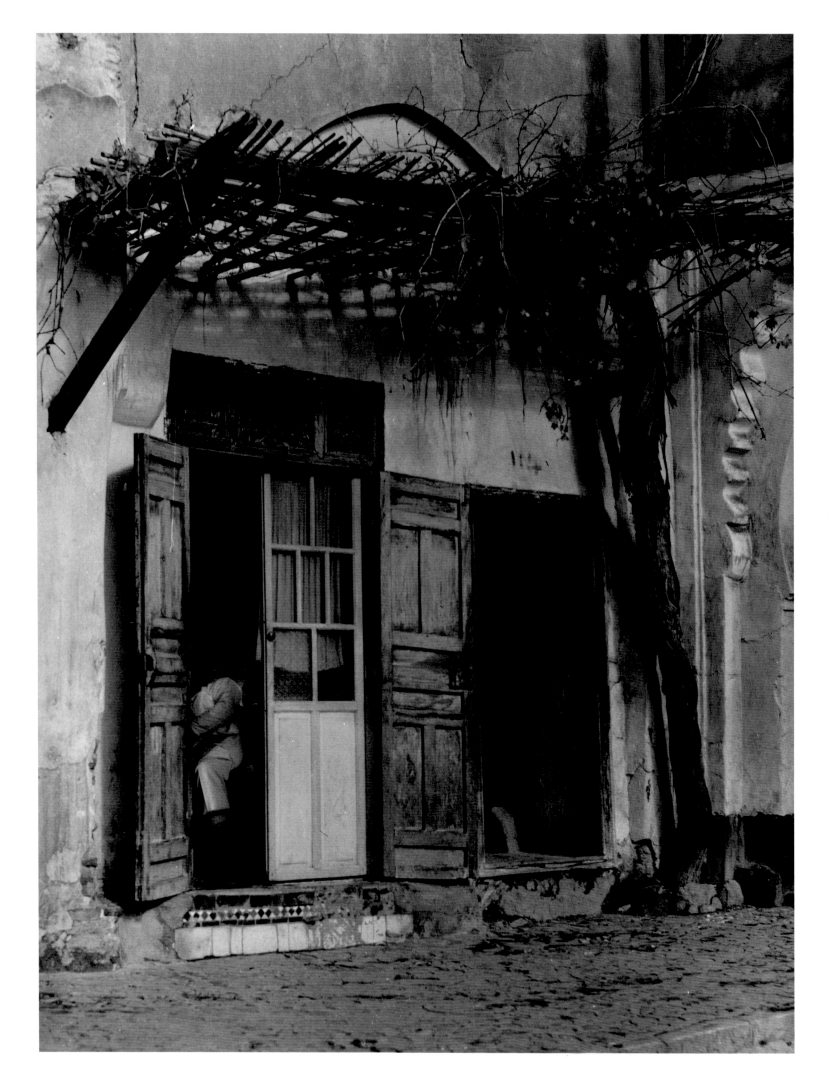

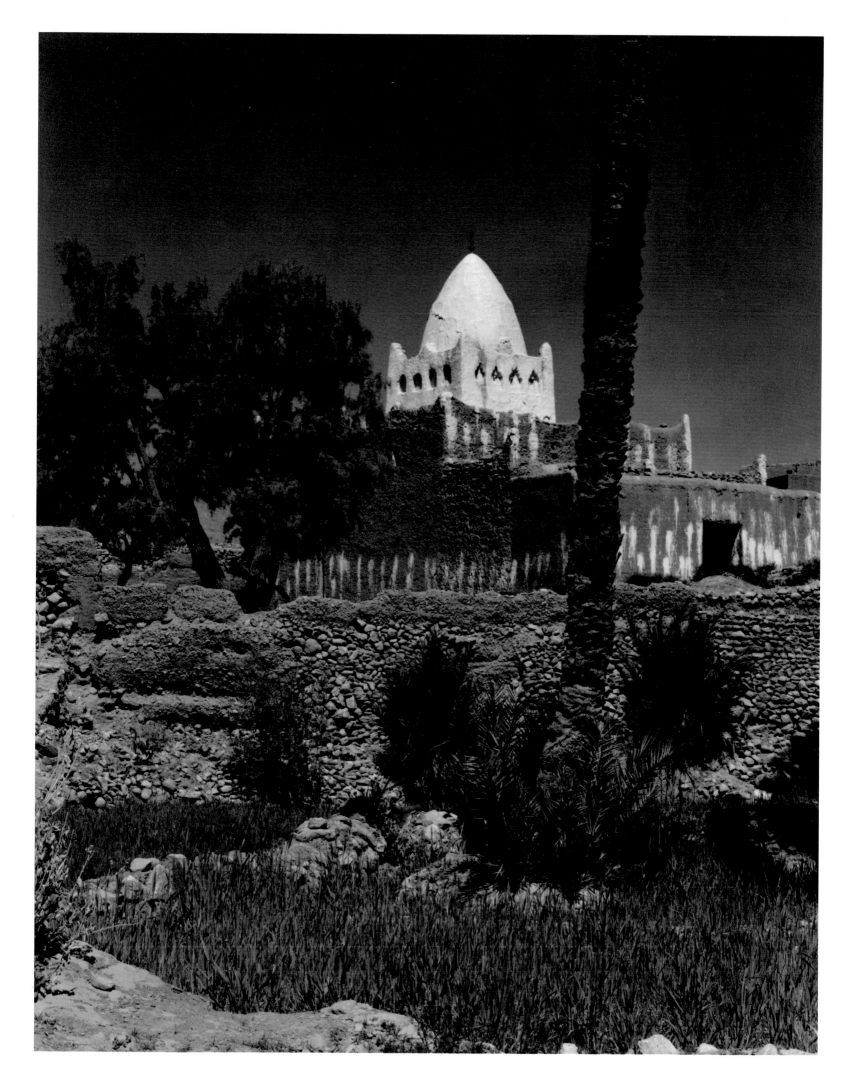

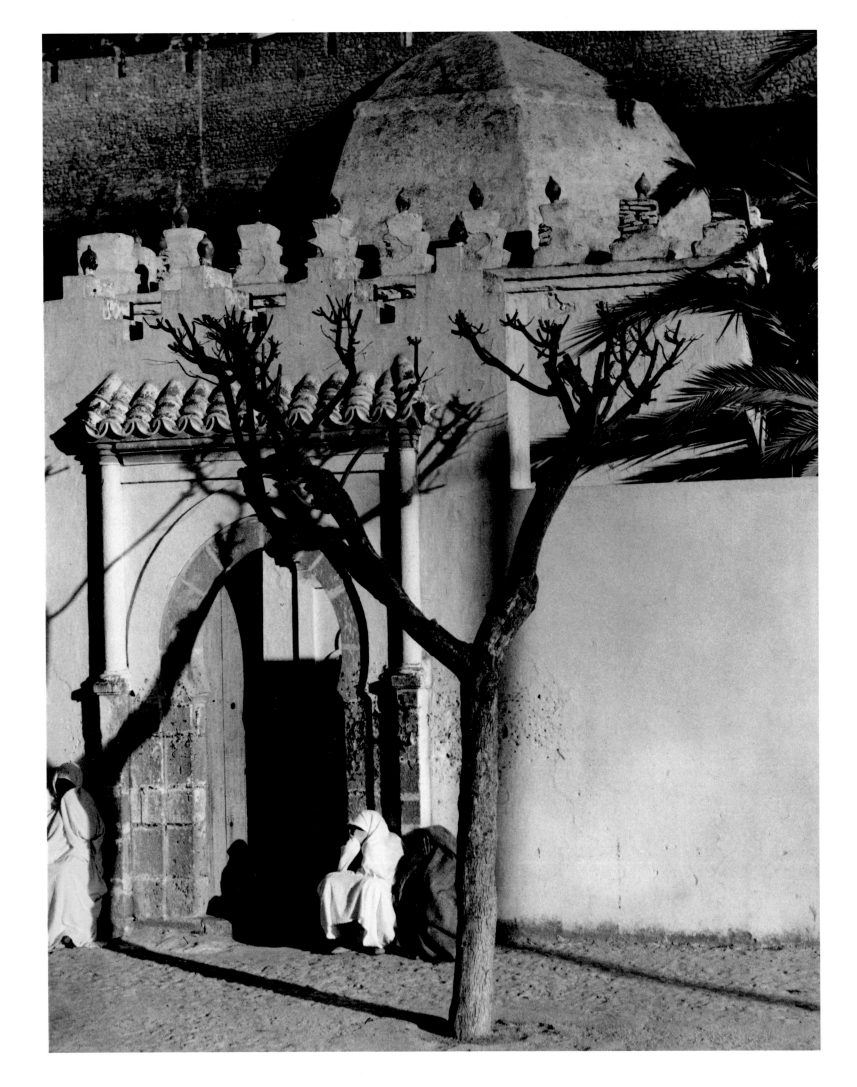

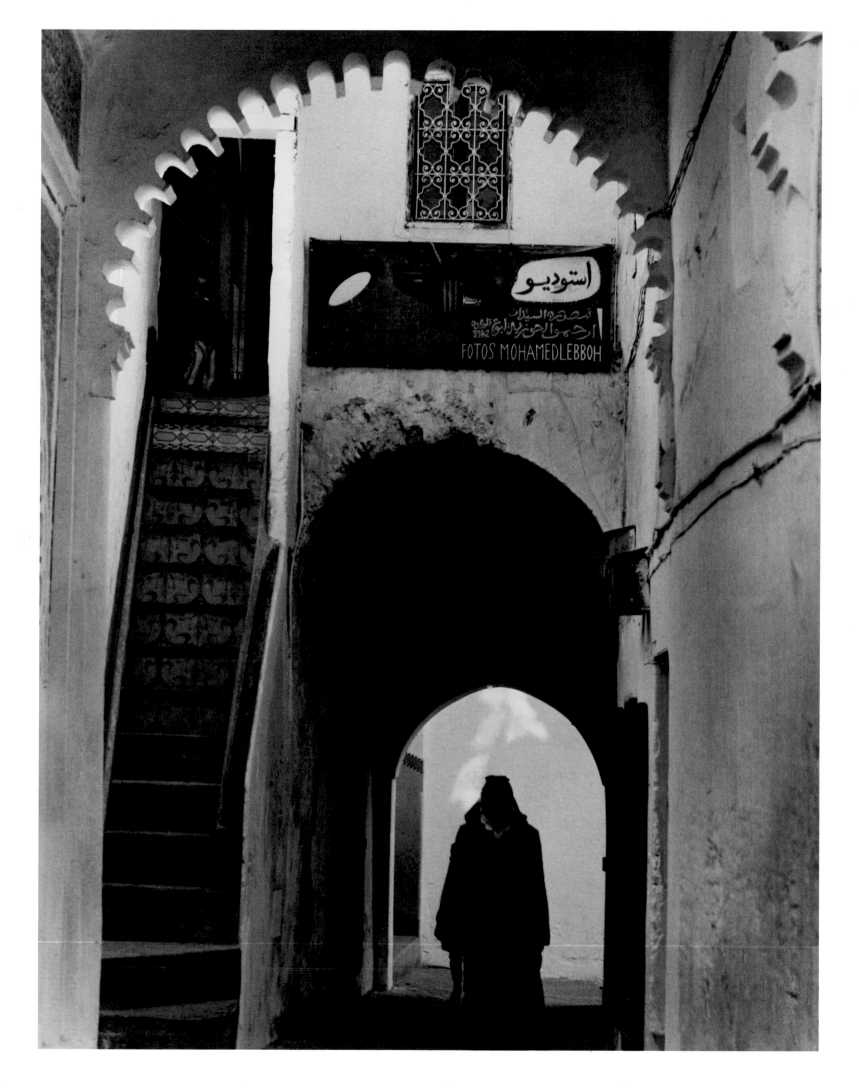

GHANA

Some time ago, Paul Strand began to think about making a portrait of Africa and its people. Other peoples had already known his penetrating candor and received his stern, affectionate gaze—among them the Mexicans and New Englanders, and in Europe the Italians, the French and the islanders of Scotland's Celtic fringe. He had also worked in Egypt and Morocco.

Now he wanted to go beyond the Sahara and find, if possible, a group of subjects that would enable him to explore and celebrate the peoples who live there in great diversity but also within an underlying unity of culture. This would be a portrait of a specific group, yet a portrait whose specificity might characterize the sub-Saharan world as a whole.

But could it be done? In setting himself this problem, Strand was being true to his lifelong humanism. He has remained among those who believe that what unites people is always more than what divides them, even if many fail to understand this, and that a future Africa, for example, will think it as reasonable and useful to recognize its own organic unity as that of any other major but united portion of the globe.

From the Introduction to *Ghana: An African Portrait,*
by Basil Davidson

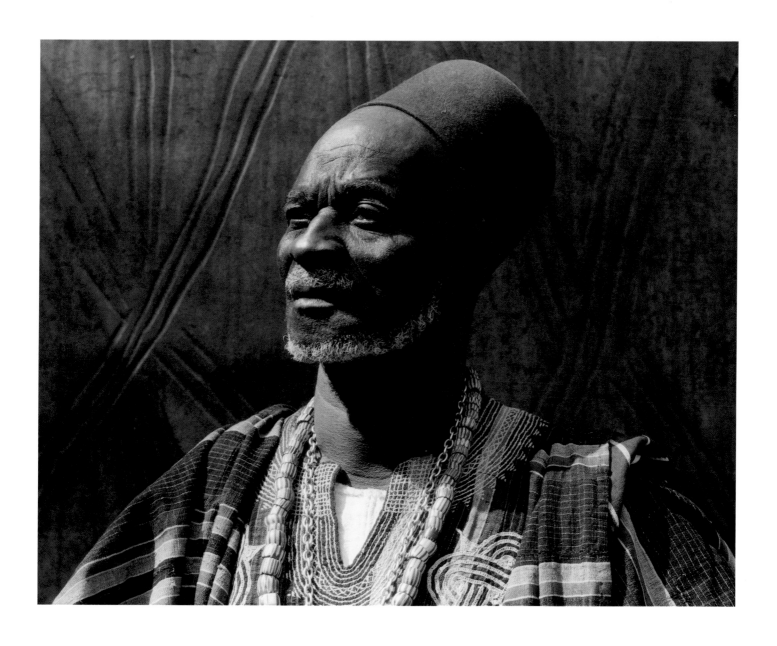

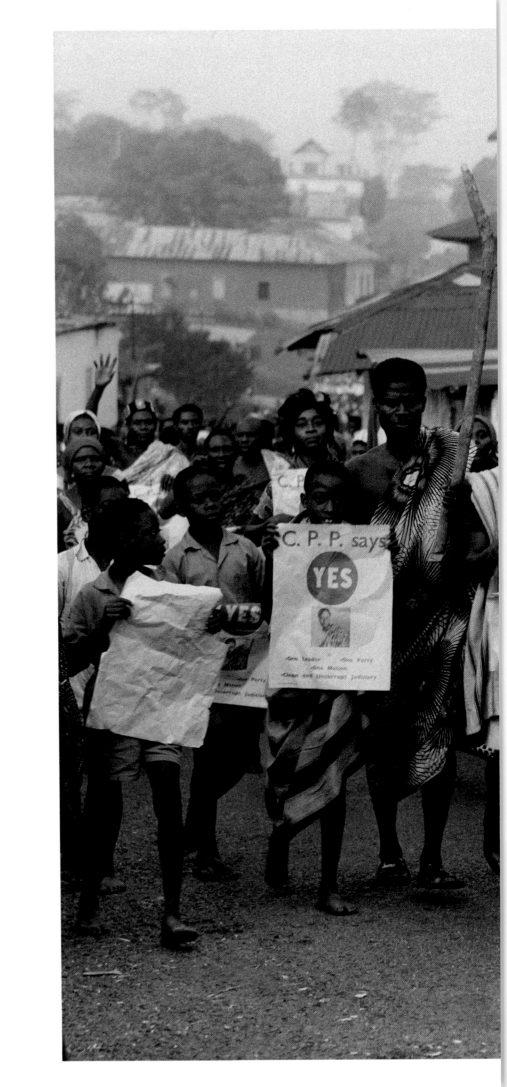

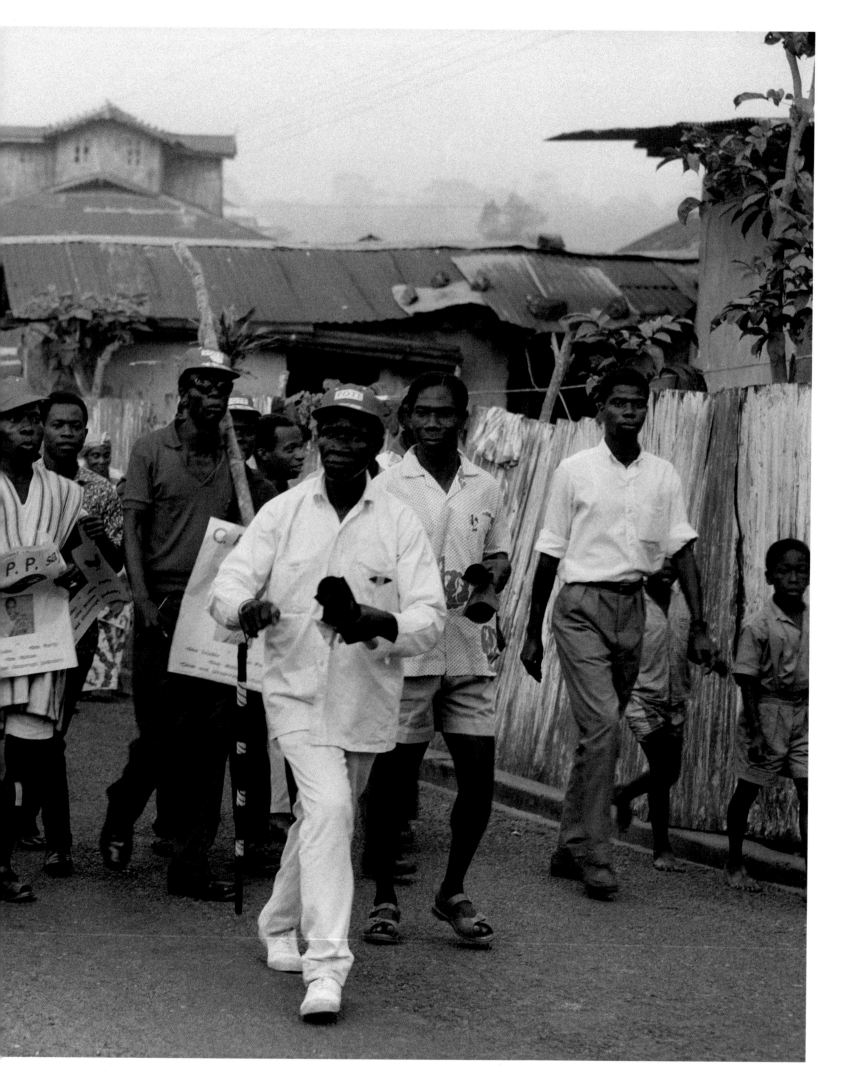

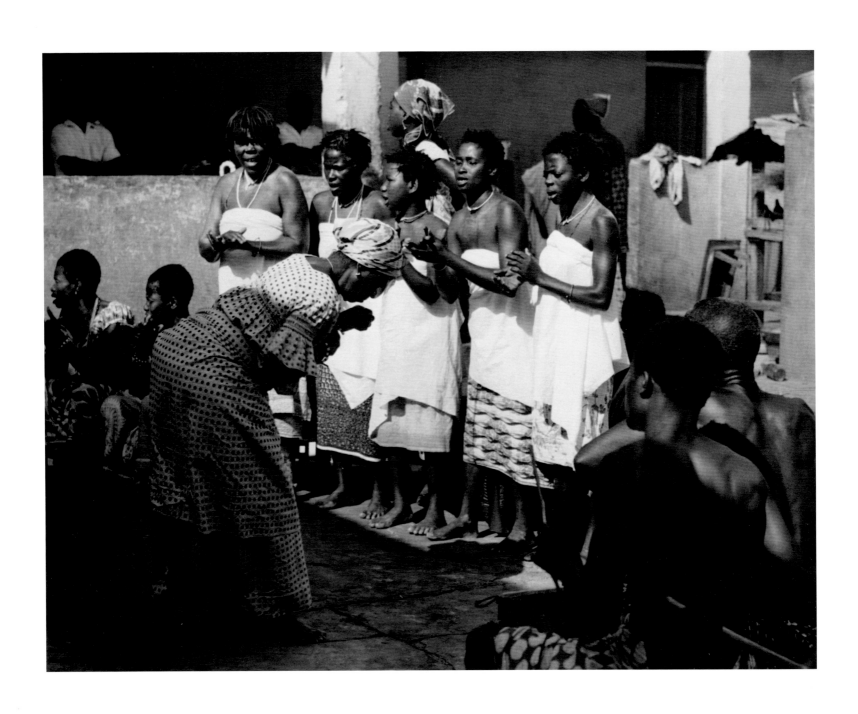

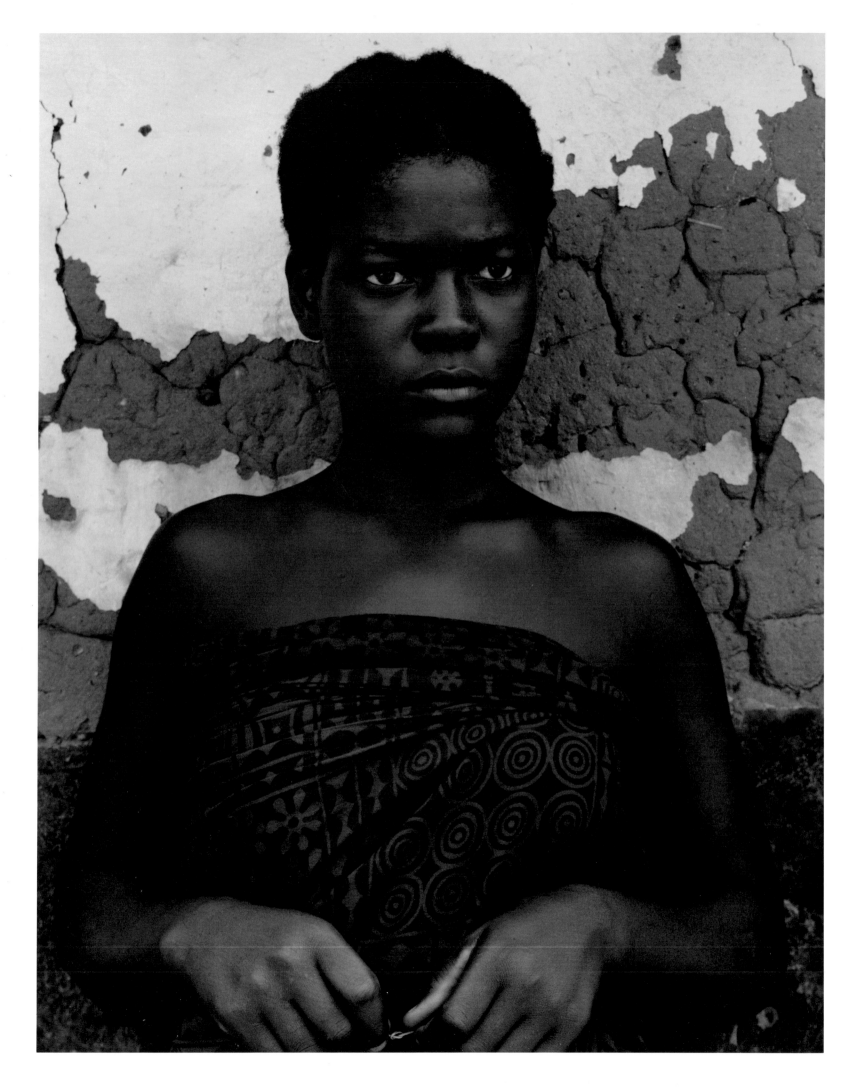

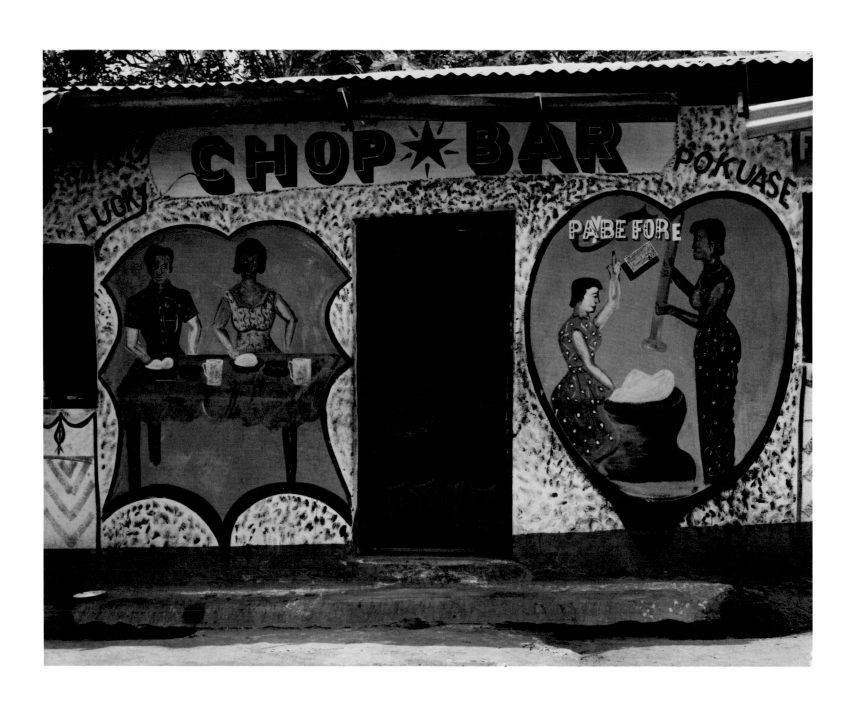

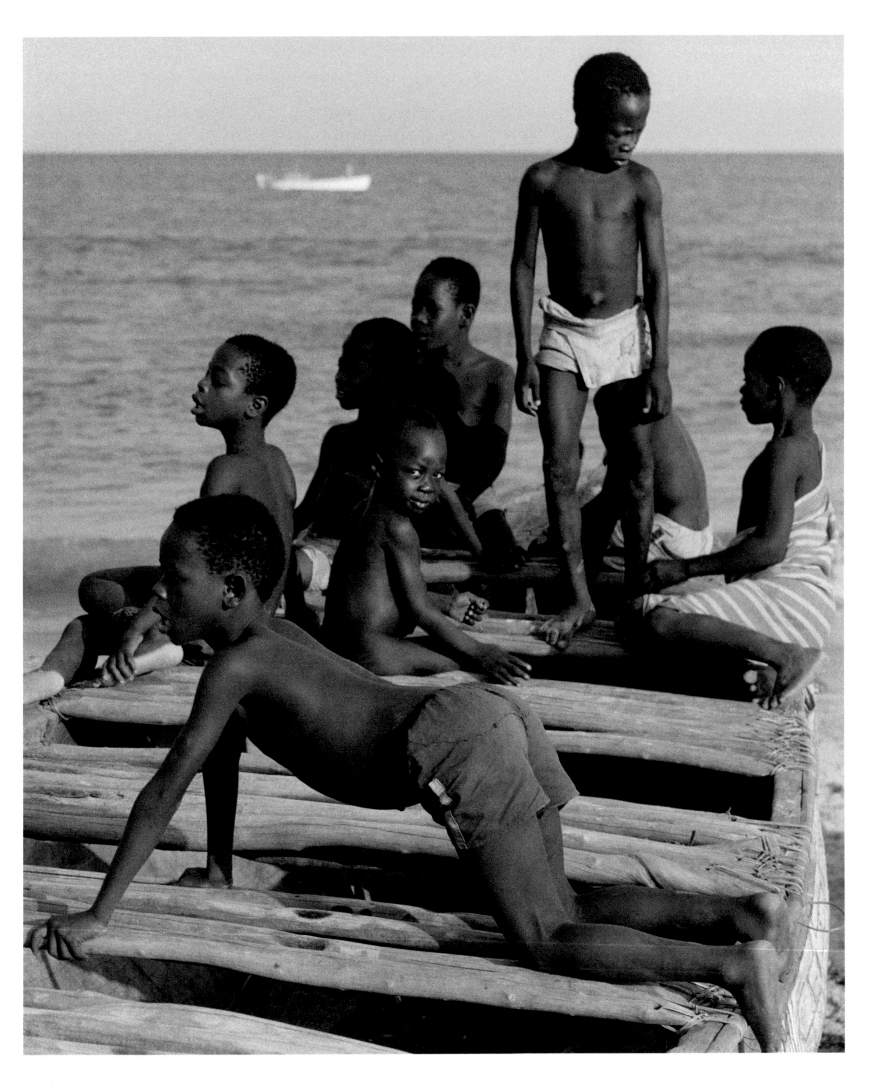

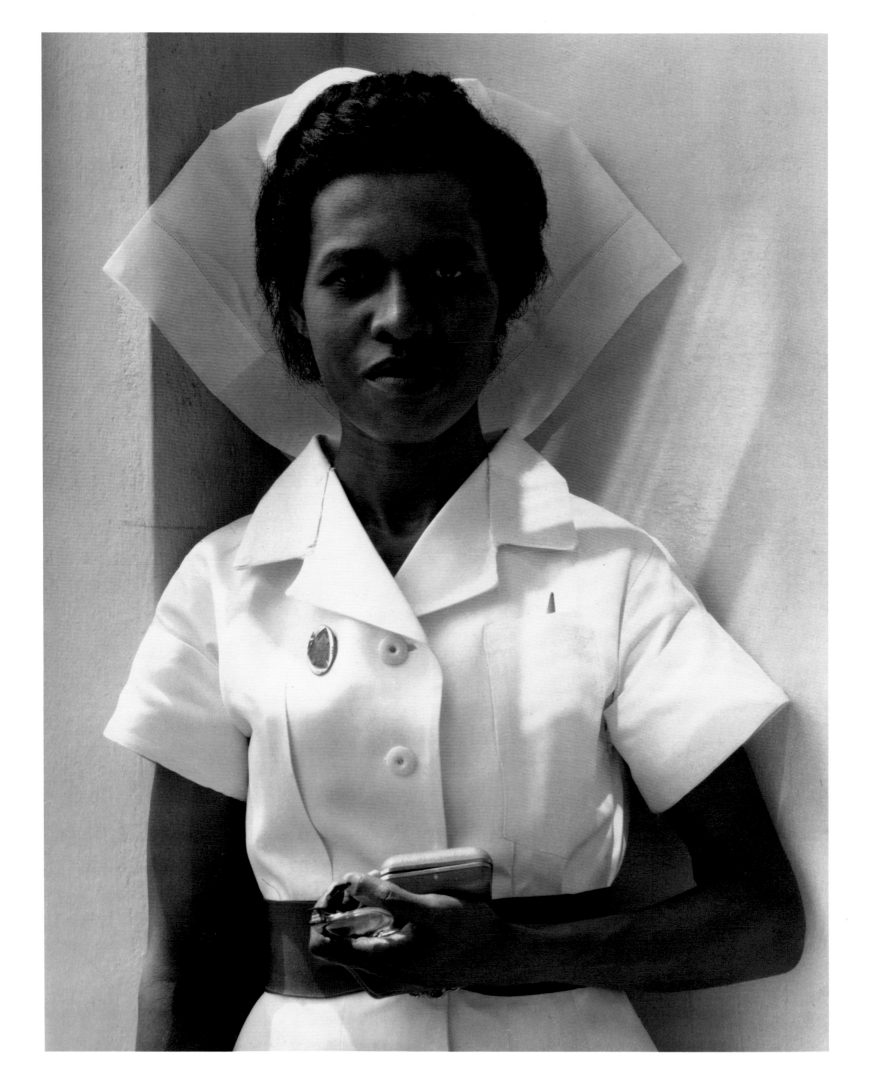

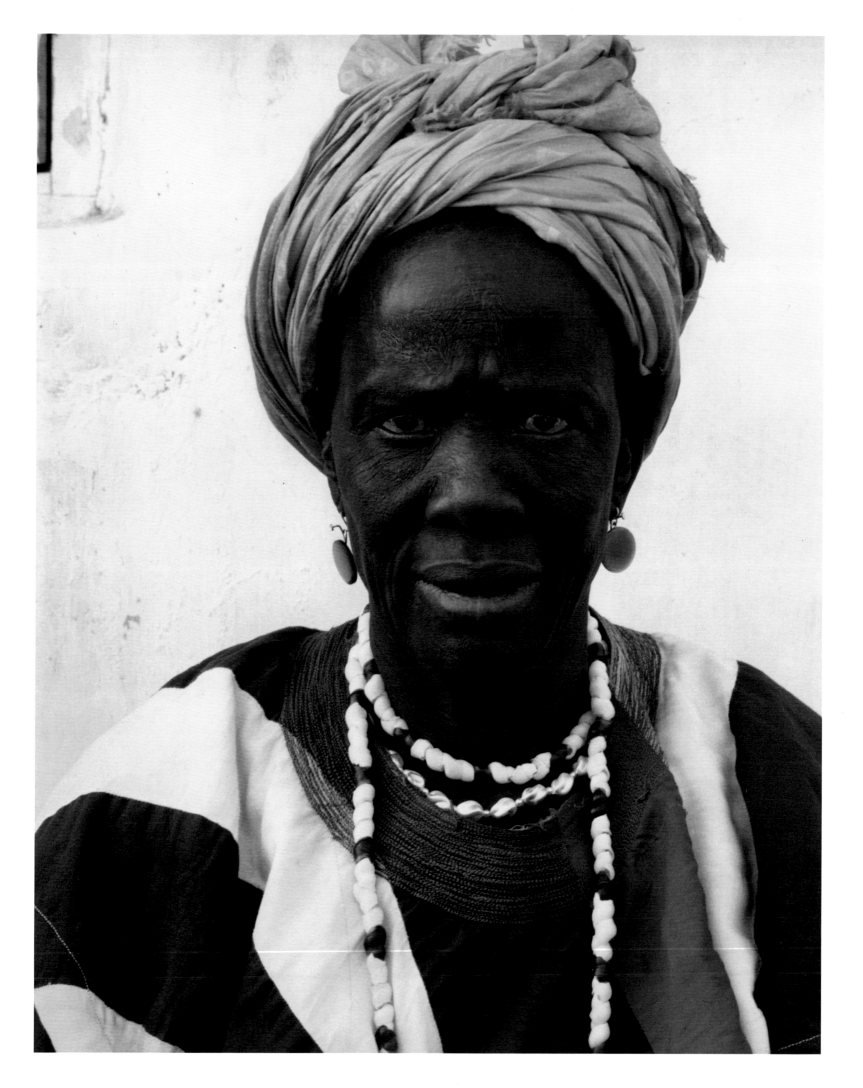

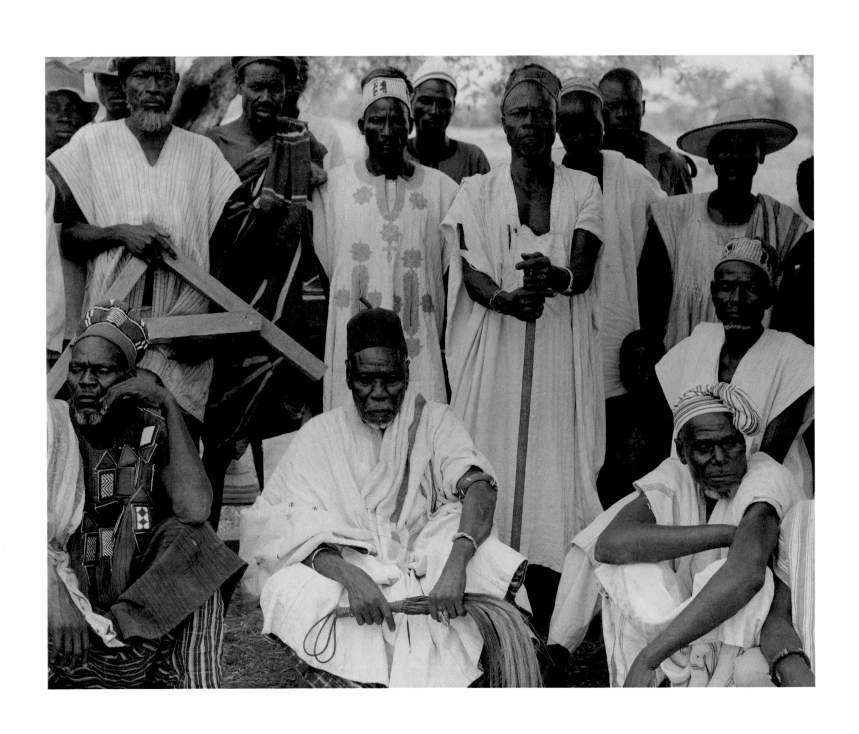

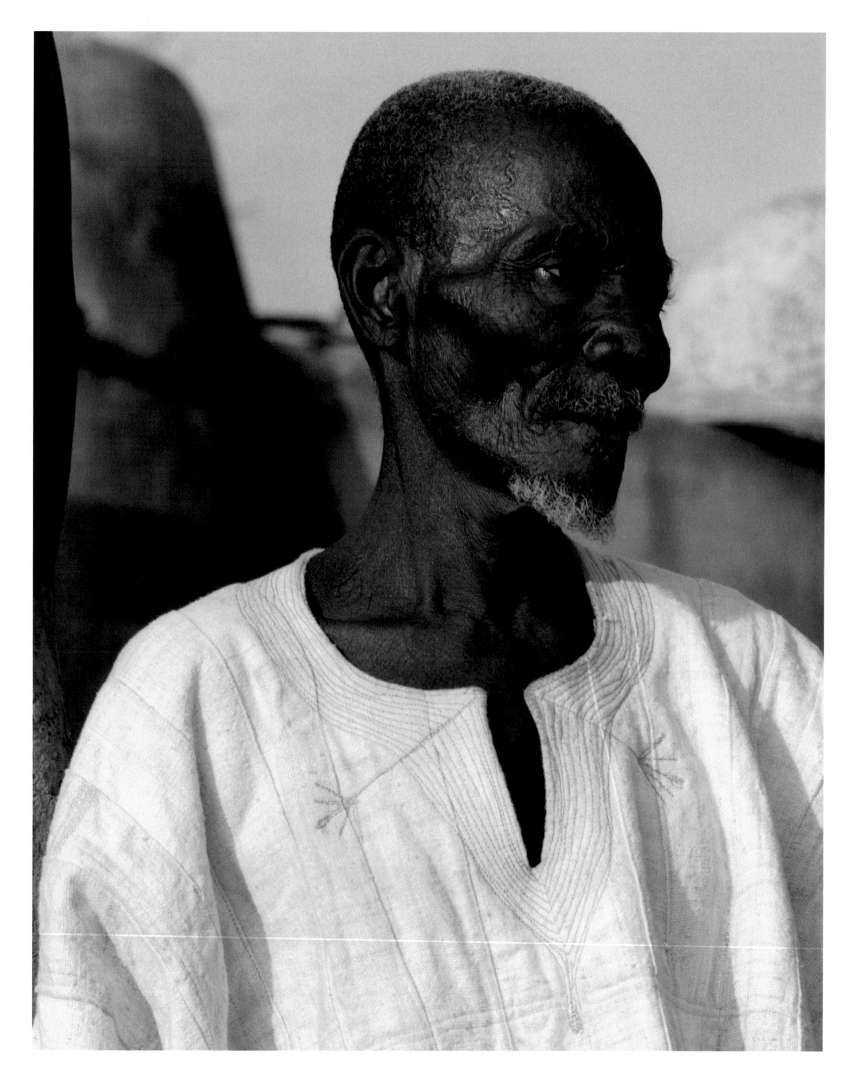

ROMANIA

It was a fine experience. For many years I wanted to expand the early work with machinery to large machines; I made up my mind that I wanted to photograph as much industry as possible....

I made a list of all the places I wanted to go... a petrochemical plant, a steel mill, a ship building site, a glass factory. I did a lot of things in Romania that I was *never* able to do anywhere else. There may never be a book [of the photographs], but I was able to work out these problems which had concerned me from the beginning....

I found all the things I discovered early in life useful, either as method or idea. I never discarded them; they always were valuable to me.

From "Completing the Circle,"
an interview with Paul Strand
by Naomi Rosenblum

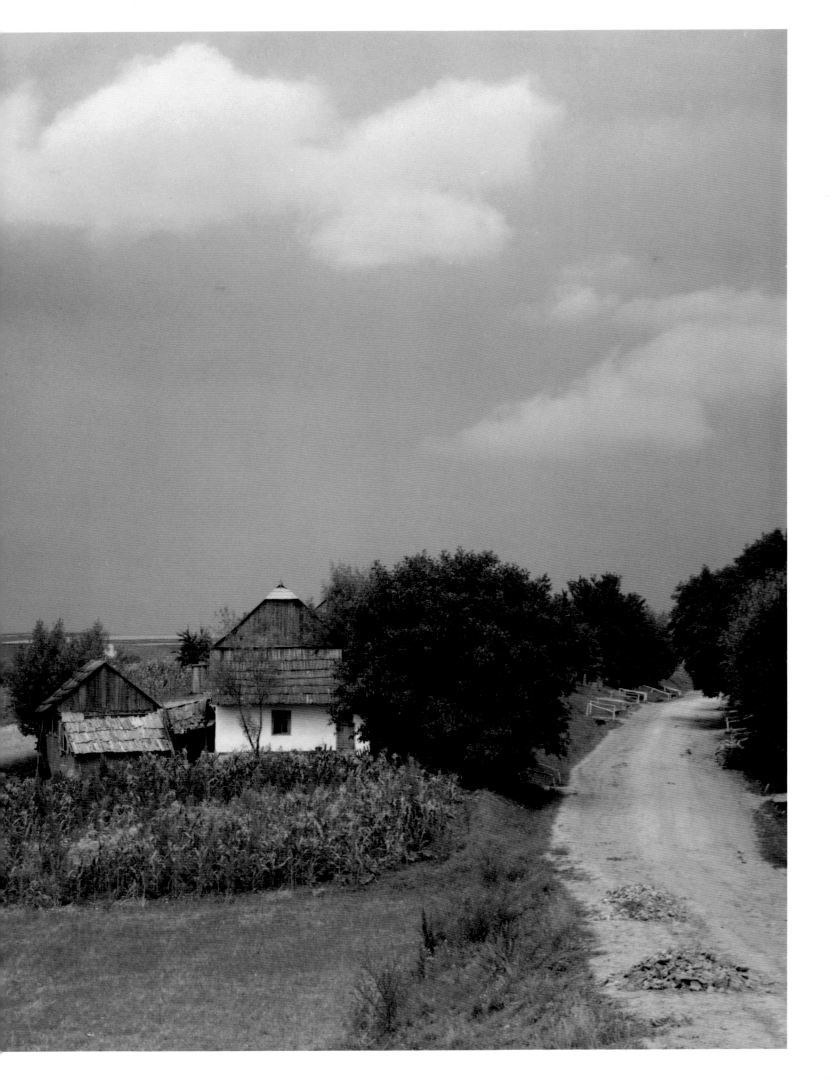

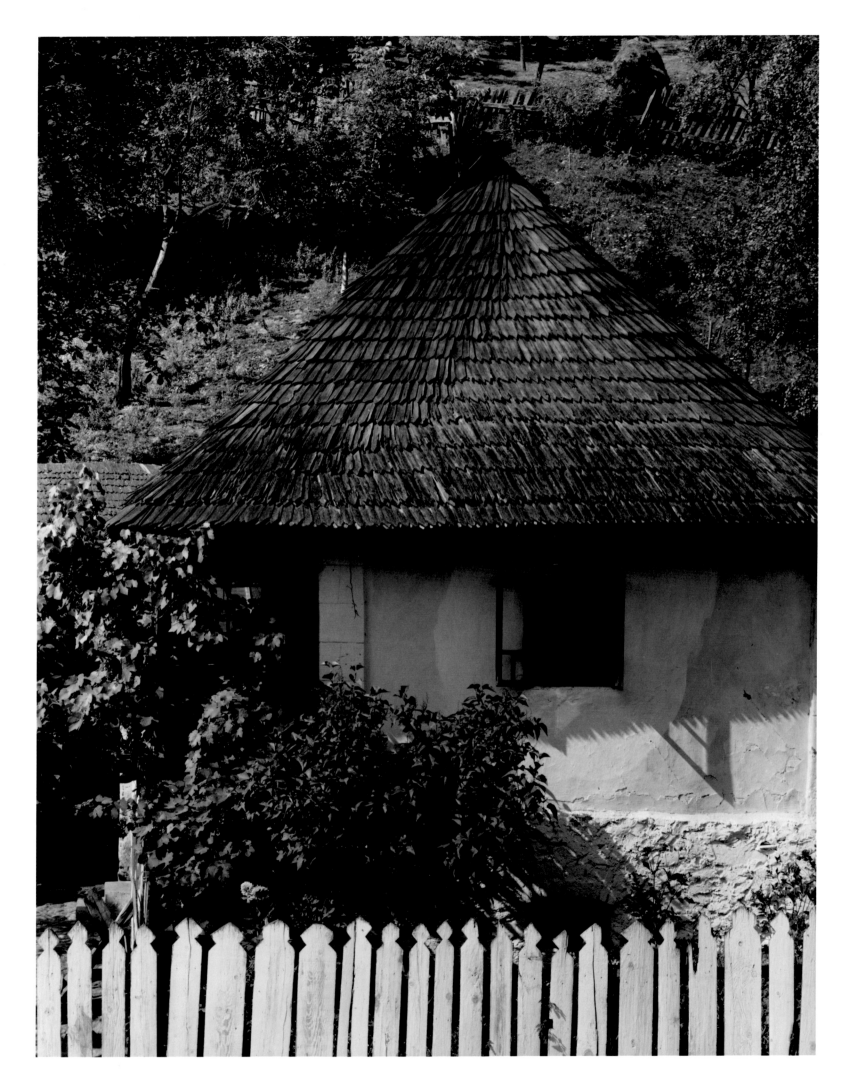

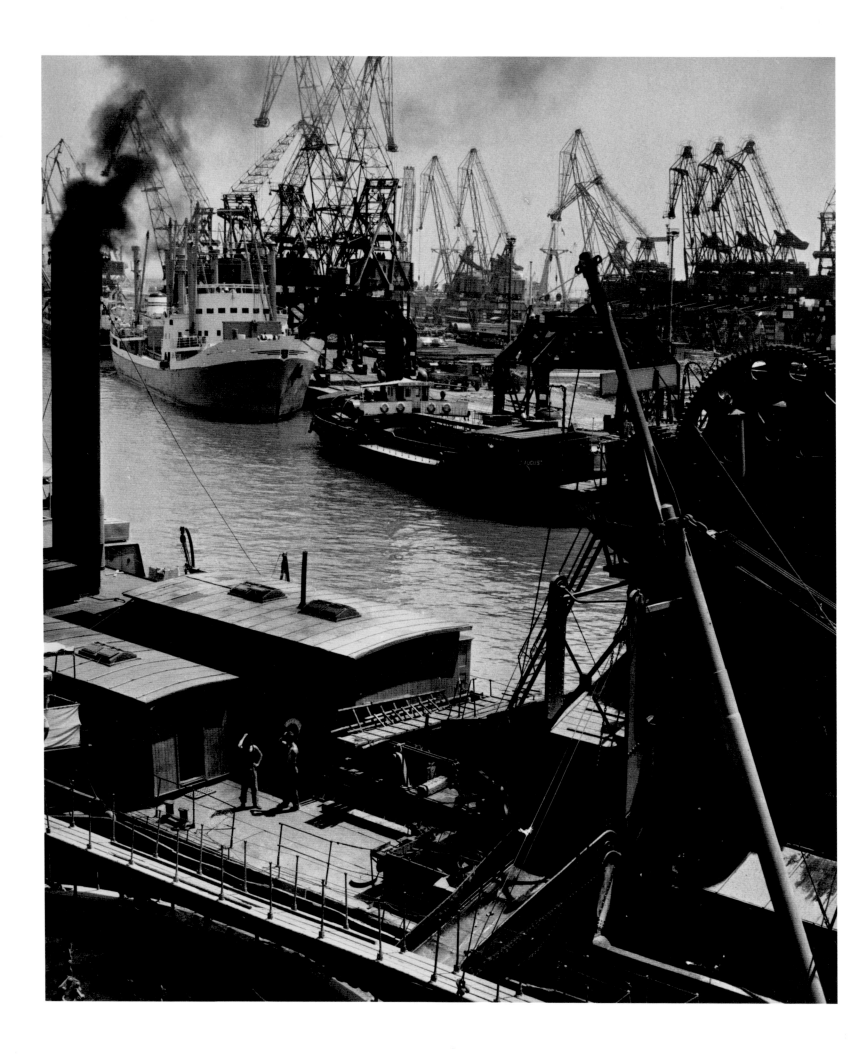

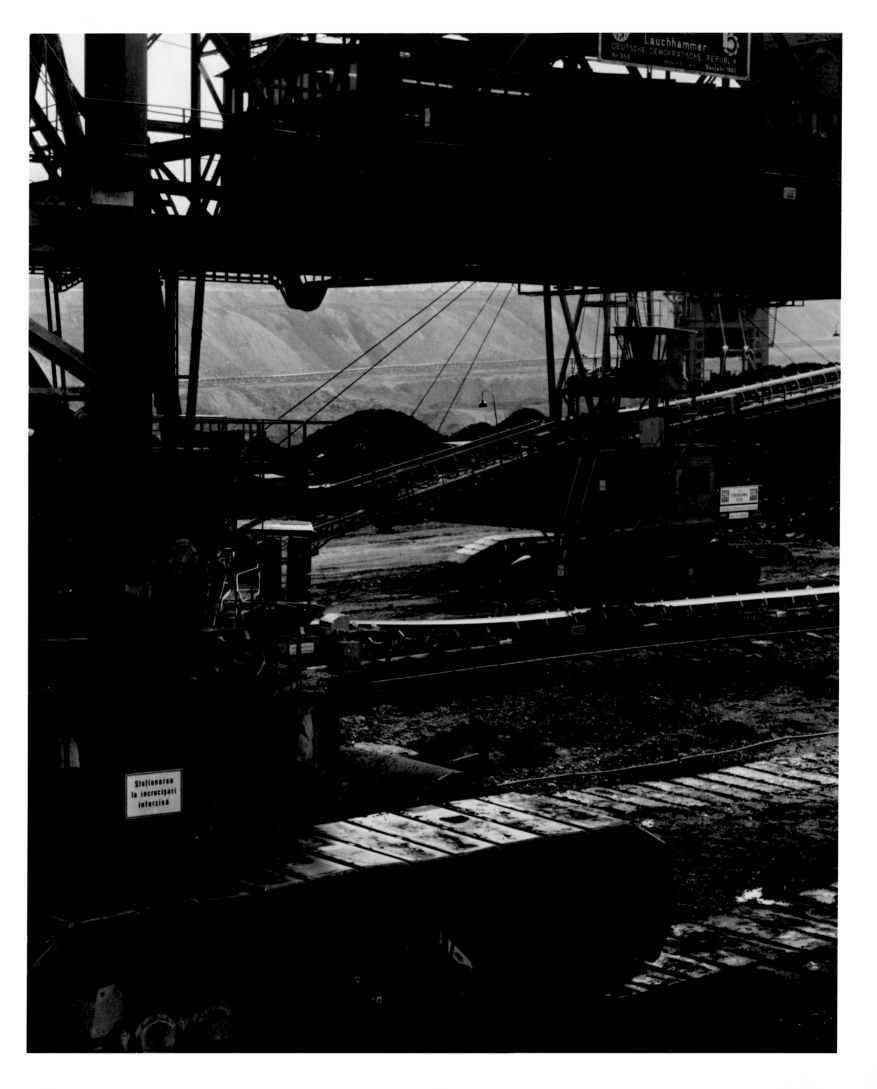

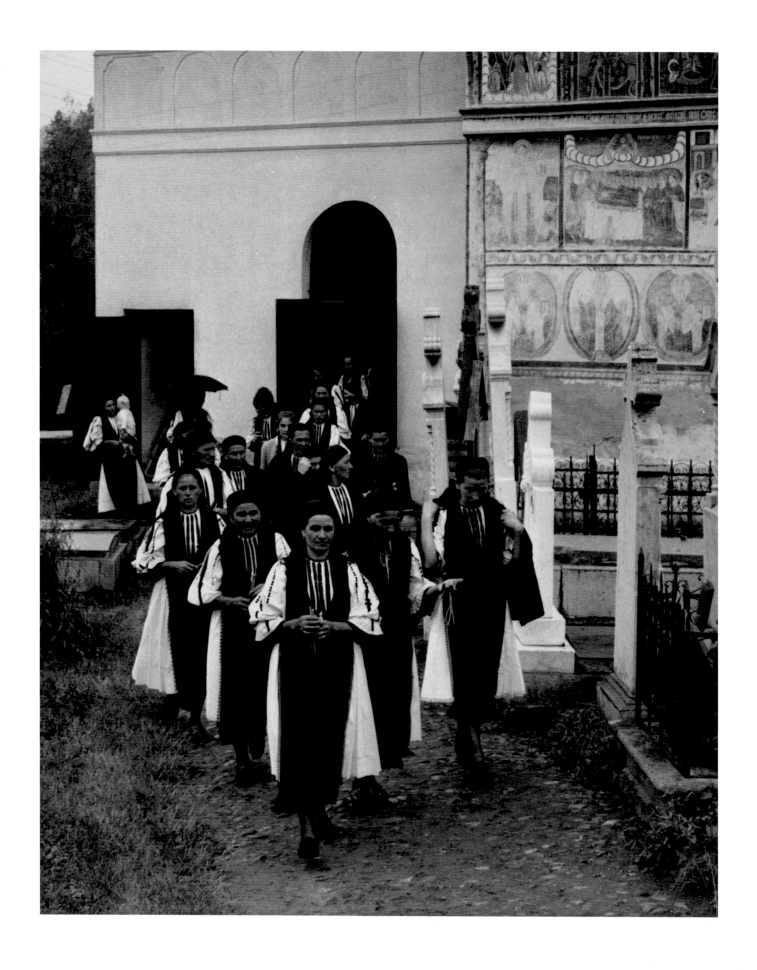

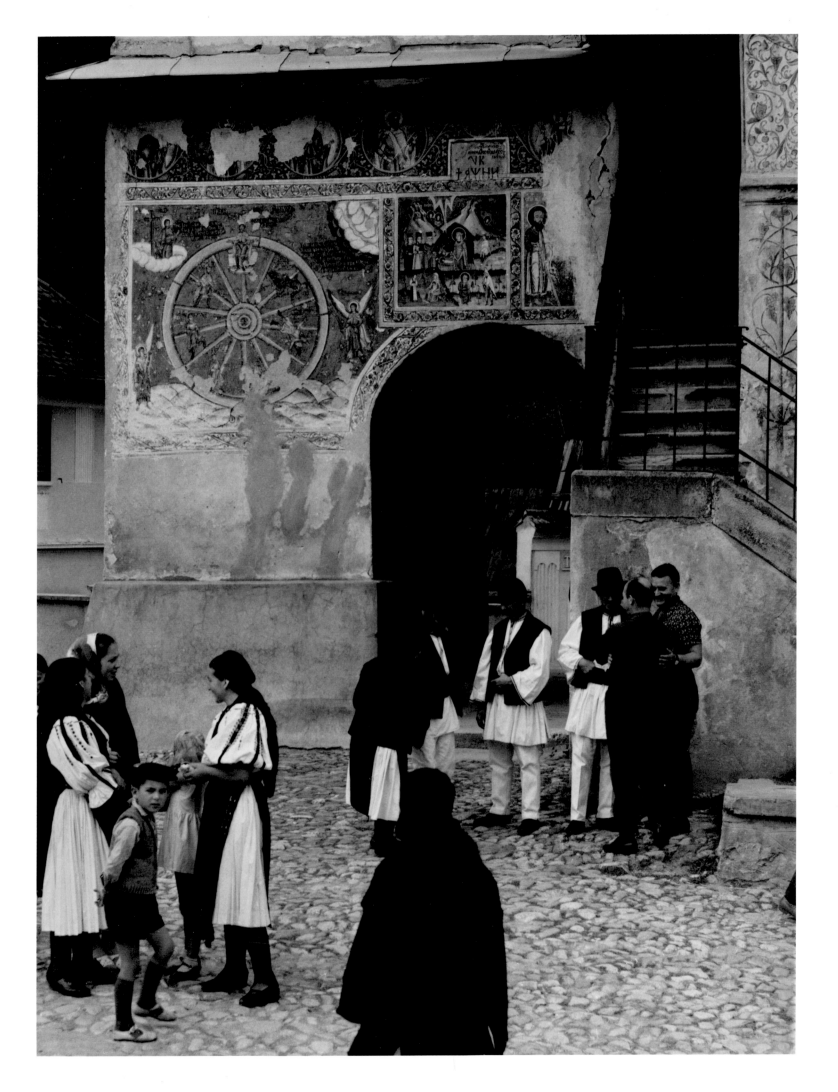

CAPTIONS

2. *Fall in Movement*, the Garden, Orgeval, 1973

5. *The Happy Family*, Orgeval, 1958

6. *Yellow Vine and Rock Plants*, the Garden, Orgeval, France, 1960

24. *Bombed Church*, Host, Moselle, Lorraine, France, 1950

26. *L'Armençon, Cuzy*, Burgundy, France, 1951

27. *Cross in the Wood*, Sainte-Mère, Gers, near the Loire Valley, France, 1951

28. *Haying*, Haut Rhin, France, 1950

30. *Portrait*, Gondeville, Charente, France, 1951

31. *Young Boy*, Gondeville, Charente, France, 1951

32. *Café du Commerce*, Corbigny, Nièvre, Burgundy, France, 1950

34. *M. Pelletier*, Gondeville, Charente, France, 1951

35. *Shop*, Le Bacarès, Pyrenées-Orientales, France, 1950

36. *Old Fisherman*, Douarnenez, Brittany, France, 1950

38. *White Shutters*, Brittany, France, 1951

39. *Levens (Narrow Village Street)*, Alpes-Maritimes, Provence, France, 1950

40. *Georges Braque*, Varengéville, France, 1957

41. *Door of the Clog Maker's Shop*, Chalmont, Ain Region, France, 1950

42. *The Camargue*, near Stes-Maries-de-la-Mer, France, 1951

45. *Tailor's Apprentice*, Luzzara, Italy, 1953

46. *Market Day*, Luzzara, Italy, 1953

48. *The Poor House*, Luzzara, Italy, 1953

49. *The Post Mistress and Daughter*, Luzzara, Italy, 1953

50. *The White Barn*, Luzzara, Italy, 1953

51. *The Scythes*, Luzzara, Italy, 1953

52. *White Horse*, Luzzara, Italy, 1953

53. *House*, near Rome, Italy, 1952

54. *Cut Grass*, Luzzara, Italy, 1953

55. *Portrait*, Luzzara, Italy, 1953

56. *The Family*, Luzzara, Italy, 1953

58. *Hat Factory*, Luzzara, Italy, 1953

59. *The Mayor's Mother*, Luzzara, Italy, 1953

60. *The Beach*, Acitrezza, Sicily, 1954

62. *Workers' Bicycles*, the River Po, Luzzara, Italy, 1953

63. *Trees, Winter*, near the River Po, Italy, 1952

64. *Tir A'Mhurain*, South Uist, Hebrides, 1954

66. *Bent Grass*, The Machair, South Uist, Hebrides, 1954

67. *Archie MacDonald*, South Uist, Hebrides, 1954

68. *Murdock MacRury*, South Uist, Hebrides, 1954

69. *Harvest*, South Uist, Hebrides, 1954

70. *Margaret MacLean*, South Uist, Hebrides, 1954

71. *Window*, Milton, South Uist, Hebrides, 1954

72. *Doorway*, Stoneybridge, South Uist, Hebrides, 1954

73. *Window*, Daliburgh, South Uist, Hebrides, 1954

74. *Approaching Storm*, South Uist, Hebrides, 1954

75. *Road to Petersport*, Benbecula, Hebrides, 1954

76. *Ewan MacLeod*, South Uist, Hebrides, 1954

77. *Loch and Lilies*, South Uist, Hebrides, 1954

78. *House*, Kilpheder, South Uist, Hebrides, 1954

79. *House*, Benbecula, Hebrides, 1954

81. *Water Wheel and Colossi*, Gurna, Upper Egypt, 1959

82. *The Nile*, Aswân, Upper Egypt, 1959

84. *Sheik Abdel Hadi Misyd*, Attar Farm, Delta, Egypt, 1959

85. *Fatma Ahmed*, Gurna, Upper Egypt, 1959

86. *El Hawaslia*, Middle Egypt, 1959

87. *Abu Gandir*, El Faiyûm, Egypt, 1959

88. *Mahmoud Abdul Nabi*, Gharb Aswân, Upper Egypt, 1959

89. *El Koddabi*, Middle Egypt, 1959

90. *Gharb Aswan*, Upper Egypt, 1959

91. *Kwthar*, Kalata al Kobra, Delta, Egypt, 1959

92. *Rif Mountains*, Morocco, 1962

94. *Taourit Casbah*, Ouarzazate, Morocco, 1962

95. Rissani, Morocco, 1962

96. *Small Square in the Medina*, Marrakech, Morocco, 1962

97. *White Tomb*, Tinerhir, Morocco, 1962

98. *Women's Mosque*, Safi, Morocco, 1962

99. *Street*, Tétouan, Morocco, 1962

101. *Awoleba Adda, The Navropio of Navrongo*, Ghana, 1963

102. *Street Procession*, Mamfe, Ghana, 1964

104. *Ritual Dance*, Larteh, Ghana, 1963

105. *Afi Negble*, Asenema, Ghana, 1964

106. *Lucky Chop-Bar*, Pokuase, Ghana, 1964

107. *Boys at Cape Coast*, Ghana, 1963

108. *Cynthia Blavo*, Korle Bu Hospital, Accra, Ghana, 1964

109. *Asenah Wara (Leader of Women's Party)*, Wa, Ghana, 1964

110. *Chief and Elders*, Naygenia, Ghana, 1963

111. *Asadare Azambgeo*, Winkogo, Ghana, 1963

112. *The White Road*, Moldavia, Romania, 1960

114. *Reeds of the Delta*, Romania, 1967

115. *Toplet*, Romania, 1967

116. *Decorated Grave Marker*, Sapinta, Romania, 1967

117. *Robesti*, Romania, 1967

118. *Harbor of Constanta*, Romania, 1967

119. *Open Coal Mining*, Rovinari, Romania, 1967

120. *Leaving Church*, Tilisca, Romania, 1967

121. *Leaving Church*, Rasinari, Romania, 1967

123. *Couple at Rucar*, Romania, 1967

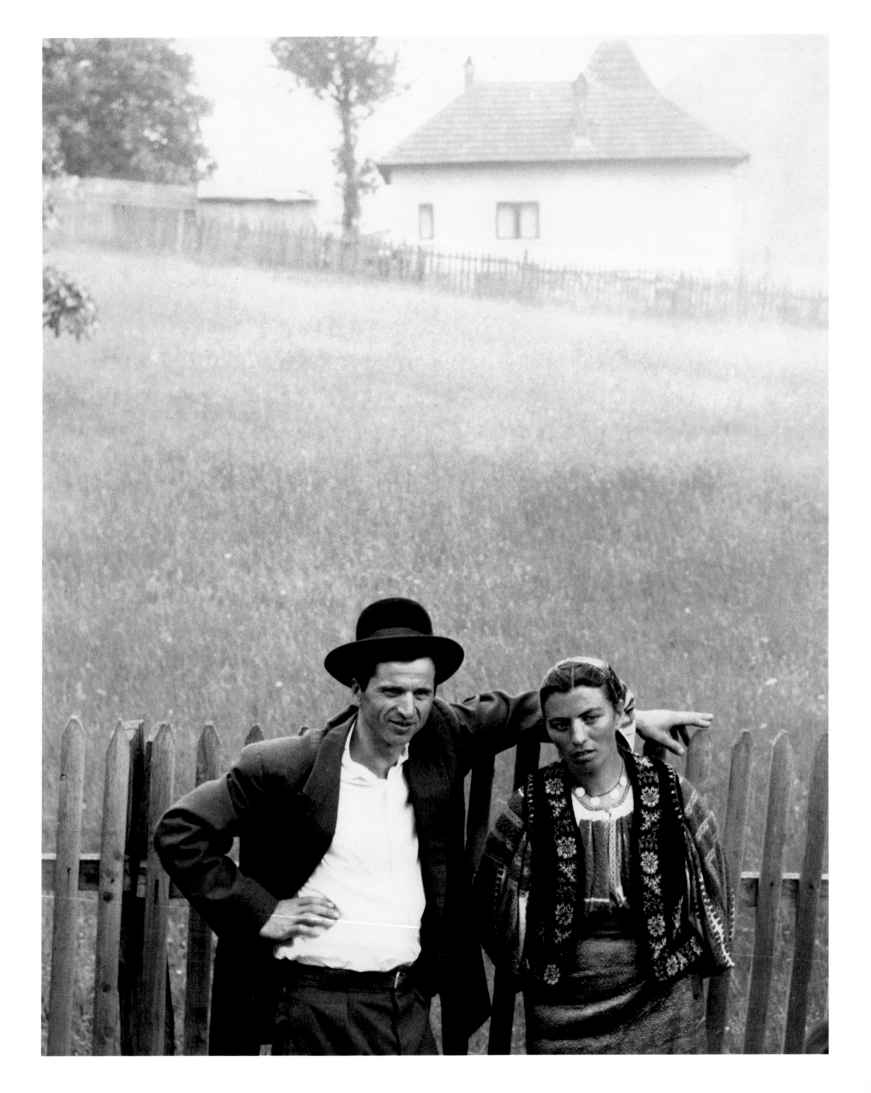

CONCEIVING
TIMELESSNESS

The Principle of Cultural
Portraits in the Late Work
of Paul Strand
by Ute Eskildsen

IN A FOREWORD to his "On My Doorstep" portfolio, published a year before his death, Paul Strand recapitulated the stages of his photographic development. Looking back on a career that had profoundly influenced generations of photographers, he concluded his introduction with three short sentences: "The artist's world is limitless. It can be found anywhere, far from where he lives or a few feet away. It is always on his doorstep."

Strand viewed the world as generally accessible, and as disengaged from the momentary. It provided him with an inexhaustible source of visual images. Pioneering the concept of "direct" or "straight" photography, in which images are made from found, real-life situations, Paul Strand's early photographic accomplishments became the prevailing alternative to the pictorialist aesthetic. Yet to fully understand his notion of "straight" photography, it is important to examine Strand's development toward a thematic orientation, expressed especially through his books.

Much has been written about Strand, most recently in *Paul Strand: Essays on His Life and Work*, a comprehensive anthology that illuminates various phases of his work. Most exhibitions have focused largely on his earlier work; this book, *The World on My Doorstep*, accompanies an exhibition of Strand's photographs after World War II, a period spent, for the most part, in Europe. His projects from 1950 until his death are especially important because they unite his mature ideas and influences, and the experiences of a varied career.

Concentrating on defined geographical areas, these projects present an intimate view of the particularities of each region. At the same time, through the book format, Strand places his images in the context of an eternal relationship between man and the existing world. Portraits are juxtaposed with images of their subjects' environment—nature, architecture, and their own world of objects. Most of the images exhibited and published here first appeared in books, and his intention to make his work available to a wide audience through publication will receive special attention in this essay. The first European book project, *La France de Profil*, was published in Lausanne in 1952, followed by *Un Paese* (1955), and *Tir a'Mhurain* (1962). These were followed by *Living Egypt* (1969), and *Ghana: An African Portrait* (1976).

PAUL STRAND WAS BORN in 1890 in a New York City undergoing a transformation to the Modern. Two people played an influential role in his development as an artist. Lewis Hine, his teacher at the Ethical Culture School, taught him not only the fundamentals of photography, but also the school's principles of ethical questioning and broad humanistic thinking. Hine also introduced Strand to his sec-

ond great early influence, Alfred Stieglitz. He became involved in the Camera Club of New York and—stimulated by Alfred Stieglitz's gallery, which showed the work of the photo-secessionists, and the publication *Camera Work*—soon began an intensive engagement in contemporary aesthetic discourse.

It was in this period, before World War I, that Strand created photographs that today are considered seminal. He sought to translate his views of social conditions, as influenced by Hine and the ideas of the Ethical Culture School, into a form of abstraction, which he saw as the aspiration of any photographer's work of transformation. Some critics have seen in Strand's early works "documents of human misery and alienation,"[1] but such images as *The Blind Woman* (1916) and *Man in a Derby Hat* (1916) point, especially when seen together with *White Fence* (1916) and *Wire Wheel* (1917), rather to the decidedly formal, aesthetic problems of a photographer exploring the possibilities of the medium.

At the same time, he was seeking to define the role of photography within the arts. In an article written for *Seven Arts* in 1917, he emphasized the need for proper application of photography, whose "contribution and... its limitation" he perceived to be its objectivity; for him, objectivity was the medium's raison d'être, its unique feature, and its legitimization as an art form. Strand came to the conclusion that "the comparison of potentialities is useless and irrelevant. Whether a watercolor is inferior to an oil, or whether a drawing, an etching or a photograph is not as important as either, is of inconsequence."[2]

His 1922 article "Photography and the New God" extended this thesis. Placing photography in the context of industrial development and the changing role of the artist, he vehemently disqualified the accomplishments of so-called art photography as "a misconception of the inherent qualities of a new medium." He also emphasized absolute attention to the specifics of photographic reproduction, depen-

dent on the mechanical characteristics of the camera, believing that the euphoric emphasis on the machine is mitigated through the creative and practical aspects of artistic production. "[The Artist]... is again insisting, through the science of optics and the chemistry of light and metal and paper, upon the eternal value of the concept of craftsmanship, because that is the only way he can satisfy himself...."[3]

After World War I, faced with the problem of earning a living, he took a job as an advertising photographer. During this period he also developed an interest in film, and made his first, *Manhatta* (1920), with the painter and photographer Charles Sheeler. This film, according to the critic Jan-Christopher Horak, "actually predates much European avant-garde film, and in a sense defines a prevalent style and theme within both European and American avant-garde film practice, the so-called 'cityfilm.'"[4]

From 1922, having purchased his own 35mm Akeley film camera, Strand began working as a freelance cameraman, mostly for sporting events and

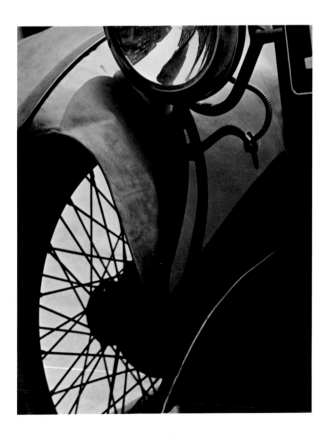

Wire Wheel, New York, 1917

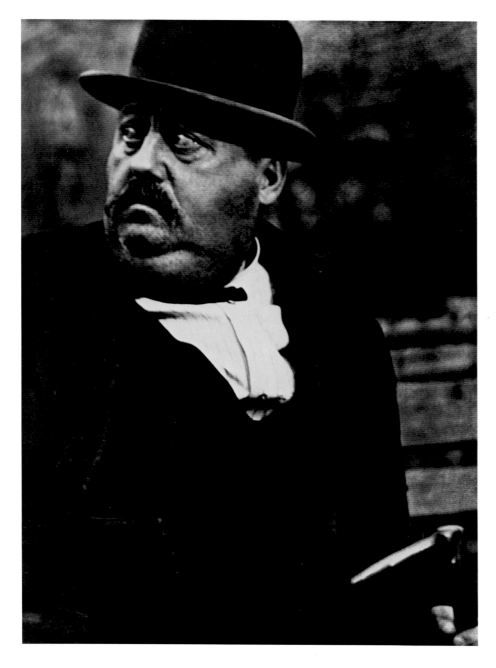

Man in a Derby Hat, New York, 1917

to transfer to nature those abstractions previously pioneered by his urban photographs. Outside the city, he started to explore organic structures and forms in landscapes, although an intense preoccupation with specific regions occurred only in connection with longer journeys to distant places, to those regions with which Strand was unfamiliar:

> In 1926 I was able to go to the Rockies and in 1927 and 1928 to Maine, during the Summer. These contacts with the land opened to me the intense life which is to be found in trees and woods, in the details of rocks, growing plants, a cobweb or driftwood on a beach.[5]

Between 1925 and 1930 Strand undertook a number of photography trips to parts of the United States and Canada, an exploration of the natural landscape that was not unusual among North American artists of the time, but that can now be seen as the beginning of an art and literary movement centered on America.[6] It was during one such trip, to the Gaspé Peninsula in Canada, that he achieved his first breakthrough in his landscape photography. The array of photographs produced shows that he no longer selected subjects only for formal reasons, but also for broader thematic content. For Strand, a portrait of the landscape that included the placement of human beings in their specific environment was now possible:

> It was always said that you really have to know a place before you start working in it; otherwise you would make something very superficial. Another shibboleth was that you can't make a portrait of a person unless you know the person, and then when you know a person you create the moment or you wait for the moment when they are most alive and most themselves. These shibboleths went out the window.... The impertinence lies really in trying to photograph the complexity of people, their environment, their land, in too short a time, but not when you start photographing.[7]

newsreels. As his film work occupied most of his professional time, his photographic activity was restricted to leisure hours, weekends, and vacations. Still photography remained for him an area of personal craftsmanship, liberated from any commercial or utilitarian concerns.

During his vacations in the countryside, Strand began to develop what would remain a life-long photographic theme. Two landscapes from 1916, *Sky and Ridge Pole* and *Twin Lakes*, document an early attempt

In this period of personal change and artistic reorientation, Strand became good friends with Harold Clurman, a critic of Western individualism and champion of Soviet collective art who was the intel-

lectual leader of the Group Theatre. Under the influence of Clurman and stimulated by other American artists, Strand developed a cultural-historical perspective during his trips to New Mexico, where he began to connect his landscape photography with an increasing fascination with the lives of ordinary people. However, his choice of medium for this aim was not photography but film, which in the next ten years became his primary focus.

In 1932, Paul Strand left the United States and took up an appointment as Chief of Photography and Cinematography in Mexico's Secretariat of Education. His move was less a search for adventure than an exploration for new personal and artistic points of departure. Strand found working in politically revolutionary Mexico compatible with his own increasing interest in an aesthetic oriented toward social concern. Of his previous work in New Mexico Belinda Rathbone writes: "Obsessed with conquering the Southwestern landscape, Strand had not yet united his idea of the land with a portrait of its people."[8] The twenty images from his Mexico photographs, which he published as a hand-pulled photogravure portfolio in 1940, document his first attempt to create a portrait of a landscape in a coherent publication format. In *Paul Strand: An American Vision*, Sarah Greenough writes of this portfolio: "In a carefully structured sequence he introduced his concept that the sense of a place—its spirit or its ineffable essence—was composed of the sum of its constituent parts.... For Strand it was his mixture of nature and people, their artifacts and vernacular architecture, that formed a portrait of a place."[9] However, her comparison of Strand's work to that of James Agee and Walker Evans a few lines later misses a vital point, important especially in view of his later work: Strand photographed Mexican culture while Agee and Evans documented the misery of their own country in Alabama. Unlike Agee and Evans, Strand's point of departure refers clearly to a cultural and not a socio-political approach. In Mexico he discovered the beauty of a foreign culture, which probably led him to a greater appreciation of the historical traces in his own country.

In 1934, after the new Mexican government under President Lázaro Cárdenas denied him continuing support for future film projects, Strand returned to the United States. In Mexico, he had been engaged in work with political intentions that addressed a clearly defined audience; for the first time Strand had propagandist goals. The Hollywood film director Fred Zinnemann, who worked in Mexico with Strand on the film *Redes/The Wave* (1934), remembered him as "the most doctrinaire Marxist."[10] Returning home from Mexico and the experience of "political education work," Strand became the ally of photographers and filmmakers who had banded together for ideological work. In 1935 he became active in the Nykino Film Collective, an offshoot of the New York Film and Photo League, and in 1937 he founded Frontier Films with Lionel Berman, Leo Hurwitz, and Ralph Steiner.[11]

It is this political activity that provided the back-

The White Fence, 1916

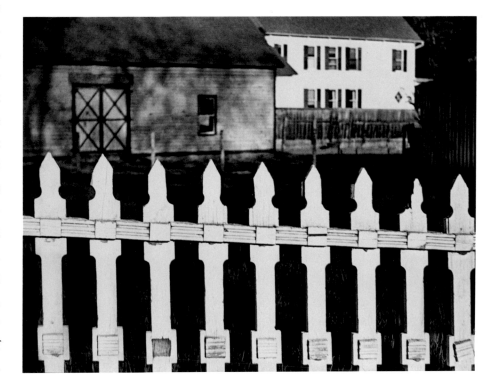

ground to his demand, formulated as Fascism was being defeated in Europe, that "the artist must be much more integrated into society than he has been in the past."[12] It is also, at least in part, an explanation for his return to still photography in 1943 to begin his *Time in New England* project.

When Strand applied for a grant from the John Simon Guggenheim Memorial Foundation for his New England project, he argued that "... it is important that artists who are not being used in the war ef-

Sky and Ridge Pole, Twin Lakes, Connecticut, 1916

fort should continue to function by recording (in all mediums) the essential character of those American traditions we are fighting to preserve."[13] With Nancy Newhall, who was to organize his retrospective exhibition at the Museum of Modern Art in 1945, he put together a book, the aim of which was to discover traditions in the contemporary appearances of landscapes, objects, and inhabitants, as both emphasized in their forewords.

In many respects *Time in New England* represents both a culmination of his photographic work of the previous years and a transition point. In its form of presentation, the thematic orientation of individual

images, and in the correlations between photographic images, the book represents a landmark in Strand's development.

The format, a juxtaposition of texts from a variety of historical documents and contemporary photographs, was intended "to create a portrait more dynamic than either medium could present," as Nancy Newhall emphasized. In relationship to the texts the photographs acquire a historical dimension. The individual image triumphs as the symbolic expression of a region, conscious of its nature and of its special historical significance, arising not only from its role as the cradle of the American Revolution, but also from its liberal political tradition.

It is often said that Strand and Newhall used film montage techniques to construct the book. It seems more likely, however, that Strand's film work sharpened his eye for individual photographic images, influencing the narrative approach he adopted in combining images and texts. Each photograph functions either as contemporary interpretation of a historical text or as formal analog to the facing image, further concentrating the symbolic meaning of the whole project.

The world of objects, represented in the images, refers constantly to New England's Puritan and democratic traditions; the assembly of these images as a book should be seen as an attempt to unite politically varied historical traces under a patriotic concept. At a time when the United States was fighting a war on two fronts, Newhall and Strand developed a book that emphasized the United States as a land of tradition and a country capable of integration.

The formal composition, a preference for frontal views and tight close-ups—especially in his representations of nature and objects—and a conscious abandonment of the momentary, points to Strand's almost religious attitude toward the existing world. He maintained an unrelenting respect for the relationship between man and nature: a tree, a portrait, a church,

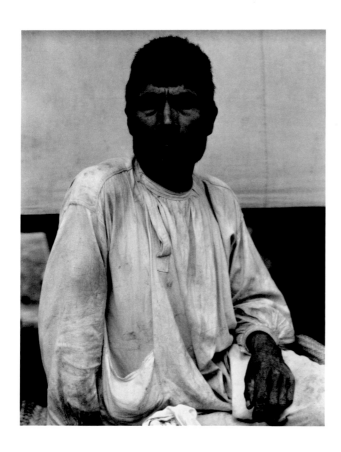

a window, a gravestone—all remain valued on the same cultural-aesthetic level.

The denotative demands made on individual images are further emphasized by being placed in a book. Juxtapositions arise that eliminate any narrative structure. Their formal characteristics are underlined still further by an inversion of scale: close-ups are reproduced in large format while landscapes and seascapes are reduced on the page, forcing a reading that goes beyond the thematic content of the image.

PAUL STRAND WAS NEITHER a journalist nor a social documentarian. His portraits, landscapes, and architectural photographs are the preconceived images of a great formalist, an aesthetic purist. The unique quality of his images lies more in a precise transformation of specific formal structures than in the potential for capturing a particular situation. The people portrayed by Strand are not torn from reality; they are placed within a photographic reality. His photographs depict a continuum of human experi-

ence in a particular place rather than frozen moments in time.

Strand was a technically and artistically mature photographer well before the 1920s. Once in Mexico he developed a method that corresponded to his cultural interests and social ideals. The extension of his catalog of motifs to found images, figures, and objects, and the juxtaposition of these with portraits, are what distinguish Strand's work from other American "straight" photographers. Walker Evans, for example, had incorporated billboards, advertising, and national memorials into his book *American Photographs* (1938), which placed deserted streets and architectural views in a contemporary context. Strand, on the other hand, created a context based mainly on the expressive structure of the objects he photographed, in an attempt to trace a repeating form as a "natural" principle.

Time in New England was his first attempt to combine this interest with historical texts. The book format was probably the only way for his work to reach a larger public in the 1940s, when neither an infrastructure for photographic exhibitions nor a photographic market existed. Illustrated magazines, the only other alternative, worked at breakneck speeds, and their cultivation of photography of the fleeting moment was quite the opposite of Strand's still and sober images.

Man, Tenancingo, 1933

Ranchos de Taos, New Mexico, 1931

When *Time in New England* appeared in 1950, government persecution of allegedly subversive organizations and people had begun, and Strand had emigrated to France. As a symbol of liberty for the common man, France had once again become the artistic center of Europe after World War II. Having celebrated his own country's democratic traditions, Strand now found its politics much too restrictive for him to stay. After his experiences in Mexico, and an unsuccessful attempt to launch a project in the Soviet Union in 1935, France became the place where he hoped to fulfill his artistic dreams.

Once there, Strand sought to realize an idea—which he had been considering for years—of visualizing a village where an unbroken exchange between people, environment, and nature could be represented. "…I would like to make a book about a village, a small place. I liked the idea of being confined to a small place and then having to dig into the smallness."[14] Together with his third wife, Hazel Kingsbury, whom he married in 1951 and who became a close working partner, Strand traveled throughout France in search of the ideal village. Unable to find the appropriate setting, he produced a portrait of the whole country, the result of a photographic search for traces of the Old World by someone of the New World to whom all was fresh: "I started to photograph the things I found in France that I'd never seen anywhere else."[15]

Two years later, his book *La France de Profil* was published with a text by Claude Roy. As in *Time in New England*, text selections appeared next to images of figures, objects, and landscapes. Unlike his previous book, the texts were designed as images—by presenting them in part as hand-written compositions with liberal decorations on the page—or as verse, running text, or newspaper column. The variety of images and text formats engages the reader in more active participation. Formally, this book is more dynamic, as images and texts are often formed as a montage. Of *La France de Profil* Ulrich Keller has suggested that "the light, superficial tone of these literary insertions defies the seriousness of Strand's photography [and is] particularly incompatible with Strand's broadly humanitarian orientation"[16]—a spurious argument, as Roy was Strand's first choice as author for the book.

La France de Profil is an ambitious attempt at using the book format to juxtapose images and texts as independent forms of visual expression. The emphasis on individual photographs is lessened through a more open-ended principle of image sequence, whether image-image or image-text combinations, and this additive principle stands in contrast to the layout and rhythm in *Time in New England*.

THANKS TO THE ITALIAN neorealist scriptwriter and venerated filmmaker Cesare Zavattini, whom he had met in 1949 at a film festival in Perugia, Strand was finally able to find his village. After exploring France with a camera—certainly an important step in an American artist's assimilation of European lifestyles—the village of Luzzara seemed an ideal choice, especially as it was the birthplace of Zavattini, on whose experience Strand could rely and who guaranteed Strand access to the locals and their social structure. Accompanied once again by Hazel Kingsbury Strand, he photographed in Italy from 1952 to 1954, publishing *Un Paese* in Italian, in 1955.

In Zavattini Strand found a guide and co-author with whom he shared basic concepts about the way the existing world should be portrayed. In an essay titled "A Few Thoughts on Film," Zavattini wrote of the general neorealist problem of finding access to reality:

> We have moved from a deep and unconscious suspicion of reality, from a deceptive and questionable break from reality, to an unlimited trust in things, in facts, in human beings…. Fundamentally, it is no longer a matter of making the fictional real (letting

* * *

I THINK THAT, AS LIFE IS ACTION AND PASSION, it is required of a man that he should share the passion and action of his time at peril of being judged not to have lived.

Accidents may call up the events of the war. You see a battery of guns go by at a trot, and for a moment you are back at White Oak Swamp, or Antietam, or on the Jerusalem Road. You hear a few shots fired in the distance, and for an instant your heart stops as you say to yourself, The skirmishers are at it, and listen for the long roll of fire from the main line. You meet an old comrade after many years; he recalls the moment when you were nearly surrounded by the enemy, and again there comes up to you that swift and cunning thinking on which once hung life or freedom—Shall I stand the best chance if I try the pistol or the sabre on that man who means to stop me? Will he get his carbine free before I reach him, or can I kill him first? These and the thousand other events we have known are called up, I say, by accident, and, apart from accident, they lie forgotten.

But as surely as this day comes round we are in the presence of the dead. For one hour at least, on this day when we decorate their graves, the dead come back and live with us. I see them now, more than I can number, as once I saw them on this earth. They are the same bright figures, or their counterparts, that come also before your eyes; and when I speak of those who were my brothers, the same words describe yours.

For the Puritan still lives in New England, thank God! and will live there so long as New England lives and keeps her old renown. New England is not dead yet. She still is mother of a race of conquerors,—stern men, little given to the expression of their feelings, sometimes careless of the graces, but fertile, tenacious, and knowing only duty. Each of you, as I do, thinks of a hundred such that he has known.

I see one—grandson of a hard rider of the Revolution and bearer of his historic name—who was with us at Fair Oaks, and afterwards for five days and nights in front of the enemy the only sleep that he would take was what he could snatch sitting erect in his uniform and resting his back against a hut. He fell at Gettysburg. His brother, a surgeon, who rode, as our surgeons so often did, wherever the troops would go, I saw kneeling in ministration to a wounded man just in rear of our line at Antietam, his horse's bridle round his arm,—the next moment his ministrations were ended. There is one who on this day is always present to my mind. He entered the army at nineteen, a second lieutenant. In the Wilderness, already at the head of his regiment, he fell, using the moment that was left to him of life, to give all his little fortune to his soldiers. I saw him in camp, on the march, in action, and never did I see him fail to choose that alternative of conduct which was most disagreeable to himself. He was indeed a Puritan in all his virtues, without the Puritan austerity.

Not all of those with whom we once stood shoulder to shoulder—not all of those whom we once loved and revered—are gone. On this day we still meet our companions in the freezing winter bivouacs and in those dreadful summer marches where every faculty of the soul seemed to depart one after another, leaving only a dumb animal power to set the teeth and to persist—a blind belief that somewhere and at last there was rest and water.

We know very well that we cannot live in associations with the past alone, and that, if we would be worthy of the past, we must find new fields for action or thought, and make for ourselves new careers.

Through our great good fortune, in our youth our hearts were touched with fire. It was given to us to learn at the outset that life is a profound and passionate thing.

JUSTICE OLIVER WENDELL HOLMES

Dead, yet Living, an address delivered on Memorial Day, 1884, at Keene, New Hampshire, before the John Sedgwick Post No. 4, Grand Army of the Republic. Boston, Green, Heath & Co., 1884.

243

From *Time in New England*, pp. 242–243, 1950

From *Time in New England*, pp. 132–133, 1950

From *La France de Profil*,
pp. 84–85, 1952

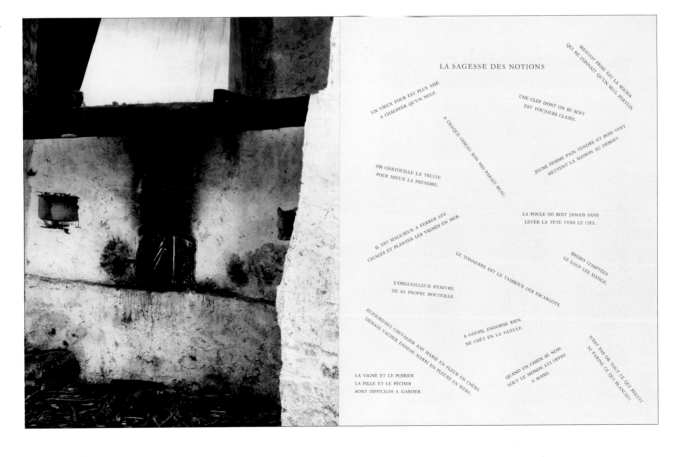

From *La France de Profil*,
pp. 50–51, 1952

them appear true or real), but rather of allowing things, as they are, to speak for themselves, and to make them as meaningful as possible.[17]

These views converged with Strand's own opinions on authorship. "I am attracted to those artists who are interested in a large panorama, and not those who are strictly concerned with their personal likes and dislikes."[18] Strand's and Zavattini's mutual enthusiasm centered on this neorealist direction away from the fictional, away from the visual invention. However, to these views Strand added a significant proviso: "It is the way he [the artist] sees his world and translates it into art that determines whether the work of art becomes a new and active force within reality, to widen and transform man's experience."[19]

Un Paese is, arguably, the outstanding project of his series of portraits of specific regions. In this book, the photographic method of consciously isolated individual images is echoed in the texts. Observed modes of living have been selected on the basis of their specific outward form, symbolizing an environment. Historically less ambitious than *Time in New England*, and of a less experimental design than *La France de Profil*, *Un Paese* achieves Strand's intention of giving the persons represented an ideal cultural context by including their own world of objects, architecture, and nature. His fascination with formal structures, patterns, and shapes is made clear by a precise and even-handed treatment of his subjects, and the relatively uniform size and simple layout of the photographs. Strand's eye concentrates on the enduring simplicity of the village; on the faces of its inhabitants and—through groups—their relationships, while Zavattini's text focuses on the stories of individual villagers, looking back on the war and forward to new beginnings.

The presence of Zavattini, his observation of Strand at work, allows an interesting insight into Strand's method:

His way of working was deliberately casual; he always acted 'like a native,' bound up with the very subject whose presence he wanted to capture and fix. People thought him careless, I suppose, or too trusting when they saw him set up his camera only to walk away, leaving it on the street as if he were more concerned with the random and commonplace than with the exceptional.[20]

Zavattini evaluated this working method as "calculated absence," but also pointed out that Strand's most penetrating photographs were made of persons who were immediately sympathetic with his project, "which became the central topic of conversation in the café, almost as soon as we arrived."[21]

Zavattini's comments complement the photographer's own observations and statement on his working method, serving to counteract romanticized ideas of photographic work. Strand's work with a large-format camera not only made his presence decidedly noticeable, but also required patience and exactitude. His portraiture demanded a different form of cooperation with his subjects than if he had used a 35mm camera. But what he shared with his European contemporaries working on similar regional portraits[22] was overcoming the problem of being a "photographic tourist": if a photographer wants to find access to a foreign place, he must integrate himself, must become as invisible as possible.

IN 1962 STRAND'S NEXT BOOK was published, *Tir a'Mhurain, Outer Hebrides*, on which he had been working since 1954. Using an island people as an example—in this case one that had experienced industrialization at the beginning of the sixties—he once again presented his concept of an isolated place in a great depth. In this book, the photographs are presented independent of the texts, which function merely as foreword and afterword. *Tir a'Mhurain* was a triumph of the tableau style—further emphasizing the symbolic potential of photographs, something that had already been foreshadowed in *Un Paese*.

Two more publications, *Living Egypt* (1969) and

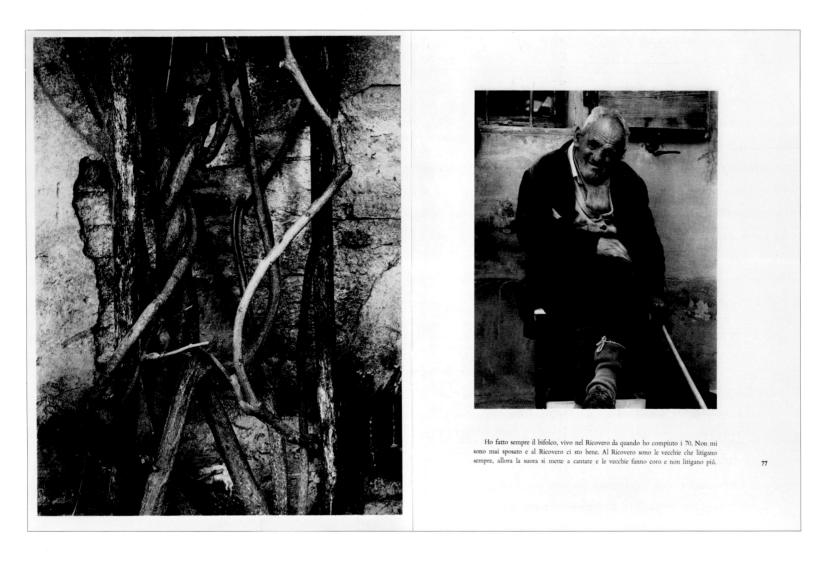

Ho fatto sempre il bifolco, vivo nel Ricovero da quando ho compiuto i 70. Non mi sono mai sposato e al Ricovero ci sto bene. Al Ricovero sono le vecchie che litigano sempre, allora la suora si mette a cantare e le vecchie fanno coro e non litigano piú. 77

From *Un Paese*, pp. 76–77, 1955

Ghana: An African Portrait (1976), follow this method of presentation: the relationship between image and text is recast in a segmented, running text, broken into sections. Thematically, these projects, produced in the socialist "colonies" in the Third World, represent an expansion of Strand's previous concerns.

Industrialization is included through monumental views of industrial complexes and factories still under construction. Their planners are shown in close-up, standing heroically in front of technical drawings or machines, which are reduced to abstract shapes. Collective work is represented merely at the fringes, while serious-looking individual workers are also shown in close-up. In both books, the modern world functions more like an afterthought, trapped by a euphoric socialist belief in the potential of progress and technology.

Industrial production, absent completely from the three European projects, is represented in the Egyptian book in a section that illustrates the transition from manual to machine labor. The focus of Strand's interest is not on the consequences of modernization vis-à-vis traditional forms of living, but rather on the propagation of social change ushering in the future.

A proper evaluation of Paul Strand's late photographic work—from 1950 until his death, in 1976—would not be complete without an attempt at placing him within the context of the photographic practice of his European contemporaries. When Strand emigrated to France, in 1950, Europe was in the process of reconstruction. Revived and newly founded illus-

trated magazines became *the* preferred employers for European photographers. After the war years, photojournalism was a guaranteed escape from the drudgery of daily life, promising both an income and the possibility of travel.

The practice of socially conscious European photo-reporters and their humanistically inclined magazine editors was supported in a significant way at the end of the 1950s when Edward Steichen's exhibition "The Family of Man" toured Europe. Its notion of a universal language through photographic images has led to misunderstandings, which persist even today.[23] At the same time that Steichen was planning his exhibition, Strand was developing a method that stood—in its apparent regional and thematic concentration and its static single images—in contrast to a "world language of photographic practice." His photographs were not suitable for the mass media, because as isolated portraits of anonymous individuals, interpreted as timeless characters, they did not fit in with the illustrated magazines' preference for "momentary human drama." Strand's interest in specific spheres of existence did not differ from European postwar photographic work in its thematic orientation, but rather in its approach to these themes and artistic method.

In the foreword to his book *The Europeans*, Henri Cartier-Bresson wrote: "Whether you are settled in a country or merely a passing visitor, to render the quality of a place or of a situation, you must have worked steadily in some community, have become a part of it." The view that photographic images do justice to a particular place was accepted by numerous European photographers. However, their choice of locales highlighted urbanity and modern life. Their observations, given form through straight photography, expressed the feelings of postwar photographers who preferred public places to the laboratory experiments of the "subjective photographers."

In the Europe of the time, there was nothing

comparable to Paul Strand's cultural interest in a peasant population, his carefully formulated and distanced approach, and the "slow" and exact process of transformation in his observation of these human beings. To find a similar methodology, one must go back to the twenties and thirties, to the book *Die Halligen* (1927) by the German photographer Albert Renger-Patzsch, and to the work of Erna Lendvai-Dircksen, for example, where the human face is presented in focused relationship to images of nature, as an organically developed individual.

Ulrich Keller sees the development in Germany in the 1920s of a new type of photograph, the "ideological portrait," for which there were a variety of structures and formats, depending on the political ideology. He observed that the rejection of tradi-

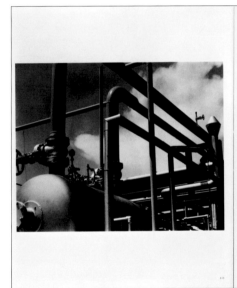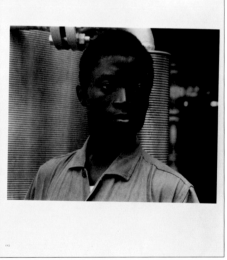

tional studio portraiture led to the development of photographic projects, sometimes financed by "economic or political associations." What bound these together, despite ideological differences, was a photographic practice through which the accumulation of images constructed a "community." However, the barbarism of Fascism and Stalinism had shaken ideological beliefs, and European photographers found taking up prewar themes and traditions impossible or taboo.

From *Ghana: An African Portrait*, pp. 112–113, 1976

DRIVEN BY HIS CONCEPT of an ideal village, Strand began to apply the "historical eye" of his New England images to the contemporary European scene. The mature, easily grasped structures of traditional social life guaranteed, especially in the Mediterranean regions, an ideal "historical terrain" that the United States, with its size, its recent immigrants, and its individualistic lifestyle, could not offer. As the photo-historian Sally Stein writes: "On the surface, Strand's advocacy of 'straight photographic methods' was not based on any literal sense of terri-

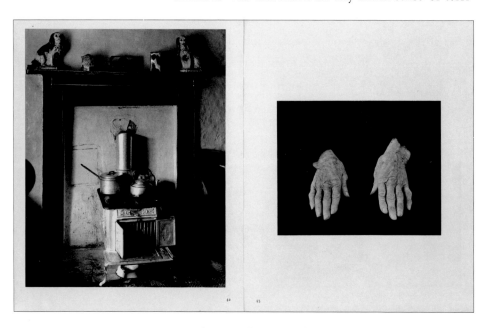

From *Tir a'Mhurain*, 1968

toriality in relation to the land. His passion for purity, his proscriptive view of 'all attempts at mixture,' prefigure a quest of something whole and organic, as an end as well as a means." Strand repeatedly highlighted the richness of forms that he searched for in the remaining "natural world." He found an equal beauty in architecture, in household objects, in tools, and in the human face. Objects of peasant life, selected and photographically isolated, exemplified a culture that had grown organically from the land. However, it was only in juxtaposition to the raw, unadorned faces that these photographs found their intended context as a dimension of unity.

The ideological point of departure for such a relationship to a "cultural landscape" lay in the no-

tion that humanity's individuality developed out of the conditions of nature, with the products of its work reflecting that origin. Strand was not concerned with documenting existing contradictions, but rather with confirming a social system defined in relation to nature.

He insisted on defining a context for life, through respect for the accomplishments of a community whose goal is a humane society in harmony with nature. Adhering to his cultural and historical precepts, Strand did not use photographic techniques as a concentration of "historical moments," but rather as a compositional method. In this sense, every photograph was a formally conscious, autonomously conceived statement, transformed through the book format. Within his books photography does not function as an illusion of the momentary, nor does it enforce a belief in pure documentation. Rather, the photographic image emerges as the result of an aesthetic practice and, beyond that, an element of humanistic vision. His fascination with rural life cannot be separated from his experience as an urban American, nor from the traditions of socialist utopias.

As a photographer, Strand journeyed from a purist concern with abstraction, to socially aware film activity in the 1930s, and then back to still photography. In stressing the unique statements of individual images and at the same time forcing a visual correspondence on the printed page, he was swimming against the tide of contemporary photography.

The exceptional contribution of Paul Strand's late work lay in combining formal methodology with the principle of integrating images within a book format. It was this mode of presentation, which affects the means and forms of perception, that Strand developed as a frame to emphasize the single photographic image as a symbol of timelessness.

Translated from the German by
Jan-Christopher Horak and David Higgins.

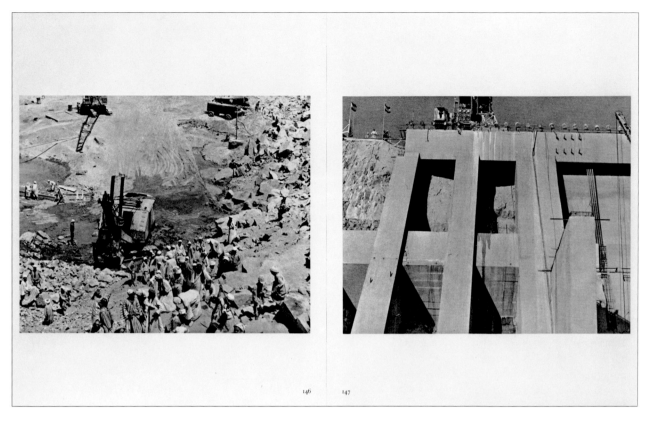

From *Living Egypt*,
pp. 146–147, 1969

NOTES

1. Ulrich Keller, "An Art Historical View of Paul Strand," in: *Image* 17: 2.

2. Paul Strand, "Photography," in: *Seven Arts*, August 1917, Vol. II, No. 10, pp. 525–526.

3. Paul Strand, "Photography and the New God," quoted in: Alan Trachtenberg, *Classic Essays on Photography* (New Haven: 1980), p. 151.

4. Jan-Christopher Horak, "*Manhatta's Manhatta* of The Romantic Impulse," in *American Film Modernism*.

5. Paul Strand, "Photography to Me," *Minicam Photography*, no. 8 (May 1945):42–47.

6. See: Paul Rosenfeld, *Port of New York* (New York, 1924; University of Illinios Press, 1961), in which the author portrays selected American artists in view of their attitude towards nature.

7. Quoted in: *Paul Strand, Sixty Years of Photographs*, (New York: Aperture, 1974), p. 155.

8. Belinda Rathbone, "Paul Strand: The Land & Its People," in: *The Print Collector's Newsletter*, vol. XXI, no. 1, 1990, p. 3.

9. Sarah Greenough, *Paul Strand: An American Vision* (New York: Aperture, 1990), pp. 43–44.

10. Quoted in Mike Weaver, "Paul Strand: Native Land," in: *The Archive* no. 27 (Tuscon, 1990): 8.

11. For further information about his film work see: William Alexander, *Film on the Left: American Documentary Film from 1931 to 1942* (Princeton: Princeton University Press, 1981).

12. "Photography and the Other Arts." Lecture delivered at the Museum of Modern Art, 1945. Published in *Paul Stand Archive, Guide Series Number Two* (Tucson: Center for Creative Photography, University of Arizona, 1980), p. 10.

13. Paul Strand, letter to Henry Allen Moe, Secretary General of the John Simon Guggenheim Memorial Foundation, October 15, 1943, PSA/CCP.

14. Paul Hill and Thomas Cooper, *Dialogue with Photography*, (New York: Farrar, Straus and Giroux, 1979), p. 7.

15. Ibid.

16. Ulrich Keller, op. cit. p. 5.

17. Cesare Zavattini, "Einige Gedanken zum Film" in Karsten Witte, ed., *Ideologiekritik der Traumfabrik* (Frankfurt, 1972), p. 205.

18. Hill and Cooper, op.cit. p. 6.

19. Paul Strand, "On My Doorstep," foreword to portfolio of the same name, Orgeval, December 1975.

20. Ceasare Zavattini on Strand, unpublished manuscript in the Strand Archive.

21. Ibid.

22. For example, Henri Cartier-Bresson (*The Europeans*, 1955), Chargesheimer and Böll (*Im Ruhrgebiet*, 1958), Joan van der Keuken (*Paris Mortal*, 1958).

23. See Claudia Gabriele Philipp: "Die Ausstellung 'The Family of Man'," in: *Fotogeschichte*, Jhg. 7, Heft 23, pp. 45–62.

24. Among others: Joan van der Keuken (*Paris Mortal*, 1958), Ed van der Elsken (*En lief des geschiedenis in Saint Germain des Près*, 1956), Chargesheimer and Böll (*Im Ruhrgebiet*, 1958). This is not the place to into these books individually. They are mentioned as paradigms of contemporary European methods.

25. See: Ute Eskildsen, "Das Prinzip der Portraitdarstellung bei E. Lendvai-Dirksen, Paul Strand und Christopher Killip," in: *Camera Austria*, Graz, 4/80, pp. 7–16

26. Ulrich Keller, "Die Deutsche Portraitfotografie von 1918 bis 1933," in: *Kritische Berichte*, Gießen, Jhg. 5, Heft 2/3, 1977, p. 41.

27. The spectrum of portrait projects in the Weimar Republic included such books as *Antlitz der Zeit* (August Sander, 1929), *Köpfe des Alltags* (Helmar Kerski), and *Das deutsche Volksgesicht* (Erna Lendvai-Dirksen, 1932).

28. Sally Stein, 'Good Fences Make Good Neighbors,' in: *Montage and Modern Life 1919–1942* (Boston, 1992), pp. 131–132.

CHRONOLOGY

1890 Born October 16, in New York City, of Bohemian descent.

1907 At the Ethical Culture School, studied under Lewis Hine, who took his class to Alfred Stieglitz's Little Galleries of the Photo-Secession at 291 Fifth Avenue.

1909 Graduated from Ethical Culture School. Continued photographing in spare time and joined the New York Camera Club.

1909–11 Worked in family enamelware business. Brief journey to Europe. First published photograph.

1911–18 Set up as a commercial photographer. Experimented with soft-focus lenses, gum prints, and enlarged negatives.

1913–14 Occasional visits to "291" to see exhibitions and to show photographs to Stieglitz for criticism. Influenced by Picasso, Braque, Brancusi, and others seen at "291" and the Armory Show.

1915 Brought folio of new works to "291" to show Stieglitz.

1916 First publication in *Camera Work*, no. 48. Close working relationship with Stieglitz. First one-person show at "291," March 13–28.

1917 Last issue of *Camera Work*, nos. 49-50, devoted to Strand's new works. Began close-ups of machine forms.

1918–19 Worked as an X-ray technician in the Army Medical Corps at Fort Snelling, Minnesota. Upon release from army began photographing landscapes and close-ups of rock formations.

1920–21 Made film, *Manhatta*, with Charles Sheeler, which was later shown under title *New York the Magnificent*.

1922 Began work as free-lance Akeley motion-picture camera specialist, continued as a free-lance movie cameraman until 1932. Made still photographs of machines. Married Rebecca Salsbury.

1923 At invitation of Clarence White, delivered lecture at the Clarence H. White School of Photography in New York, subsequently printed in *British Journal of Photography*.

1925 Part of "Seven Americans" exhibition at the Anderson Galleries, New York, March 9-28, with Charles Demuth, John Marin, Marsden Hartley, Georgia O'Keeffe, Alfred Stieglitz, and Arthur Dove.

1926 Traveled to Colorado and New Mexico in summer. Photographed tree-root forms and Mesa Verde cliff dwellings.

1927–28 Summered at Georgetown Island, Maine, near sculptor Gaston Lachaise and Madame Lachaise. Took close-ups of plants, rocks, and driftwood.

1929 Solo exhibition at The Intimate Gallery, New York.

Traveled to the Gaspé peninsula in the summer. Strand's first interpretation of a locality, and his first attempt to integrate a landscape, to find the relationship of land and sky.

1930–32 Summered in New Mexico. Landscape interest continued in clouds, adobe architecture, ghost towns.

1932 Exhibited with Rebecca Strand in April at An American Place, New York. Further work in New Mexico. Strand's marriage dissolves.

1932–34 Traveled to Mexico to photograph. One-person show at Sala de Arte, Mexico City, February 1933. Appointed chief of photography and cinematography, Department of Fine Arts, Secretariat of Education of Mexico. Photographed and supervised production for the Mexican government of film *Redes*, released in the United States in 1936 as *The Wave*.

1935 Joined Group Theater directors Harold Clurman, Lee Strasberg, and Cheryl Crawford on a brief trip to Moscow. On return to the United States, photographed with Ralph Steiner and Leo Hurwitz *The Plow That Broke the Plains*, produced for the Resettlement Administration and directed by Pare Lorentz.

1936 Returned to the Gaspé in summer, made new Gaspé series. Married Virginia Stevens.

1937–42 Became president of Frontier Films, a nonprofit educational film production group with which Hurwitz, Lionel Berman, Steiner, Sidney Meyers, Willard Van Dyke, David Wolf, and others were originally associated.

1937 Edited the first Frontier Films release, *Heart of Spain,* with Hurwitz.

1940 Completed portfolio of twenty hand-pulled gravures of Mexico, published in New York by Virginia Stevens as "Photographs of Mexico."

1942 *Native Land* released, a Frontier Film photographed by Strand and co-directed by Strand and Hurwitz.

1943 Camera work on films for government agencies. As chairman of the Committee of Photography of the Independent Voter's Committee of the Arts and Sciences for President Roosevelt, edited exhibition with Hurwitz and Robert Riley at Vanderbilt Gallery, New York City.

1943–44 Traveled to Vermont, returned to still photography after ten years in film work.

1945 Solo exhibition, The Museum of Modern Art, New York.

1945–47 Traveled in New England, worked on book with Nancy Newhall, subsequently published as *Time in New England.*

1949 Invited to Czechoslovakia Film Festival in July, at which *Native Land* was awarded a prize.

1950 Traveled to Paris, began work on a book subsequently published as *La France de Profil,* with text by Claude Roy.

1951 Married Hazel Kingsbury. France became home and center for work.

1952–53 Made photographs of Italy that were later used in *Un Paese,* text by Cesare Zavattini.

1954 On the island of South Uist, in the Outer Hebrides, made photographs for *Tir a'Mhurain, Outer Hebrides,* text by Basil Davidson.

1955 Bought house in Orgeval, France.

1955–58 Worked on series of portraits of prominent French intellectuals, and close-ups of the Orgeval garden.

1956 Exhibited with Walker Evans, Manuel Alvarez Bravo, and August Sander in the exhibition "Diogenes with a Camera III," directed by Edward Steichen at The Museum of Modern Art, New York.

1959 In Egypt, photographed for the book *Living Egypt,* text by James Aldridge.

1960 Brief photographic trip to Romania.

1962 In Morocco, began work on series of photographs and researched Arab life.

1963 Placed on Honor Roll of the American Society of Magazine Photographers, New York.

1963–64 Traveled to Ghana at the invitation of President Nkrumah to make a book with text by Basil Davidson.

1965 Nancy Newhall introduced Michael Hoffman, publisher of Aperture, to Strand.

1967 Awarded David Octavius Hill Medal by the Gesellschaft Deutscher Lichtbildner in Mannheim, Germany. Returned to Romania to complete photographs begun in 1960. Supervised second printing of *The Mexican Portfolio,* produced by Aperture for Da Capo Press.

1969 Exhibitions at Kreis Museum, Haus der Heimat, Freital, East Germany, and Museum of Fine Arts, St. Petersburg, Florida.

1969–70 One-person exhibition organized by Gilbert de Keyser and Yves Auquéir for the Administration Générale des Affaires Culturelles Françaises of Belgium, shown throughout Belgium and the Netherlands.

1970 Held an exhibition of gravures, Stockholm, Sweden, as guest of the Swedish Photographers Association, received Swedish Film Archives Award, film series showed *Heart of Spain, The Wave,* and *Native Land.* Worked with Hoffman on selecting and printing photographs for the monograph and Philadelphia Museum retrospective.

1971–72 Retrospective exhibition, Philadelphia Museum, November 24, 1971, to January 30, 1972. Exhibition traveled to the Museum of Fine Arts, Boston; the City Art Museum, St. Louis; The Metropolitan Museum of Art, New York; and the Los Angeles County Museum of Art. *Paul Strand: A Retrospective* monograph published by Aperture in two volumes.

1973 Strands return to the U.S. for two years. Attended the opening of the retrospective exhibition at the Metropolitan Museum of Art in New York City and the Los Angeles County Museum. Strand operated on for cataracts.

1974 Calvin Tomkins's profile of Strand published in the *New Yorker,* September 16.

1975 Photographed in the backyard of the Fifth Street apartment in New York during the summer. Returned to Orgeval to work on the text of a book on his garden with Catherine Duncan. Prepared and signed prints for two portfolios: *On My Doorstep* and *The Garden.*

1976 *Ghana: An African Portrait* published by Aperture. Strand dies in Orgeval, France. Two portfolios, *On My Doorstep* and *The Garden,* published.

BIBLIOGRAPHY

In Chronological Order

BOOKS AND PORTFOLIOS BY PAUL STRAND

Photographs of Mexico. Foreward by Leo Hurwitz, New York: Virginia Stevens, 1940. Reprinted as *The Mexican Portfolio,* preface by David Alfaro Siquieros. New York: produced by Aperture, Inc., for Da Capo Press, 1967.

Time in New England. Text selections by Nancy Newhall. New York: Oxford University Press, 1950.

La France de Profil. Text by Claude Roy. Lausanne: La Guilde du Livre, 1952.

Un Paese. Text by Cesare Zavattini. Turin: Giulio Einaudi, 1955.

Tir a'Mhurain. Text by Basil Davidson. Dresden: VEB Verlag der Kunst, 1962; London: MacGibbon and Kee, 1962; and New York: Aperture, Grossman, 1968.

Living Egypt. Text by James Aldridge. Dresden: VEB Verlag der Kunst, 1969; London: MacGibbon and Kee, 1969; and New York: Aperture, Horizon Press, 1969.

Paul Strand: A Retrospective Monograph. The Years 1915–1968. 2 vols., New York: Aperture, 1970. Single volume reprint, Millerton, N.Y.: Aperture, 1971.

The Garden. New York: Aperture, 1976. (portfolio)

Ghana, An African Portrait. Text By Basil Davidson. Millerton, N.Y.: Aperture, 1976.

On My Doorstep. New York: Aperture, 1976. (portfolio)

ARTICLES BY PAUL STRAND

"Photography." *The Seven Arts* 2 (August 1917): 524–525. Reprinted in *Camera Work,* nos. 49–50 (June 1917): 3–4, and in Nathan Lyons, ed., *Photographers on Photography.* Englewood Cliffs, N.J.: Prentice-Hall, Inc., 1966: 138–144.

"Aesthetic Criteria." *The Freeman* 2 (January 12, 1921): 426–427.

"The Subjective Method." *The Freeman* 2 (February 2, 1921): 498.

"Alfred Stieglitz and a Machine." New York: privately printed, February 14, 1921. Reprinted in *MSS* 2 (March 1922): 6–7. Rewritten for *America and Alfred Stieglitz,* Frank Waldo et. al., eds. New York: The Literary Guild, 1934: 281–285.

"The 'Independents' in Theory and Practice." *The Freeman* 3 (April 6, 1921): 90.

"American Watercolors of The Brooklyn Museum." *The Arts* 2 (December 1921): 148–152.

"John Marin." *Art Review* 1 (January 1922): 22–23.

"The Forum." *The Arts* 2 (February 1922): 332–333.

"Photography and the New God." *Broom* 3 (November 1922): 252–258. Reprinted in Lyons, 1966: 138–144.

"News of Exhibits: Sometimes a Week Elapses before Criticisms Are Published." Letter to the Editor of *The Sun* (January 31, 1923).

"The New Art of Colour." *The Freeman* 7 (April 18, 1923): 137. Letter to the Editor in response to Willard Huntington Wright, "A New Art Medium," *The Freeman* 6 (December 6, 1922): 303–304.

"Photographers Criticized." *The Sun* (June 27, 1923): 20. In response to Arthur Boughton, "Photography as an Art," *New York Sun* (June 20, 1923): 22.

"The Art Motive in Photography." *British Journal of Photography* 70 (October 5, 1923): 613–615. From an address delivered at the Clarence White School of Photography, 1923. Reprinted in Lyons, 1966. Précis of text and notes of discussion in "The Art Motive in Photography: A Discussion," *Photographic Journal* 64 (March 1924): 129–132.

"Georgia O'Keeffe." *Playboy* 9 (July 1924): 16–20.

"Marin Not an Escapist." *The New Republic* 55 (July 25, 1928): 254–255.

"Photographs of Lachaise Sculpture." *Creative Art* 3 (August 1928): xxiii–xxviii. Reprinted in "Lachaise," in *Second American Caravan*, A. Kreymborg et. al., eds. New York: The Macaulay Co., 1928: 650–658.

"Steichen and Commercial Art." *The New Republic* 62 (February 19, 1930): 21.

"A Picture Book for Elders." Review of *David Octavius Hill* by Heinrich Schwarz, *Saturday Review of Literature* 8 (December 12, 1931): 372.

"El Significado de la Pintura Infantil." *Pinturas y Dibujos de los Centros Culturales.* Mexico City: Departmento del Distrito Federal, Dirección de Acción Civica, 1933.

"Correspondence on Aragon." *Art Front* 3 (February 1937): 18. In response to Louis Aragon, "Painting and Reality." *Art Front* 3 (January 1937): 7–11.

"Les Maisons de la Misère." *Films* 1 (November 1939): 89–90.

"A Statement on Exhibition Policy." *Photographs of People by Morris Engel.* New York: New School for Social Research, 1939. Reprinted in *Photo Notes* (December 1939): 2.

"An American Exodus by Dorothea Lange and Paul S. Taylor." *Photo Notes* (March–April 1940): 2–3.

"Photography and the Other Arts." Lecture delivered at the Museum of Modern Art, 1945. Published in *Paul Stand Archive, Guide Series Number Two.* Tucson: Center for Creative Photography, University of Arizona, 1980: 5–11.

"Photography to Me." *Minicam Photography* 8 (May 1945): 42–47, 86, 90.

"Weegee Gives Journalism a Shot for Creative Photography." *PM* (July 22, 1945): 13–14.

"Alfred Stieglitz, 1864–1946." *New Masses* 60 (August 6, 1945): 6–7.

"Stieglitz, An Appraisal." *Popular Photography* 21 (July 1947): 62, 88, 90, 92, 94, 96, 98. Reprinted in *Photo Notes* (July 1947): 7–11.

"Address by Paul Strand." *Photo Notes* (January 1948): 1–3.

"A Platform for Artists." *Photo Notes* (Fall 1948): 14–15.

"Paul Strand Writes a Letter to a Young Photographer." *Photo Notes* (Fall 1948): 26–28.

"Realism: A Personal View." *Sight and Sound* 18 (January 1950): 23–26. Reprinted as "International Congress of Cinema, Perugia," in *Photo Notes* (Spring 1950): 8–11, 18.

Photographs of Walter Rosenblum. Exhibition catalogue. New York: Brooklyn Museum, 1950.

"Italy and France." In *U.S. Camera Yearbook 1955.* New York: U.S. Camera Publishing, 1954: 8–17.

"Painting and Photography." *The Photographic Journal* 103 (July 1963): 216. Letter to the Editor in response to A. John Berger, "Painting—or Photography?," *The Observer Weekend Review* (February 24, 1963): 25.

"Manuel Alvarez Bravo." *Aperture* 13 (1968): 2–9.

"The Snapshot." *Aperture* 19 (1973): 46–49.

SELECTED WORKS ON PAUL STRAND

Brown, Milton W. "Paul Strand and His Portrait of People." *The Compass* (December 31, 1950): 12.

Berger, John. "Arts in Society: Paul Strand." *New Society* (March 30, 1972): 654–655.

Tomkins, Calvin. "Profiles: Look to the Things around You." *New Yorker* (September 16, 1974): 44–94.

Keller, Ulrich. "An Art Historical View of Paul Strand." *Image* 17 (December 1974): 1–11.

Paul Strand, Sixty Years of Photographs. Profile by Calvin Tomkins. Millerton, N.Y.: Aperture, 1976.

Duncan, Catherine. "Paul Strand. The Garden: Vines and Leaves." *Aperture* 78 (1977): 46–61.

Paul Strand Archive. Compiled by Sharon Denton. Guide Series, no. 2. Tucson, AZ: Center for Creative Photography, University of Arizona, 1980.

Rosenblum, Naomi. *Paul Strand: The Stieglitz Years at 291 (1915–1917).* New York: Zabriskie Gallery, 1983.

Paul Strand. Introductory Essay by Mark Haworth-Booth. Aperture Masters of Photography, no. 1. New York: Aperture, 1987.

Greenough, Sarah. *Paul Strand: An American Vision.* New York: Aperture/National Gallery of Art, 1990.

Stange, Maren, ed. *Paul Strand: Essays on His Life and Work.* New York: Aperture, 1990.

Aperture would like to thank the following for their guidance and participation in this project: In France: Catherine Duncan, Hélène and Raymond Letutour, Ruth Lazarus, Marion Michelle. In Germany: Ute Eskildsen. In the United States: Susan Barron, Jan-Christopher Horak, Naomi and Walter Rosenblum, Virginia Zabriskie.

Library of Congress Catalog Card Number: 93-73446
Hardcover ISBN: 0-89381-545-4
Paperback ISBN: 0-89381-578-0
Museum Catalogue ISBN: 0-89381-579-9

Printed and bound in Italy by Sfera/Officine Grafiche Garzanti Editore S.p.A.
Tritone separations by Richard Benson and Thomas Palmer.
Book design by Amy Henderson.
Jacket design by Louise Fili.

The staff at Aperture for *Paul Strand: The World on My Doorstep* is
Michael E. Hoffman, Executive Director/Editor in Chief;
Roger Straus III, Publisher/General Manager; Rebecca Busselle, Michael Sand, Editors;
Anthony Montoya, Director of the Paul Strand Archive;
Stevan Baron, Production Director; Sandra Greve, Production Associate;
Antonia Townsend, Editorial Work-Scholar.

First edition
10 9 8 7 6 5 4 3 2 1

Paul Strand: The World on My Doorstep is published on the occasion of a major exhibition opening at the Museum Folkwang in Essen, Germany, which will tour European venues including the Stadt Museum, Munich; the Palais des Beaux Arts, Brussels; the Lillehammer Art Museum; and the Kunsthaus Zürich. The exhibition was organized by the Aperture Foundation and made possible by American Express Company.